CLICK 1

CLICK 1

THE BRIGHTEST IN COMPUTER-GENERATED DESIGN AND ILLUSTRATION

Project editor: J. Ellen Gerken

With a foreword by Primo Angeli

Cincinnati, Ohio

Click 1. Copyright © 1990 by North Light Books. Printed and bound in Hong Kong. All rights reserved. No part of this book may be reproduced in any form or by any electronic or mechanical means including information storage and retrieval systems without permission in writing from the publisher, except by a reviewer, who may quote brief passages in a review. Published by North Light Books, an imprint of F&W Publications, Inc., 1507 Dana Avenue, Cincinnati, Ohio 45207. First edition.

94 93 92 91 90 5 4 3 2 1

Library of Congress Cataloging in Publication Data

Click 1 / project editor, J. Ellen Gerken ; with foreword by Primo
 Angeli. — 1st ed.
 p. cm.
 ISBN 0-89134-348-2
 1. Computer art — Themes, motives. I. Gerken, J. Ellen.
 N7433.8.C55 1990
 700 — dc20 90 - 7257
 CIP

Pages 147-149 constitute an extension of this copyright page.

Concept and editorial direction: Diana Martin

Interior design: Sandy Conopeotis

ACKNOWLEDGMENTS

A book of this nature is a difficult undertaking from a technological standpoint. Much of the Macintosh-based work arrived in its original disk format. The generous cooperation of the following software manufacturers enabled a significant portion of the pieces to be reproduced as closely as possible to the original electronic file. The Macintosh files were taken straight to negative film in many cases.

Adobe Systems, Inc. Adobe Separator and Illustrator 88

Aldus Corporation Persuasion, Freehand, and Pagemaker

Casady & Greene Typefaces

Letraset Letrastudio, Ready, Set, Go

Claris Corporation MacDraw II

Electronic Arts Studio/8

Altsys Fontographer and Fontastic

Microsoft Corporation Microsoft® Word and Microsoft® Powerpoint®

Quark, Inc. Xpress and Quarkstyle

A very special thank you is extended to Mr. Ron Barwig and the QMS Corporation, Cincinnati branch office, for the full-day loan of a QMS Colorscript 100 thermal printer. The Macintosh files were printed out in 300 dpi resolution for review purposes.

THANKS

To the administration and faculty of Northern Kentucky University for computer support and release time to write

To senior editor Diana Martin, content editor Perri Weinberg-Schenker, associate editor Mary Cropper, and all the fine people at North Light Books

To Lori Siebert and Paul Woods for their special perspectives and their contribution of valuable time and experience

To my wonderful and gifted students who ask hard questions and force me to think clearly; especially to Molly Merten and Rose Topie for assistance with the project

To both my family and my husband's family, especially my brother David Lytle Eichler who assisted with mailings

To my business partner, Debbie Labermeier, who managed patience with me and took good messages no matter what language they were in

To the Cincinnati design community — highly aesthetic, under-appreciated, invigorating, and somehow simultaneously competitive and nurturing

To Gordon Salchow, a role model of the design educator and the "keeper of the faith"— no matter what the real world tells you design ought to be

To two great visual artists, Marcia Hartsock-Moulton and Bev Kessler, both of whom were responsible for teaching me that the only boundaries in this life are in your head

Most of all, to my husband, Bruce, who is the wind beneath my wings

FOREWORD

Few events challenge our ability to change more vividly than the technical imminence of the ubiquitous computer. This curious little box may be the most dominant business and communications tool in the world. This timely book reminds us to put aside our egos and stop worrying about too much communication impacting our style.

Things change. But unfortunately, all too often as one becomes more experienced and successful, one's rationale becomes more convincing in explaining why new things can't work. Some established designers are still debating the merits of these quantitative and impersonal machines. But, of course, one could imagine the same debate regarding the advent of movable type. Picture scribes of the fifteenth century discussing the issue and perhaps producing unique (one at a time) protest posters of Gutenberg as the martyred St. Sebastian festooned with quills.

Marketing design, as a specific case in point, is on the cusp of a golden age because this particular brand of visual communication is driven by a worldwide economic necessity to produce more highly competitive products and services as a means of national survival. In that functional capacity then, design is no longer an abstraction; therefore, an openness to new and useful tools and ideas has to be nurtured.

As a creative director, I personally am not all that interested, as an engineer might be, in the mechanics of high-tech equipment. On the one hand, when one hears "bits, bytes, megabytes, disks and drives" jammed together, they sometimes sound like a complex machine falling down a flight of stairs. On the other hand, for some people it's the sound of music. But the fact remains that besides having their own unique characteristics, computers allow us more of that magic ingredient — time. Time to explore and develop creative solutions is often consumed by today's new economic demands of constrained budgets and detailed drudgery found in slower tools and older work models.

The other essential elements in competitive communication are passion and imagination. Those elements, blessed with sufficient time, turn on the wellspring of all great ideas—the magical subconscious—which gives us the opportunity to explore and reveal undreamed-of design possibilities.

In a world of exponential change, the challenge of new invention is everywhere. We should not be too comfortable with our past victories, but rather use them as inspiration. Look forward to new visual adventures as a way of creatively experiencing the future. For just as the nature of the universe is a season of changes, we too are a moving part of that universe. I believe that in the final analysis, our mutual interests lie in creativity. This depends on openness, acceptance, and maintaining our sense of wonder, our childlike capacity to see — and to play with all the available toys.

Primo Angeli

DEDICATION

While researching designers for this book, I spoke to the chief executive of a prominent advertising firm who tried to dissuade me from pursuing the entire project. "The whole premise is useless since *the best people* don't use computers." Since I had no luck convincing him with words, this book is dedicated to proving him wrong with images from those designers, illustrators, and artists we consider to be the best people.

J. E. Gerken

TABLE OF CONTENTS

INTRODUCTION

Machiavelli once said "There is nothing more difficult to take in hand, more perilous to conduct, or more uncertain in its success, than to take the lead in the introduction of a new order of things." This is certainly true of the designers and artists who have pioneered the way toward legitimizing the computer as a tool for visual artists.

Computer graphics in the visual arts seems to be one of the most controversial topics since the discovery of movable type. And while computers are the answer to the dreams of some artists and the stuff of nightmares for others, it's inarguable that they are permanent fixtures. We now have to go about seeing what they will do and what they can do for us as creative and business tools.

OUR HOPES

Click is meant to help you learn more about what is happening with artists who are breaking ground with the computer. It is meant to show you some of the creative opportunities computers can offer, help you make clearer sense of what computers can do for you, and maybe turn you on just from the quality of the imagery.

WHAT WE LEARNED

Creation of this book has been a lengthy process. Much time was spent compiling a list of nearly seven hundred artists known to work on the computer. In response to our invitation over a thousand pieces were submitted, the majority from the United States. We were thrilled, albeit buried under the avalanche for a while!

The submissions affirmed our feeling that computers are being used for every imaginable application and some surprising ones — annual reports, identity packages, packaging, and posters; illustration and fine art, experimental art, and information graphics; even playing cards, fabrics, environmental graphics, and comic books. Video, animatics, and broadcast graphics were well represented too.

We discovered, not surprisingly, that the most developed, progressive, and exciting art is in the experimental and fine art areas. You can judge for yourself on pages 47-71.

The artists' creative processes were fascinating and we'll share these with you throughout the book. Here are a few of them:

- Textures and shapes were generated from nearly anything scannable—fingers and fingernails, jewelry, clay models, and, more typically, photographs
- Images were merged and manipulated
- Photographic details from different images were collaged
- Sketches were computer-generated, transferred to canvas and painted traditionally
- Computer output was combined with traditional mediums like colored pencil, photocopying, torn paper, and paint

You'll find information on the specific computer tools used—hardware and software, scanning and output equipment. You'll learn who the client was and what the piece was done for. For many pieces you'll be able to read "behind-the-scenes" commentary from the artists.

HOW THE ART WAS SELECTED

Review of the submissions was done slowly and thoughtfully by myself and three other people who brought their individual expertise to this difficult challenge.

- *Paul Woods*, design consultant for Apple Computer and partner in Woods + Woods, specializes in packaging, product promotion, and identity development. "I reviewed the art based on a simple premise — that it should work in the conventional design sense, not just because a computer was used in a particularly novel way. The pieces that truly were surprising were those of pure and simple good design. The computer should not be an obvious element or, if it is, not intrusive to the total piece. The computer is only a tool, no more important than the pencil."

- *Lori Siebert*, owner of Siebert Design Associates, Inc. is designer for HOW magazine. "It seems as though the more interesting work is in the area of fine art or illustration. It is easy to create work that screams computer, but I was drawn to the pieces that used the computer as a tool and did not let the technique override the pure aesthetics. The layering and richness of texture achieved was very beautiful. I also noted interesting typographic manipulation in several of the design pieces where layering again seemed to occur in the overlap and interplay between type and image. I appreciated such a painterly quality achieved through this medium."

- *Diana Martin* is North Light Books Senior Editor for graphic design and illustration books. "*Click* enjoys a unique vision. It is an editorially-driven work rather than the by-product of a paid entry contest as most compendiums are. Our goal was to share with artists one full-bodied vision of the computer in design today. The art you'll see was chosen to give you a taste of what's happening in a broad ensemble of disciplines."

IT WASN'T ALL SMOOTH SAILING

While creation of the editorial for *Click* went along comfortably, production was not without its computer-generated problem. As editorial corrections were being input, a computer virus, now thought to have ridden along with one of the disks submitted to the book, took up residence in our Macintosh system. A suitable vaccine remedied the problem, but editorial material was lost, as was valuable time. Computers are not pain-free tools.

THE PACE OF CHANGE

We've reached a funny place in our technological development. Quite simply, computers can't do everything we want. They don't completely replace non-electronic methods, although deep down we may expect them to. My sophomore design students constantly ask "Can I do this project on the computer?" They don't yet understand the value of training the hand and eye to work together — until I ask them what they would do if the power should ever go out.

There is danger in completely letting go of the traditional way of doing things. Yet change is all around us and it can't be ignored. If you are ready for it and plan for it, it's actually invigorating. Lyle Schaller said in *The Change Agent* that "...the person who has a systematic approach to the future and a frame of reference for evaluating alternatives has a tremendous advantage over the person who functions without either." Thus, designers, illustrators and fine artists will probably be in a better position than most professions to deal with the pace of change. After all, change is our stock-in-trade.

The majority of letters and calls received while compiling this book expressed wonder and excitement about what the artists had learned and accomplished. Most eagerly anticipate the effects computer graphics will have on the visual arts. Some were tempered with yearnings for capabilities and technology that hasn't yet been developed. The positive attitude and enthusiasm of these artists shows clearly in their work. We hope you'll share our feeling that this book reflects these artists' feelings and special endeavors.

J. Ellen Gerken

ILLUSTRATION
AND INFORMATION
GRAPHICS

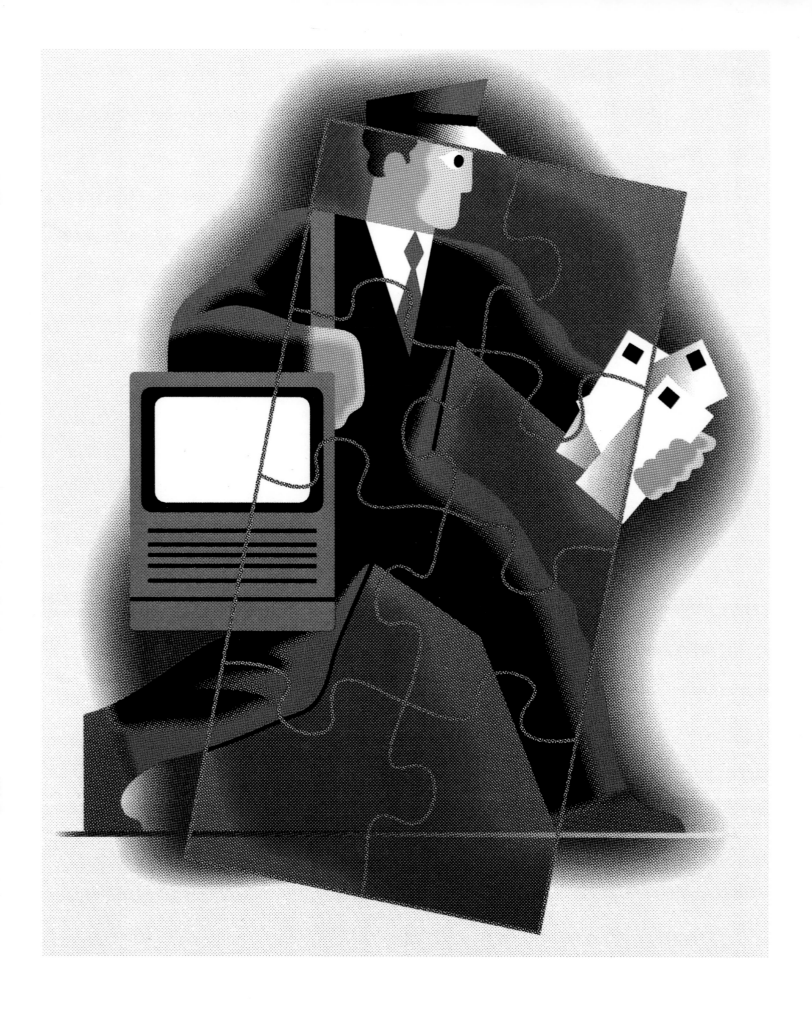

◀

Illustrator
Ron Chan
San Francisco, California

Client
MacWorld magazine
San Francisco, California

Illustration for an article on electronic mail.

• Apple Macintosh IIcx computer; Adobe Illustrator 88 software; output on Linotronic Imagesetter.

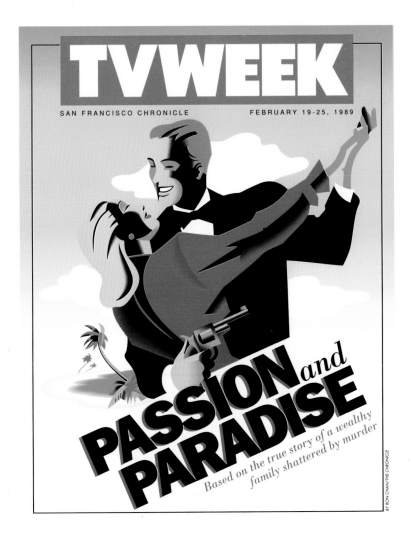

▲

Illustrator
Ron Chan
San Francisco, California

Client
San Francisco Chronicle
San Francisco, California

Passion and Paradise, cover of *TV Week,* a television guide supplement; *TV Week* covers have been produced exclusively on computer since 1988.

• Apple Macintosh IIcx computer; Adobe Illustrator 88 software; output on Linotronic Imagesetter. The blending capabilities of Adobe Illustrator software form a basis of the artist's illustrative style. The illustrations and type were entirely computer generated.

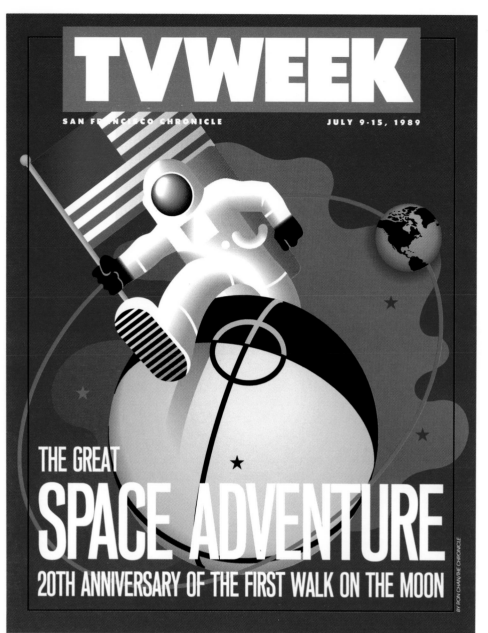

TVWEEK

SAN FRANCISCO CHRONICLE

JULY 9-15, 1989

THE GREAT
SPACE ADVENTURE
20TH ANNIVERSARY OF THE FIRST WALK ON THE MOON

BY RON CHAN/THE CHRONICLE

Illustrator
Ron Chan
San Francisco, California

Client
San Francisco Chronicle
San Francisco, California

Space Adventure, cover of *TV Week*, a television guide supplement; *TV Week* covers have been produced exclusively on computer since 1988.

• Apple Macintosh IIcx computer; Adobe Illustrator 88 software; output on Linotronic Imagesetter. The blending capabilities of Adobe Illustrator software form a basis of the artist's illustrative style. The illustrations and type were entirely computer generated.

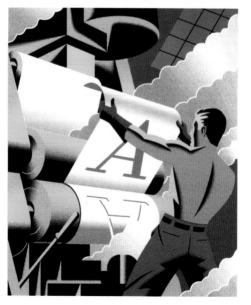

Illustrator
Ron Chan
San Francisco, California

Client
MacWorld magazine
San Francisco, California

Cover illustration.

• Apple Macintosh IIcx computer; Adobe Illustrator 88 software; output on Linotronic Imagesetter.

Illustrator
Howard Mandel
New Media Design Group
New York, New York

James Brown, illustration for
European computer graphics
workshop.

• Apple Macintosh II computer; Adobe Illustrator 88 software;
output on Linotronic Imagesetter. Layers and layers of blends build up
soft transitions that rival airbrush.

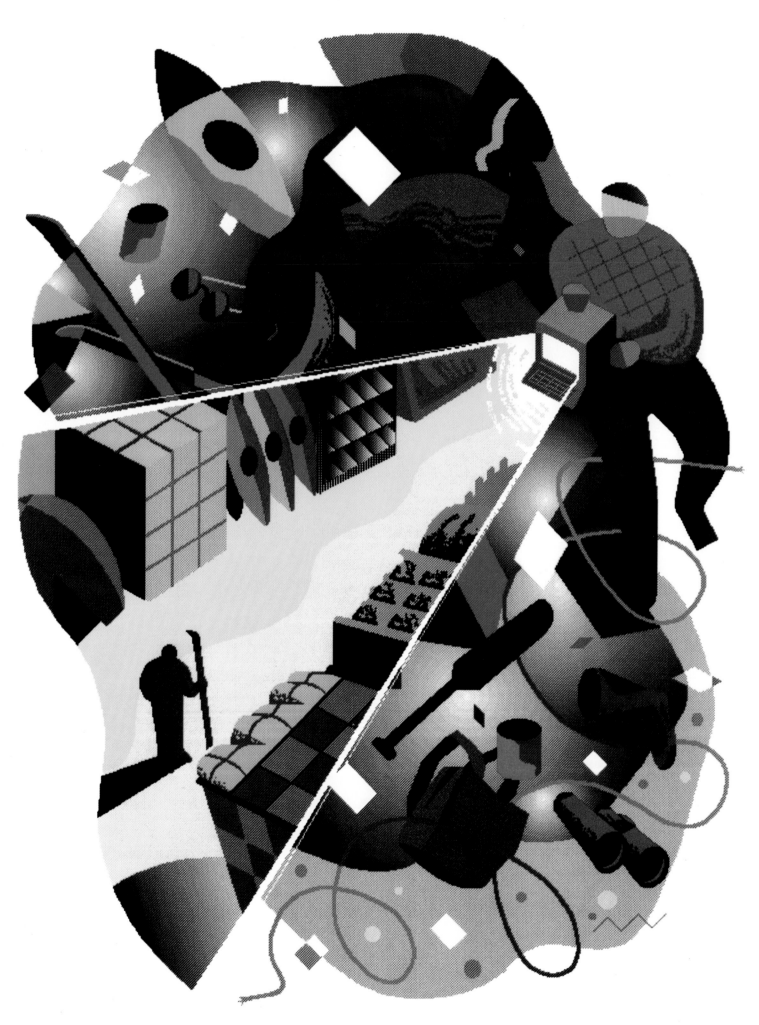

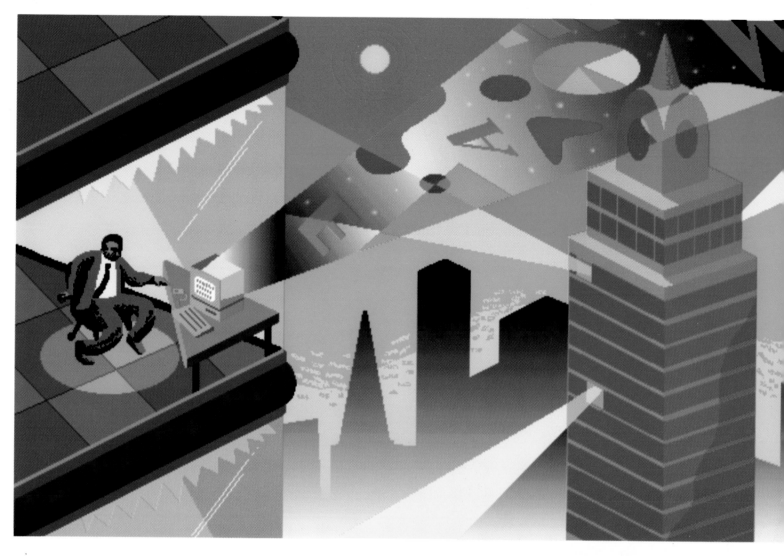

▲

Illustrator
Mick Wiggins
Berkeley, California

Client
MacWeek magazine
San Francisco, California

▶

Ilustrator
Mick Wiggins
Berkeley, California

Client
MacWeek magazine
San Francisco, California

◀

Illustrator
Mick Wiggins
Berkeley, California

Client
Outside Business Magazine
Chicago, Illinois

Illustration for article on the proliferation of desktop publishing in corporate offices.

• Apple Macintosh II computer; SuperMac PixelPaint software; Linotronic Imagesetter used for color separations.

Editorial illustration for an article about the black-market sales of Chinese-made Macintosh clones.

• Apple Macintosh II computer; SuperMac PixelPaint software; Linotronic Imagesetter used for color separations.

Editorial illustration showing small retail sporting goods stores how to use computers to reduce chaos and increase inventory efficiency.

The results are not the impressive part of creating — the process is. There are real limitations and shortcomings in the end result, but the process outweighs them since the illustration is malleable right up to the end. — *Mick Wiggins*

• Apple Macintosh II computer; SuperMac PixelPaint software; Linotronic Imagesetter used for color separations.

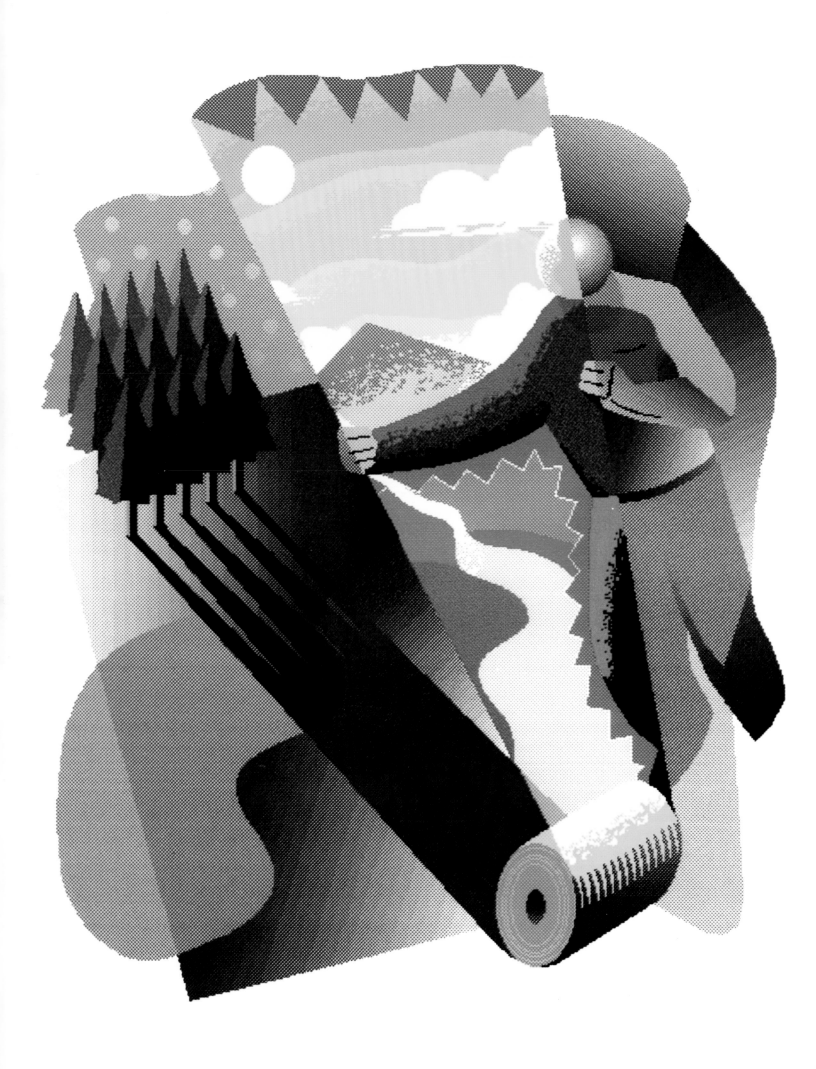

◄

Illustrator
Mick Wiggins
Berkeley, California

Client
Great Northern Nekoosa Corp.
Norwalk, Connecticut

Annual report illustration portraying the future use of high technology in the planning and management of a large paper manufacturer.

● Apple Macintosh II computer; SuperMac PixelPaint software; output on Scitex through proprietary Imageset interface.

Illustrator
Mick Wiggins
Berkeley, California

Client
Digital Equipment
of Canada, Ltd.
Toronto, Canada

Illustration for in-house publication explaining how executives have immediate access to business information through computers.

● Apple Macintosh II computer; SuperMac PixelPaint software; output on Scitex through proprietary Imageset interface.

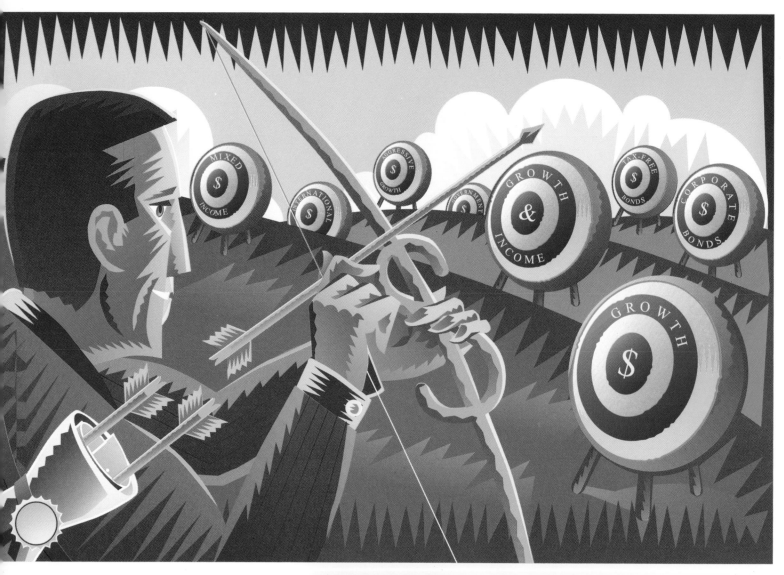

▲
Illustrator
Steve McKinstry
Media Design/DPI
Anacortes, Washington

Client
U.S. News & World Report
Washington, D.C.

Illustration for feature article on the year's best mutual funds.

• Apple Macintosh II computer with a Turbo Mouse; Aldus FreeHand
2.0 software; Linotronic Imagesetter used for full-color separations.
All type and imagery were computer generated.

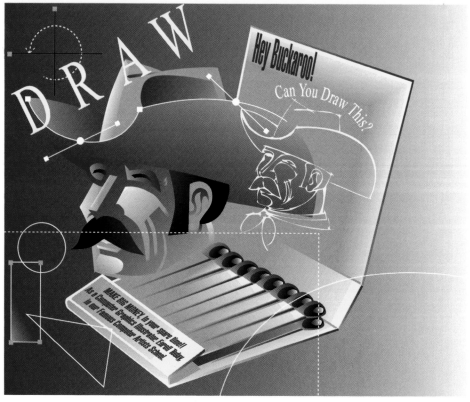

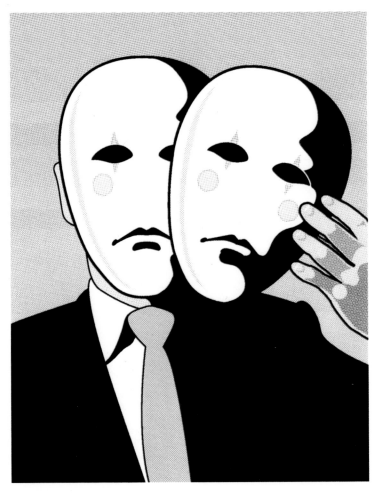

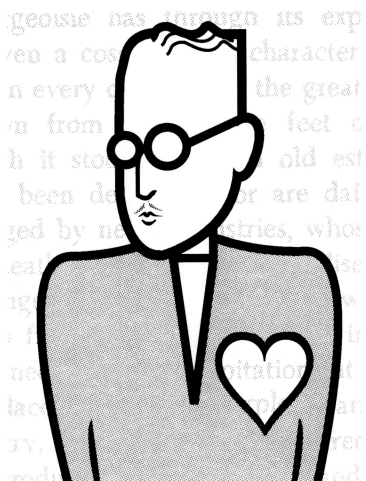

Illustrator
J. Patrick Sedlar
Detroit, Michigan

Client
The Detroit News
Detroit, Michigan

Schizophrenia's Two Faces, newspaper science page illustration.

• Apple Macintosh II computer; Adobe Illustrator 88 software; output on Varityper 600.

Illustrator
J. Patrick Sedlar
Detroit, Michigan

Client
The Detroit News
Detroit, Michigan

Heartless Intellectual, newspaper page illustration to accompany a book review.

• Apple Macintosh II computer; Adobe Illustrator 88 software; output on Varityper 600.

◄

Illustrator
Steve McKinstry
Media Design/DPI
Anacortes, Washington

Client
MacWorld magazine
San Francisco, California

Draw the Cowboy, editorial illustration.

• Apple Macintosh II computer with a Turbo Mouse; Aldus FreeHand 2.0 software; Linotronic Imagesetter used for full-color separations. Facsimile rough sketches were scanned into the computer; no stripping or further composition was done. Final image was transferred electronically to the client.

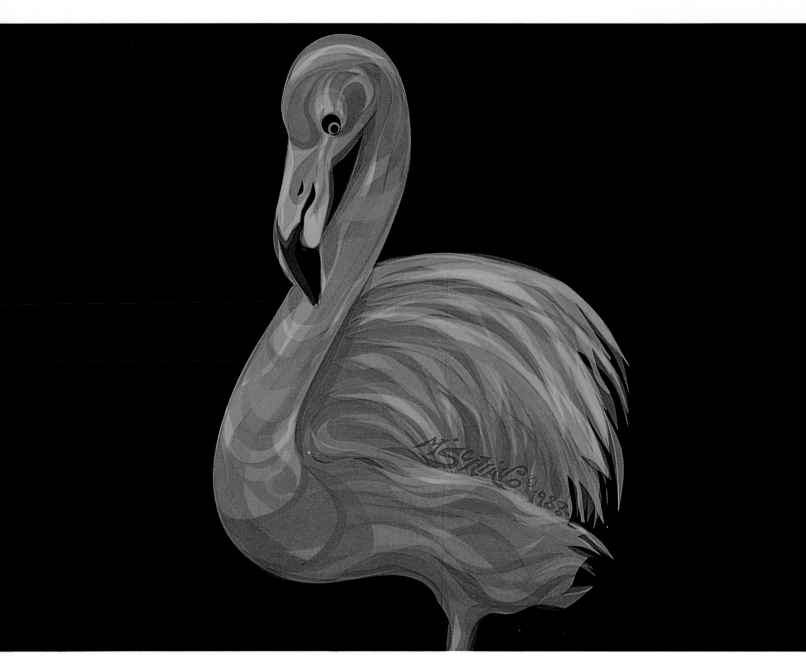

Artist
Marian Schiavo
Arts on Fire
Douglaston, New York

Clients
Flamingo Graphics
Cambridge, Massachusetts
Audio Visual Communications
New York, New York

Promotional poster for graphics company, cover for *A. V. Communications* magazine, and inside art for *Computer Pictures* magazine.

• Compaq 386 computer with Truevision TARGA 16 graphics board; Flamingo Graphics Logo Editor software; Loeb Julies Research Lab 8x10 film recorder used for imaging. This image illustrates the spline curves of a new software for IBM-PC computers. The flamingo was created solely from spline curves.

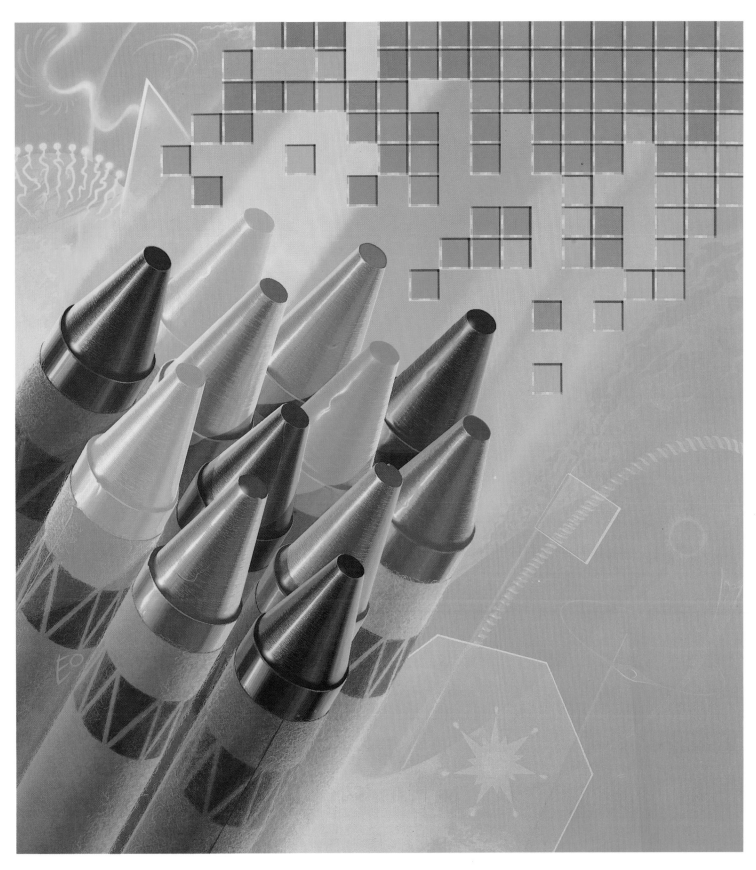

Illustrator
Erol Otus
Island Graphics Co.
San Francisco, California

Client
Computer Graphics World
magazine
Westford, Massachusetts

Crayons, magazine cover illustration.

The magazine requested crayons that were both fuzzy and shiny.
The textures were easier to achieve in a high-resolution computer
image than in a medium such as acrylics, which I traditionally use.
— *Erol Otus*

• IBM-AT computer with Truevision TARGA 32 graphics board; Island
Graphics GiantPaint software; output on Dunn digital film recorder.

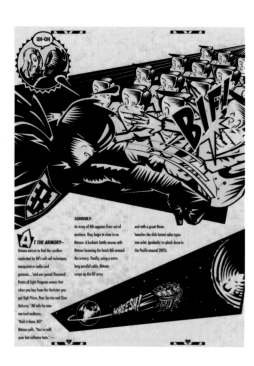

Illustrator
Johnee Bee
The Johnee Bee Show
Irvine, California

Client
Ingram Micro D
Santa Ana, California

Illustrated comic book used at MacWorld Exposition to announce products and special events to vendors attending the show.

• Apple Macintosh IIx computer; Adobe Illustrator 88 software; Linotronic Imagesetter used for color separations.

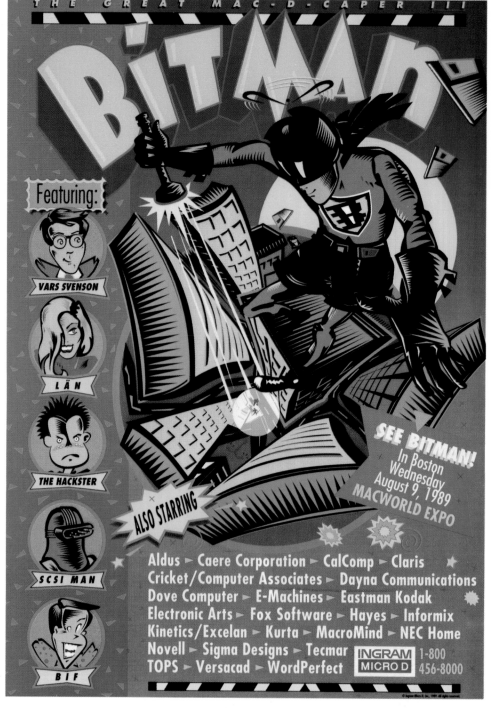

Illustrator
Johnee Bee
The Johnee Bee Show
Irvine, California

Client
Ingram Micro D
Santa Ana, California

Illustrated ads for Micro D, used to attract vendors attending the MacWorld Exposition.

A high-resolution drawing program creates sharp angles characteristic of the artist's style and gives him control over typography and the color separation process.

• Apple Macintosh IIx computer; Adobe Illustrator 88 software; Linotronic Imagesetter used for color separations.

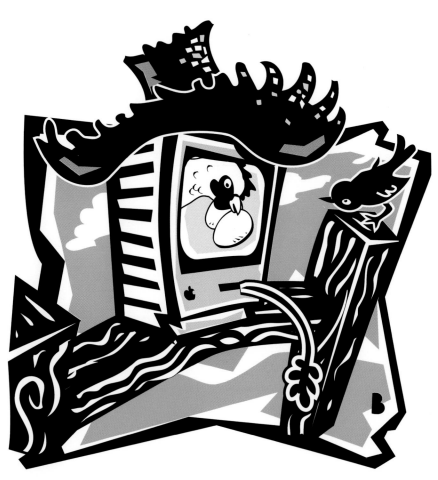

Illustrator
Johnee Bee
The Johnee Bee Show
Irvine, California

Client
Ingram Micro D
Santa Ana, California

The Real McCoys, editorial illustration for promotional magazine.

Illustration was completely computer generated, with the art director approving the illustrations off the color monitor.

• Apple Macintosh IIx computer; Adobe Illustrator 88 software; Linotronic Imagesetter used for color separations.

Illustrator
Johnee Bee
The Johnee Bee Show
Irvine, California

Client
Ingram Micro D
Santa Ana, California

Waiting for Laser Printer, editorial illustration for promotional magazine.

• Apple Macintosh IIx computer; Adobe Illustrator 88 software; Linotronic Imagesetter used for color separations.

Illustrator
Jonathan Herbert
Computer Illustration
New York, New York

Self-Portrait, direct mail self-promotional piece.

● Indtech 286 computer with Truevision TARGA 24 graphics board; JVC video digitizer; RIO, Topas, Asavision, QFX and Island Graphics TIPS software; output on Matrix QCR film recorder. Photography is "hand-colored" by computer methods.

Illustrator
Jonathan Herbert
Computer Illustration
New York, New York

Client
Leaders Magazine
New York, New York

High Tech Spy, magazine editorial illustration.

● Indtech 286 computer with Truevision TARGA 24 graphics board; JVC video digitizer; RIO, Topas, Asavision, QFX, and Island Graphics TIPS software; output on Matrix QCR film recorder.

Illustrator
Jonathan Herbert
Computer Illustration
New York, New York

Client
Leader Magazine
New York, New York

File Cabinet, one image from a series used as an editorial illustration for a magazine.

• Indtech 286 computer with Truevision TARGA 24 graphics board; JVC video digitizer; RIO, Topas, Asavision, QFX, and Island Graphics TIPS software; output on Matrix QCR film recorder. Color blends simulate effects previously only achieved with an airbrush.

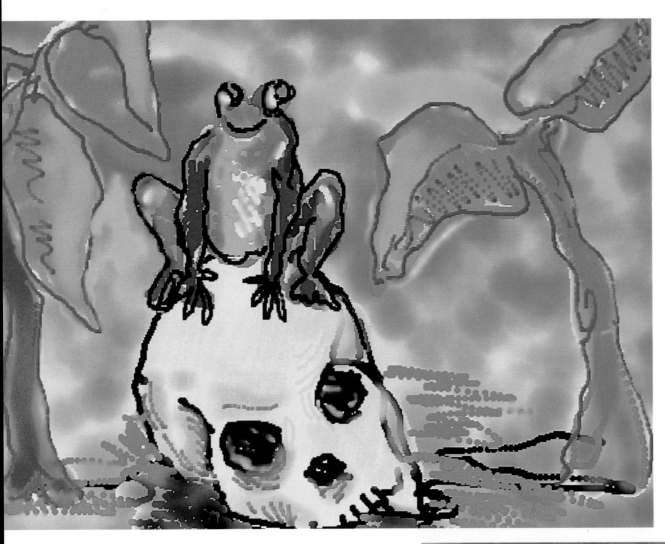

Illustrator
Jonathan Herbert
Computer Illustration
New York, New York

Frog on Skull, self-promotional
illustration.

The ability to rework, undo, remove, and change colors is the magical
thing about a computer. Freedom is what computer illustration
means to me. — *Jonathan Herbert*

• CSS Labs 386/33 computer with Truevision TARGA 24 graphics
board; Island Graphics TIPS software; output on Matrix QCR-2 film re-
corder.

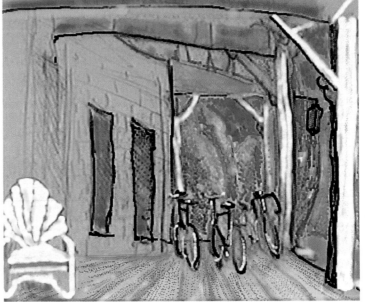

Illustrator
Jonathan Herbert
Computer Illustration
New York, New York

Porch in Quogue, self-
promotional illustration.

• Indtech 286 computer with Truevision TARGA 24 graphics board;
JVC video digitizer; Island Graphics TIPS software; output on Matrix
QCR film recorder.

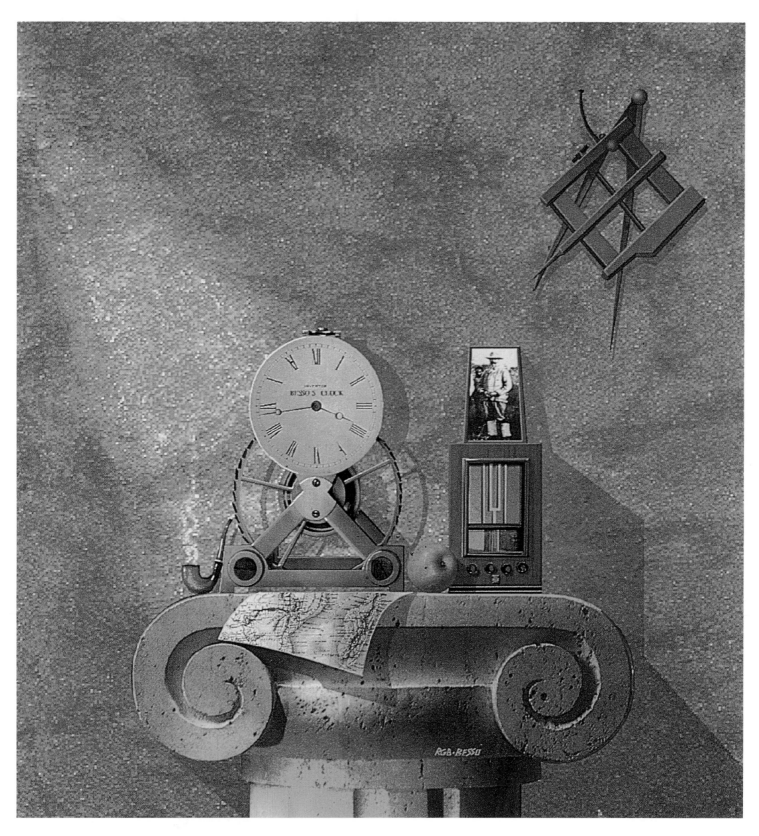

Designer
Francesca Besso
RGB Computer Graphics
Service SRL
Milan, Italy

Client
Computer Graphica &
Applicazioni
Milan, Italy

Capitello, advertising illustration.

● IBM-PC AT computer; Lumena/16 software; output on Matrix PCR film recorder. This 24-bit image is painted from a palette of 16.8 million colors.

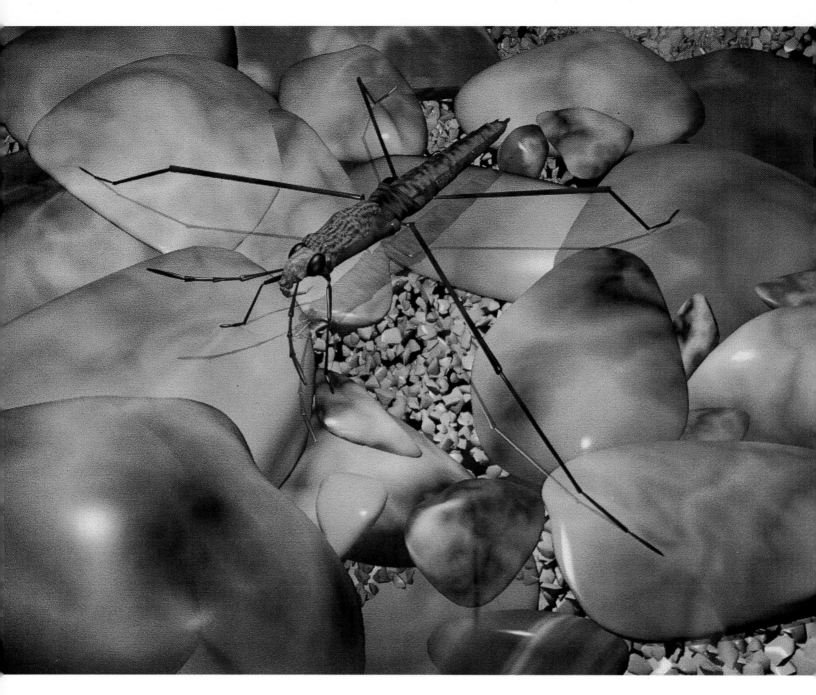

Illustrator
Daniel Langlois
SOFTIMAGE, Inc.
Montreal, Canada

Water Strider, promotional
piece for SOFTIMAGE software
and opening image of
SIGGRAPH 1988 calendar.

This image consists of 2,160 individual grains of sand and 33 rocks,
lit by three light sources. The water strider is composed of 82 articu-
lated elements. The image was rendered using the equivalent of
500,000 polygons and 52 procedural solid textures, at a resolution
of 1,000 by 760 lines. — *Daniel Langlois*

● Silicon Graphics computer; SOFTIMAGE 4D Creative Environment
software; output to film recorder in high resolution.

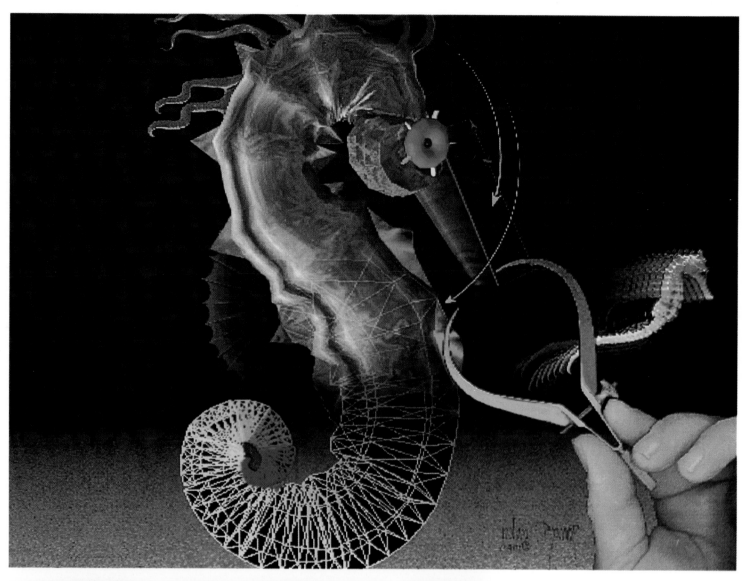

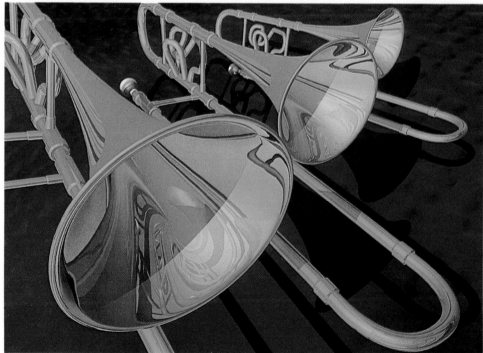

▲

Artist
James Dowlen
Santa Rosa, California
Client
Vision Technologies
Fremont, California

Sea Horse, cover illustration for *Computer Graphics Review* magazine.

The ability to experiment with so many possibilities is probably the most amazing quality of this system. Grabbing textures from the real world with my scanner then running these textures through the computer to enhance, emboss, colorize, duplicate, or merge them — all this was not easily available before this technology.
— *James Dowlen*

• Everex 286 computer with Vision Technologies graphics board; Color Scheme II, Lumena, and Topas 3-D software; output to Matrix PCR film recorder.

© Vision Technologies.

Illustrator
Daniel Langlois
SOFTIMAGE, Inc.
Montreal, Canada

Trombones, promotional piece
for SOFTIMAGE software.

• Silicon Graphics computer; SOFTIMAGE 4D Creative Environment software; output to film recorder in high resolution. The illustration contains environment maps, bump maps, and true cast shadows. It was output at 2,048 by 1,498 lines of resolution.

▶

Artist
Serban Epuré
Frankfurt, Gips and Balkind
New York, New York

Client
ID, The Magazine of
International Design
New York, New York

The Ultimate Computer, visualized as the human mind.

• Apple Macintosh II computer, 45MB removable hard disk drive, Abaton scanner; Adobe Illustrator 88, custom-colorized Letraset Imagestudio 1.0, Curator, Capture, and SuperMac PixelPaint software; photographed off screen. The artist combined scanned and drawn imagery.

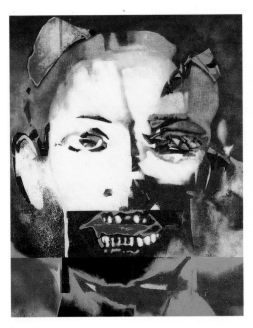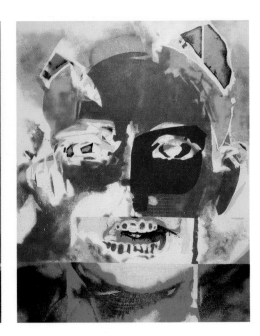

Artist
Jeremy Gardiner
Pratt Institute
Brooklyn, New York

Client
Blitz magazine
London, England

The Anchorman, 60x48-inch triptych used as editorial illustration.

• DEC PDP 11/73 computer with CGL Images II software; Iris 1044 ink-jet printer; Matrix QCR film recorder and Scitex used for color separations. The image was computer-designed, then transferred to canvas for the final image in acrylic paints.

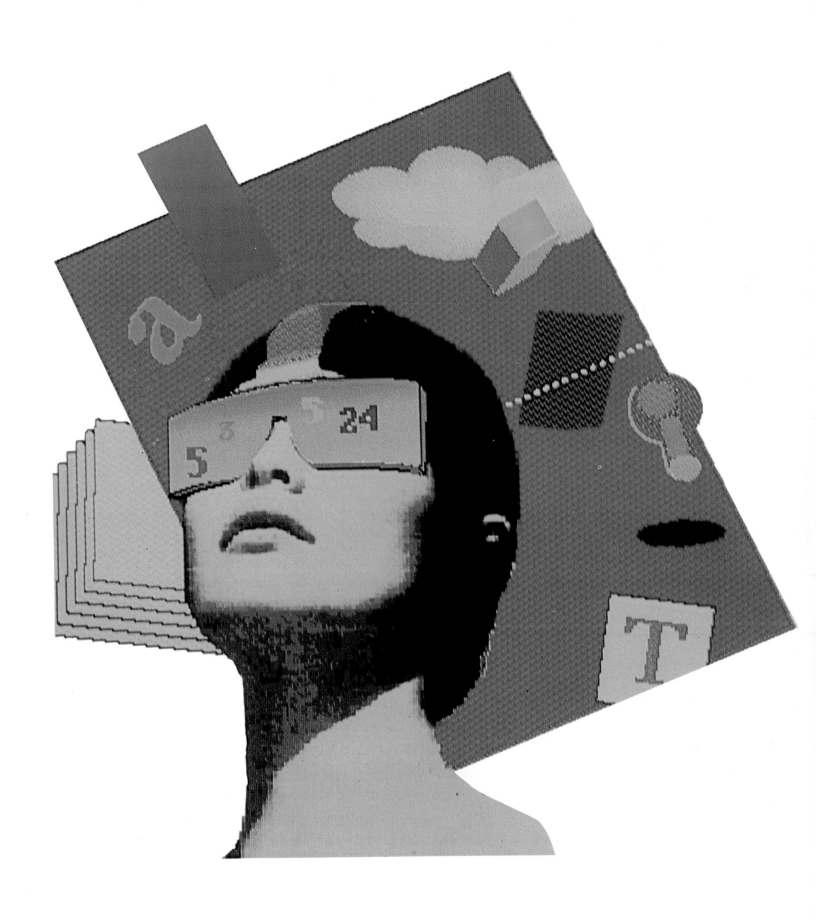

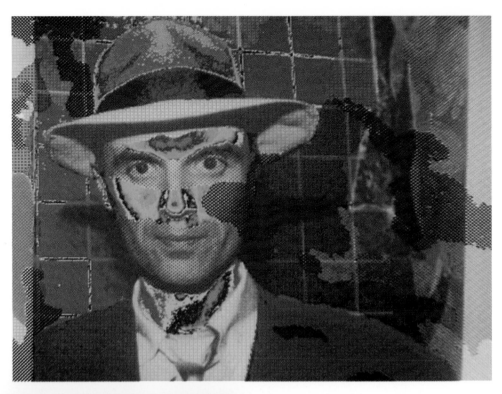

▲

Illustrator
Micha Riss
Sunnyside Gardens, New York

Photographer
Arthur L. Field
Little Neck, New York

Client
Musician Magazine
New York, New York
Boston, Massachusetts

Half-page magazine illustration of David Byrne of the Talking Heads.

There is a freehand touch to this illustration that would have been impossible without a computer. I used an electronic brush to put colored dot patterns over a black-and-white photograph.
— *Micha Riss*

● CGL Images II computer graphics system and software; output to a Matrix film recorder.

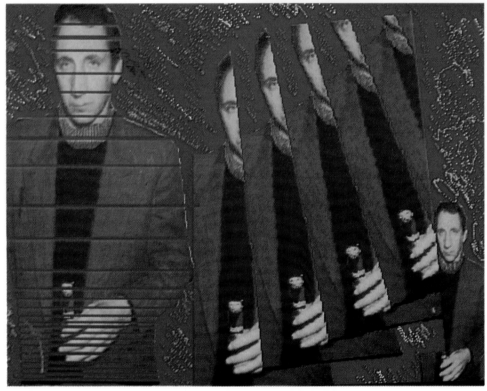

Illustrator
Micha Riss
Sunnyside Gardens, New York

Photographer
Arthur L. Field
Little Neck, New York

Client
Spin Magazine
New York, New York

Quarter-page magazine illustration of Pete Townsend of The Who.

● CGL Images II computer graphics system and software; output to a Matrix film recorder.

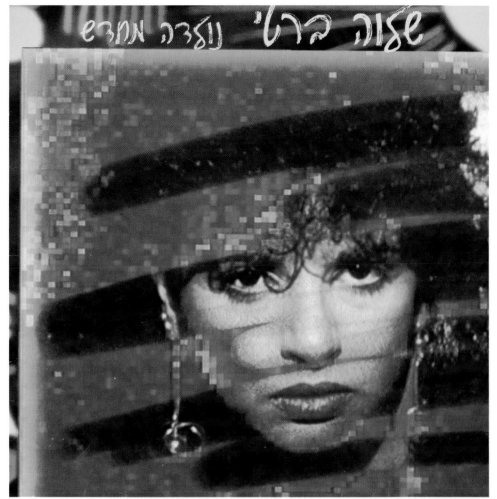

Illustrator
Micha Riss
Sunnyside Gardens, New York
Client
Hed-Arzi Records
Tel-Aviv, Israel

Album cover for Shalva Berti.

• Quantel Paintbox Videographics system and software; output to slides.

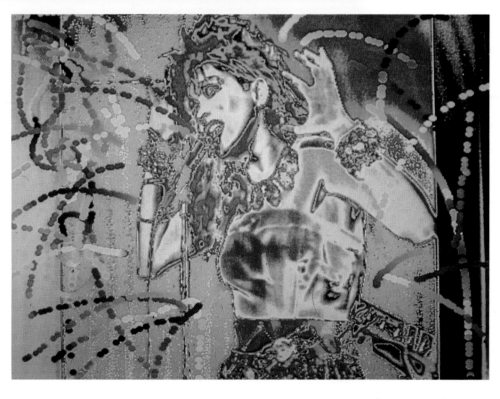

Illustrator
Micha Riss
Sunnyside Gardens, New York

Photographer
John Bellissimo
New York, New York

Client
Rock Photo magazine
New York, New York

Two-page spread illustration of Cyndi Lauper.

• CGL Images II computer graphics system and software. The image was solarized, then painted with a round electronic brush. Output to film recorder.

Illustrator
John Derry
Time Arts
Santa Rosa, California

Client
Electronic Arts
San Mateo, California

Corporate Christmas card reflecting the client's ■●▲ logo and promoting its painting software.

● Apple Macintosh II computer; Electronic Arts Studio 8 software; output to Scitex plotter for four-color separations.

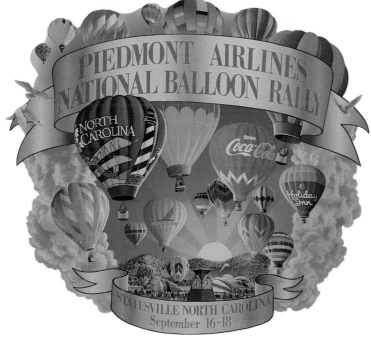

Illustrator
Scott Baldwin
Chestnut Ridge, New York

Client
MacWorld Magazine
San Francisco, California

Switching to Hypercard, editorial illustration.

The artist uses low-resolution pixels to add texture and life to solid color illustration.

● Apple Macintosh Plus computer; Silicon Beach SuperPaint software; output to Linotronic ImageWriter II for proofing; four-color separations on a Scitex scanner.

Illustrator
Jim Thompson
Technical Illustrations
Statesville, North Carolina

Client
Statesville Chamber of
Commerce
Statesville, North Carolina

Poster illustration to promote Piedmont Airline's National Balloon Rally.

● IBM-PC AT computer and video digitizer; Lumena/16 software; output to Matrix QCR-Z film recorder.

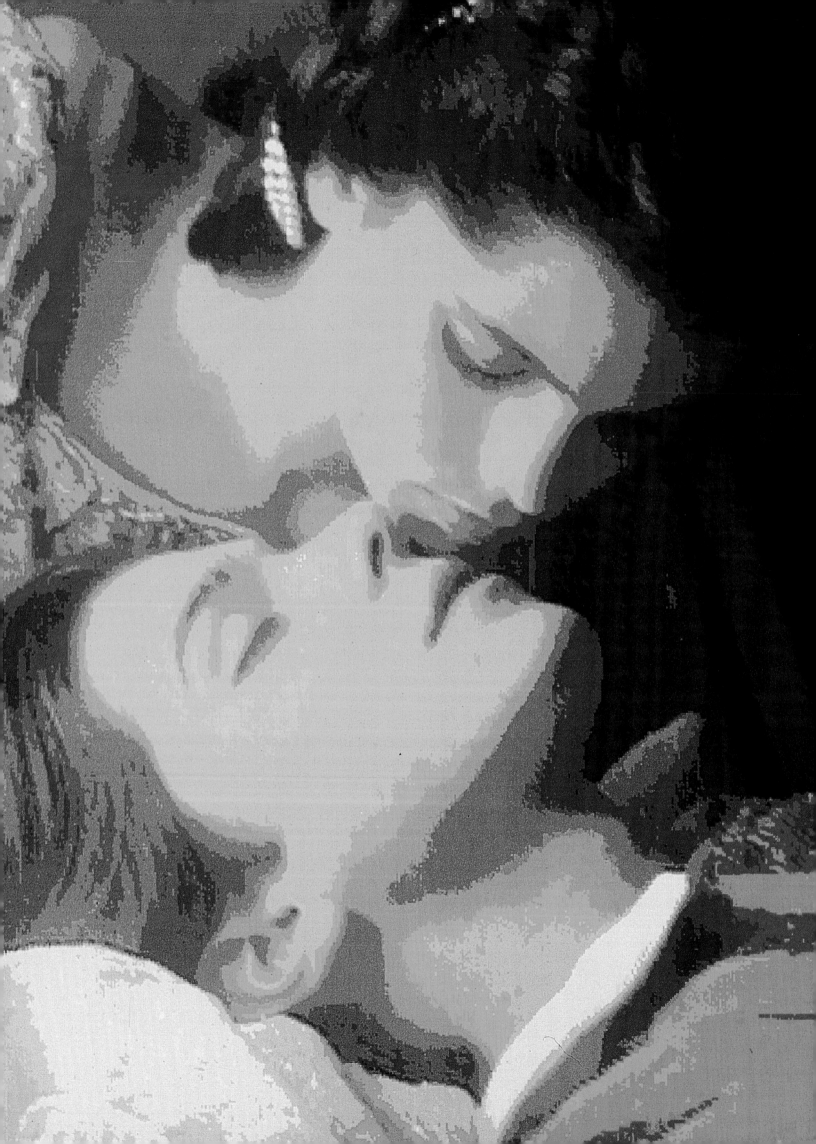

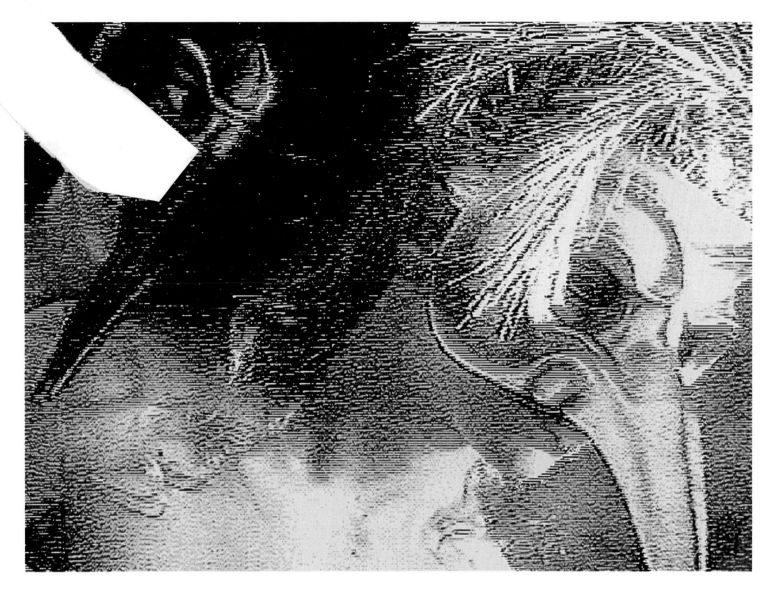

◄

Photographer/Illustrator
Alan Brown
Photonics Graphics/PhotoDesign
Cincinnati, Ohio

Client
Cincinnati Opera
Cincinnati, Ohio

Romeo and Juliet, program cover and poster.

The client wanted "warm and ethereal." Combining electronic still video for the coarse texture with computer illustration for effect worked nicely for what they needed. — *Alan Brown*

• Apple Macintosh IIx computer, Canon Electronic Still Video Camera, and MacVision Digitizer; PhotoMac, Truevision, and Conductor software; output on Agfa Matrix Slidewriter film recorder.

Photographer/Illustrator
Alan Brown
Photonics Graphics/PhotoDesign
Cincinnati, Ohio

Birdwomen, self-promotional illustration to educate clients to the myriad possibilities inherent in photo-illustration.

• Apple Macintosh IIx computer, Canon Electronic Still Video Camera and MacVision Digitizer; PhotoMac, Truevision, and Conductor software; output on Agfa Matrix Slidewriter film recorder. The photographer/illustrator sought to emulate the look of lithography and etching with the application of texture and tinting.

Illustrator
Mick Wiggins
Berkeley, California

Client
Computer World
Framingham, Massachusetts

Lil' Boats, editorial illustration for in-house publication. Used in conjunction with illustration of ocean liners to compare small, maneuverable desktop computers with larger, lumbering mainframe computers.

• Apple Macintosh computer; SuperPaint software; Chromaset used for color separations.

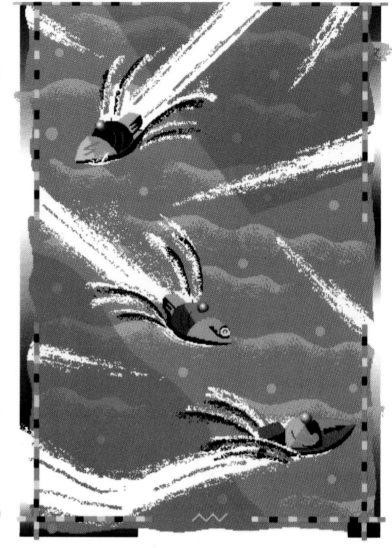

▼
Illustrator
Lawrence W. Lee
Cirrus Arts Corp.
Tucson, Arizona

Client
Harbinger House
Tucson, Arizona

The Mirror, illustration for children's book.

I would not have attempted this using traditional methods. I was able to create a library of images that could be easily modified and intermixed. The computer was helpful in the editing process for making rapid alterations. — *Lawrence W. Lee*

• Apple Macintosh II computer with 5MB RAM, 144 MB hard disk drive; SuperMac PixelPaint and Deskpaint software; four-color separations made from 35mm film positives created on a Matrix film recorder.

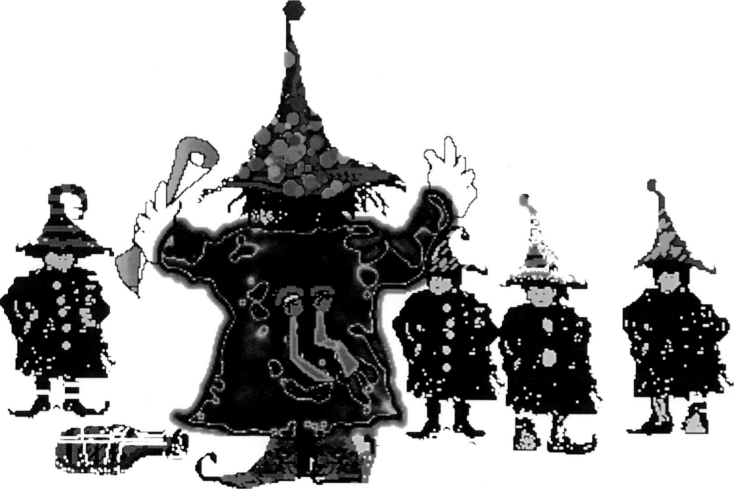

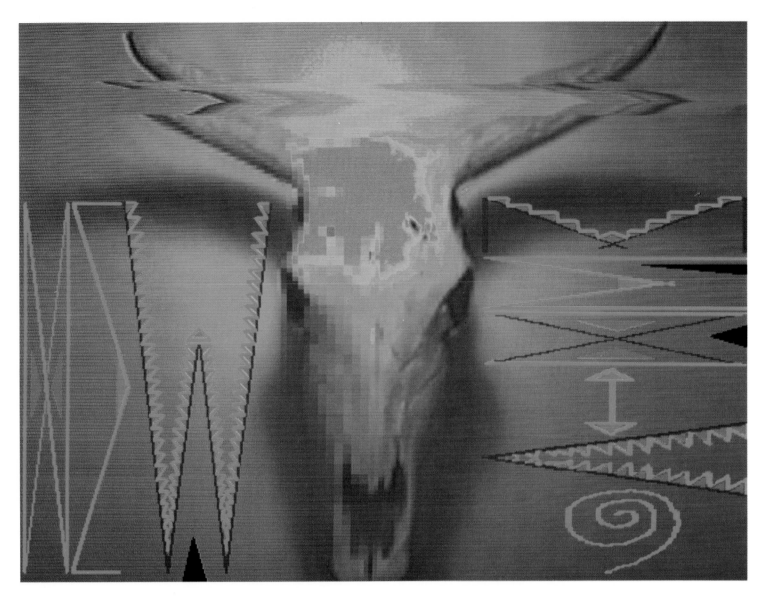

Illustrator
Sharmen Liao
Alhambra, California

New Mexico, self-promotional
portfolio piece.

I placed a skull in front of a video camera and fed it with interesting
lighting. Later I added very illustrative type to the piece. It's always
a challenge to create a new look and mood by using a computer. A
computer at its best is an experimental machine. — *Sharmen Liao*

• IBM-AT computer with 24-bit Truevision TARGA graphics card;
AT&T Truevision software; output to 4x5 transparency.

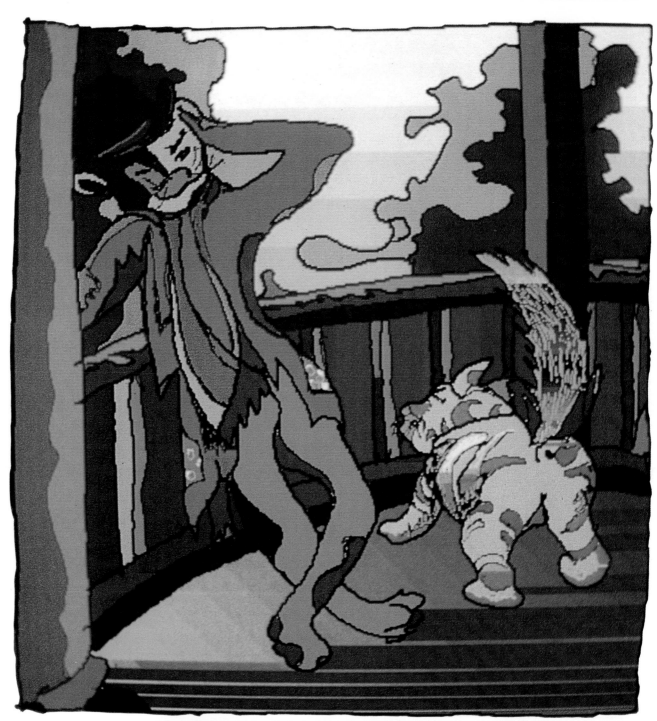

►

Designers
Saul Rubin
Tony Cato
Data Motion Arts, Inc.
New York, New York

Client
Frunzi-Nadeau Images
Philadelphia, Pennsylvania

Visualization of proposed corporate jet interior design.

The computer allowed us to get a high level of photorealism. Most people cannot tell that it is computer-generated; they mistake the piece for a photograph. — *Tony Cato*

• Silicon Graphics 4D/20 workstation; TDI Explore software; output on Matrix QCR 2 film recorder.

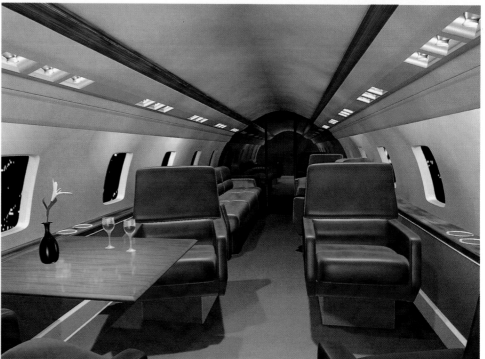

◀

Illustrator
Denis A. Dale
University of Wisconsin
Stoughton, Wisconsin

Study for silkscreen illustration.

The ability of the computer to match the speed of conception adds great pleasure to the creative process. For the way that I work, watercolor is the only traditional medium that comes close to the computer; yet the computer is different since I am painting with light and have immediate unlimited color selections. — *Denis A. Dale*

- ArtStar computer graphics system by Colorgraphics, Inc.

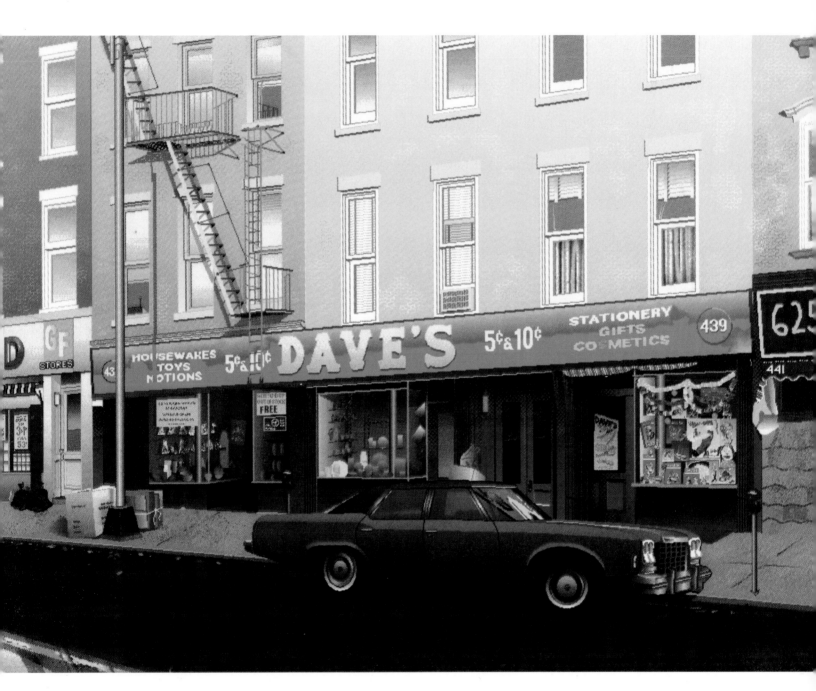

Illustrator
Bert Monroy
Brooklyn, New York

Dave's 5 & 10, experimental illustration published in *Verbum* and *MacWorld* magazines.

- Apple Macintosh II computer; Adobe Illustrator 88 and PixelPaint software; ouput on Montage film recorder. The artist hand-drew the entire piece in Adobe Illustrator 88 and took full advantage of PixelPaint's color-blending capabilities. The images are so large and the files so complex that it takes one and a half hours to proof each on a color thermal printer.

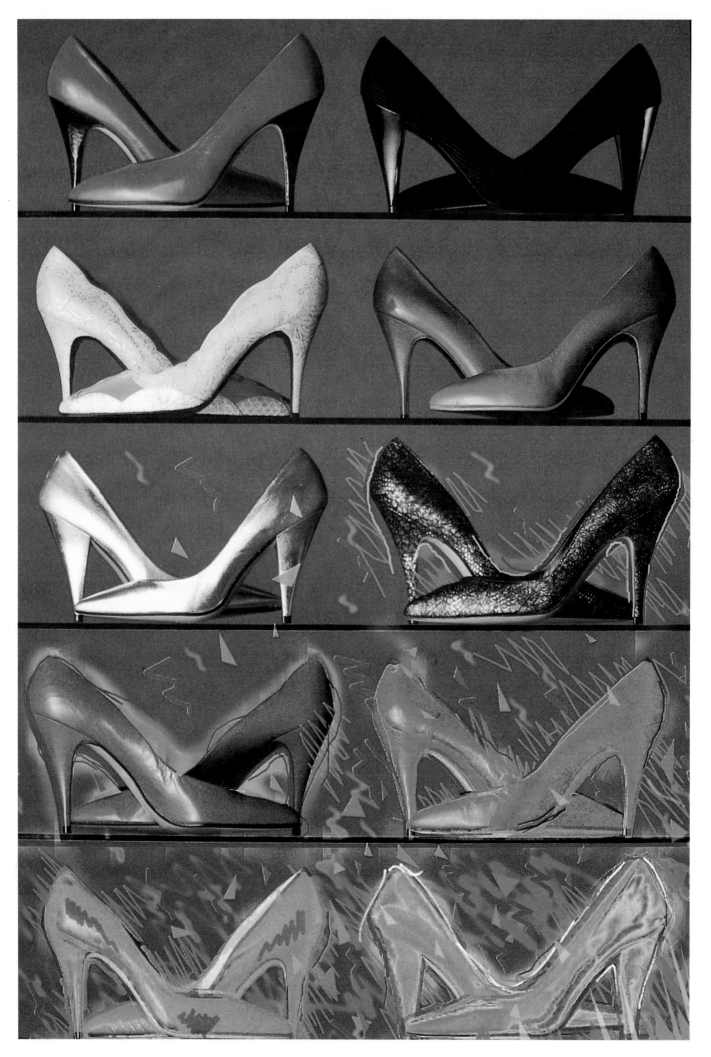

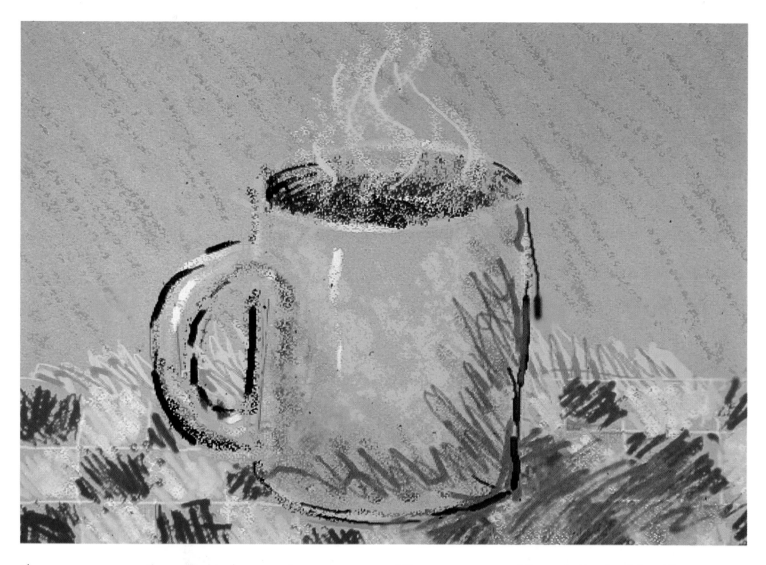

◀

Artist
John Derry
Time Arts
Santa Rosa, California

Client
Chromaset
San Francisco, California

Shoes, promotional piece for pre-press service.

This piece showcases the combination of photographic realism and computer graphics for print. — *John Derry*

• Dupont Vaster computer graphics system; output to Scitex Eray plotter for proofs and Scitex Imager/3 for four-color separations.

Artist
John Derry
Time Arts
Santa Rosa, California

Client
Wacom
Paramus, New Jersey

Coffee, promotional image for trade-show exhibit.

This image appears to be traditionally created. The fact that it was digital in nature opens a major door into a world where this image could be acted upon in numerous, nontraditional ways.
— *John Derry*

• Compaq 386 computer with Wacom pressure-sensitive graphics tablet; Lumena/32 software; ouput on Matrix PCR film recorder. The Wacom pressure-sensitive tablet, coupled with Lumena's pressure-sensitive software, allows for near-faithful replication of traditional media.

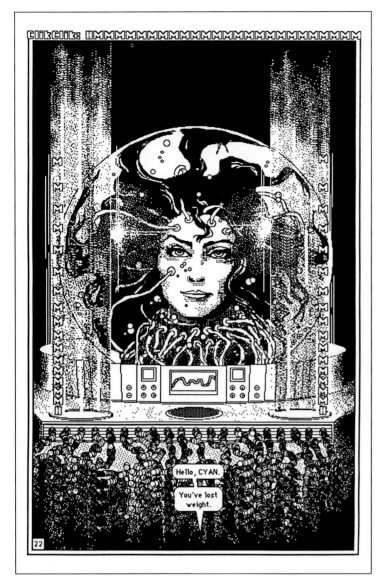

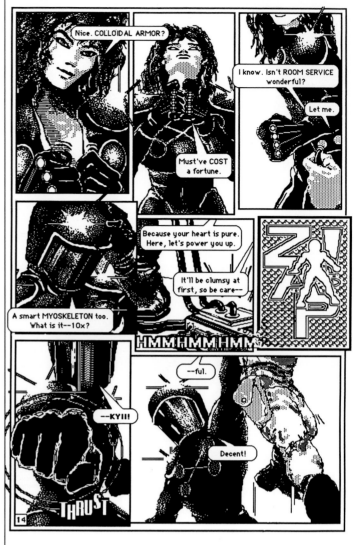

Illustrator
Charlie Athanas
Legs Akimbo
Chicago, Illinois

Client
First Publishing
Chicago, Illinois

Hello, Cyan and *Nice. Colloidal Armor?*, pages from the comic book *Shatter*.

The look of a non-scanned, low-resolution illustration is unique to the computer. The neatest aspect of using the computer in this process is both the ability to re-use stored imagery and to ink the drawing and add the type in one step. — *Charlie Athanas*

Illustrator
John Craig
Soldiers Grove, Wisconsin

Client
Encyclopaedia Britannica
Science Yearbook
Chicago, Illinois

Section opening illustration in which fantasy creatures represent invisible computer viruses.

● Apple Macintosh II computer; SuperMac PixelPaint software; output on Linotronic Imagesetter.

Illustrator
John Craig
Soldiers Grove, Wisconsin

Client
Petrick Design
Chicago, Illinois

Robot Voices, editorial illustration for *Telecommunications Magazine*.

● Apple Macintosh II computer; SuperMac PixelPaint software; output on Linotronic Imagesetter.

Artist
Avril Harrison
Island Graphics Corp.
San Rafael, California

Client
Dai Nippon Screen
Manufacturing Co.
Kyoto, Japan

Tubes, advertising illustration for printing manufacturer.

• 386 PC-AT computer with Truevision TARGA 32 graphics board; Island Graphics GiantPaint software; output on Matrix QCR film recorder.

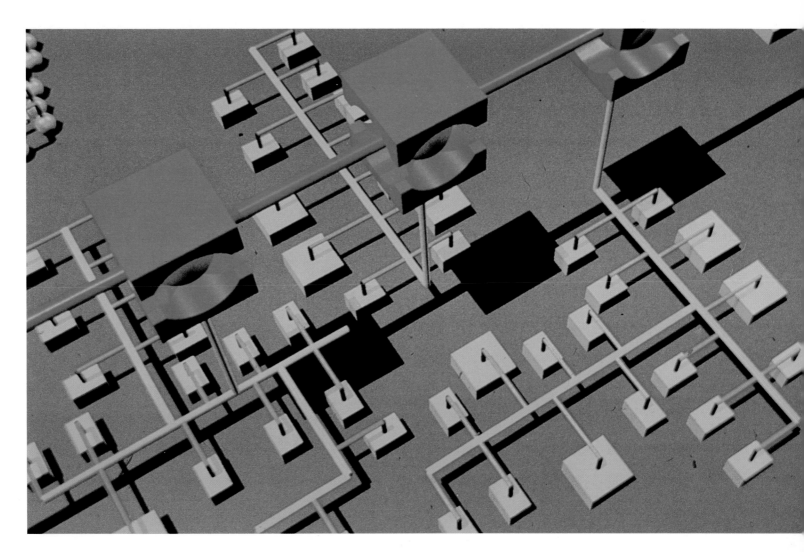

Designers
Judson Rosebush
Gail Goldstein
George Tsakas
Steve Leginsky
Gene Miller
Larry Elan
New York, New York

Client
Photosynthesis for Northern
Telecom
Dallas, Texas

Telephone Network, center frame of a triptych for multi-media show.

The content is abstract — a fragment of a vast telephone environment. The environment was blueprinted by hand in plan and elevation, then digitized into the computer. The images are displayed using multiple projectors and polarizing filters while viewers wear special glasses. A computer was essential to calculate the subtle positions between the viewers' two eyes.
— *Judson Rosebush*

• Gould CPU, IBM PC computers; Synthavision software; output on Celco film recorder.

Designer
Michael Renner
The Understanding Business
San Francisco, California

Client
Pacific Bell Directory
SMART Yellow Pages
San Francisco, California

Icons for the clothing and personal care, health and well-being, and entertainment and leisure sections.

The ease in manipulating the electronically stored images made it possible to quickly find the formulation that best communicated the content. Having reached this stage, the process was taken a step further and an individual system for each icon within a group was achieved. The economy and speed of the new methods made it possible to use icons as visual guidance throughout the *SMART Yellow Pages* and maintain a high level of visual communication.
— *Michael Renner*

• Apple Macintosh II computer; Adobe Illustrator 88 software; ouput on Linotronic Imagesetter.

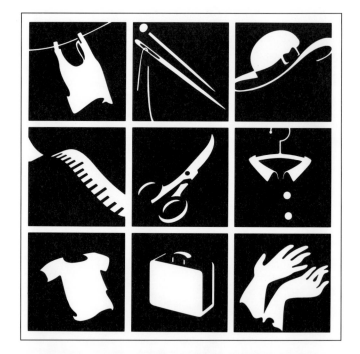

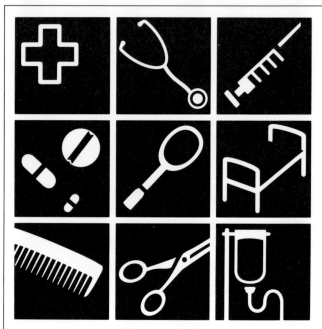

Designer
Michael Renner
The Understanding Business
San Francisco, California

Client
Pacific Bell Directory
SMART Yellow Pages
San Francisco, California

Two-page spreads.

We were able to choose overprinting as a design and communication element because of the ease of using screens and the ability to separate colors. A standard format was established for all the pages, a "master page," which allowed us to standardize the design specs of a giant project in every detail and make the visual vocabulary consistent throughout the project without making it boring.
— *Michael Renner*

• Apple Macintosh II computer; Adobe Illustrator 88 software; output on Linotronic Imagesetter.

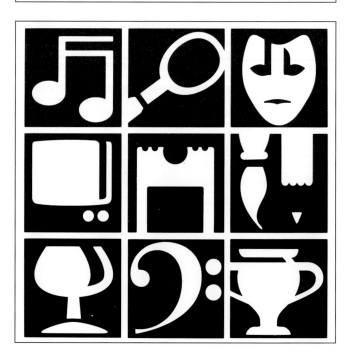

EXPERIMENTAL AND
FINE ART

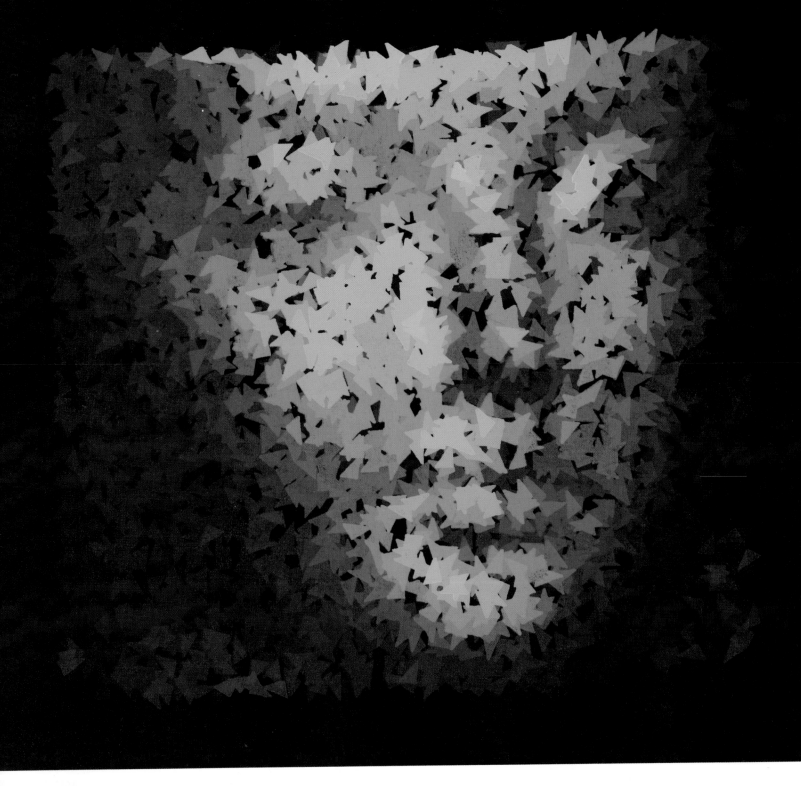

Artist/Programmer
Carolyn L. Lockett
Department of Fine Arts
University of Oregon
Eugene, Oregon

Face, photo-process silkscreen.

The process for creating this image began with making a video image of a lit three-dimensional artist's cast of a head. I then selected eleven groups of random pixels; each group represented a different value. A program I wrote just for this image "drew" a triangle over each pixel. This program then output eleven laserprints, one for each value group. I made the laserprints into Xerox transparencies and from the transparencies made this silkscreen. — *Carolyn L. Lockett*

• IBM-AT with Truevision TARGA 16 graphics board and Apple Macintosh II computers; video camera for scanning; Island Graphics TIPS software and proprietary image processing software; output on Apple LaserWriter to photographic negative, exposed to photosensitive silkscreen.

▶

Artist
Serban Epuré
Frankfurt, Gips and Balkind
New York, New York

Landscape with a Woman, fine artwork also published in *MacWeek*.

• Apple Macintosh IIcx computer, Apple Scanner; Letraset Image-studio, Electronic Arts Studio 8, Aldus FreeHand, Photomac, QuarkXpress, and Applescan software; output on Matrix film recorder. One master file was used to create three versions of the same image, each in a different color palette.

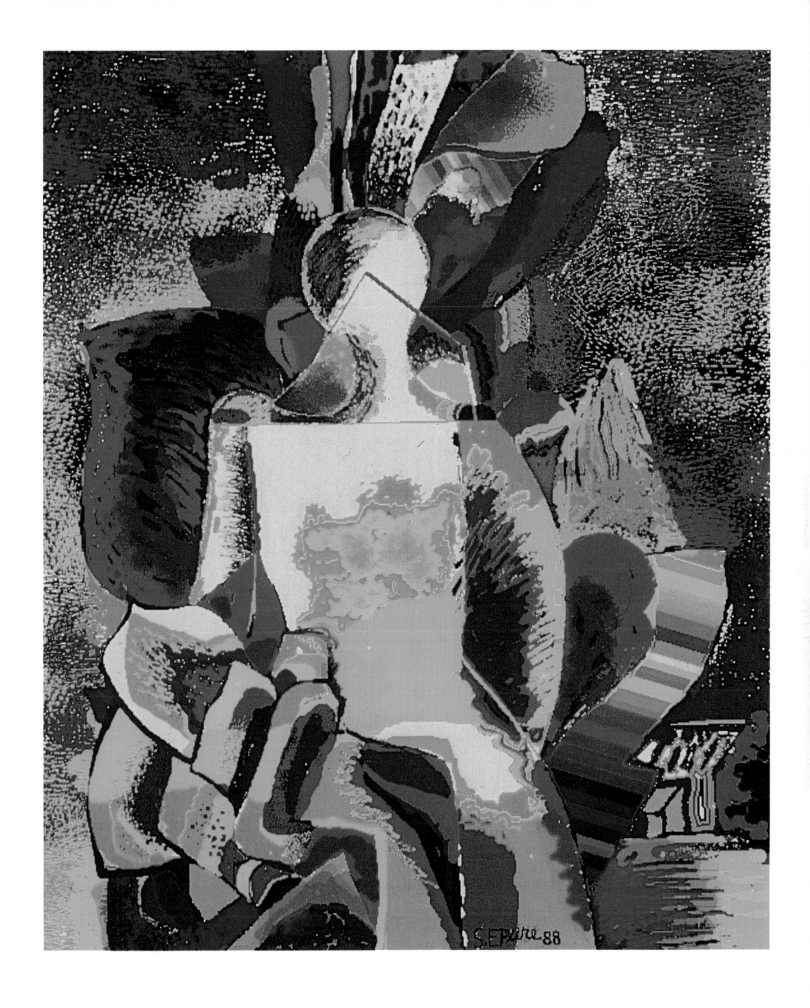

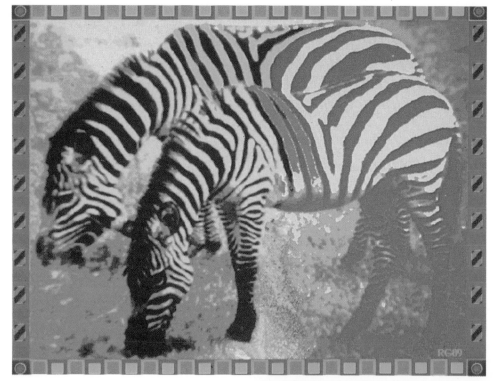

► Artist
John Derry
Time Arts
Santa Rosa, California

Client
Chromaset
San Francisco, California

Sacramento Street #3, demonstration piece.

I am fascinated with the computer's ability to blur various media, such as the distinction between photography and painting. This image came out of a visit along Sacramento Street in San Francisco. I photographed a variety of unique textures, scanned them into the Lumena system, and collaged the elements to create a mood.
— *John Derry*

• 386 AT-class PC computer; Lumena/32 software; output on Mitsubishi G-650 thermal printer.

▲
Artist
Rachel Gellman
New York, New York

Two Zebras, experimental image.

• Apple Macintosh computer; Electronic Arts Studio 8 software; output on Mirus film recorder. The image utilized color and photographic manipulation.

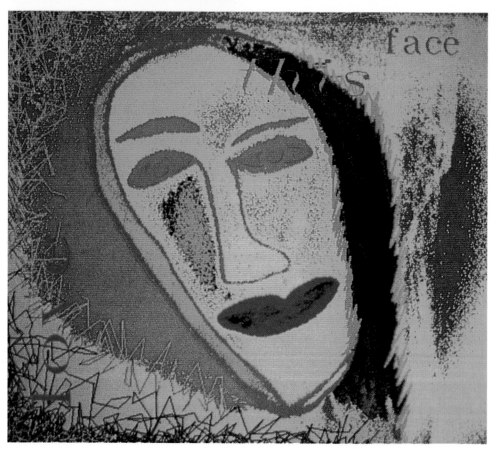

Artist
Rachel Gellman
New York, New York

Love this face, experimental image.

An original sketch was scanned in as the source of this image. Scanning causes unpredictable but good accidents, such as textures. Color manipulation and combination is one of my favorite parts of computer art. — *Rachel Gellman*

• IBM-PC computer with Scion board; Easel and Dr. Halo software; shot directly off screen.

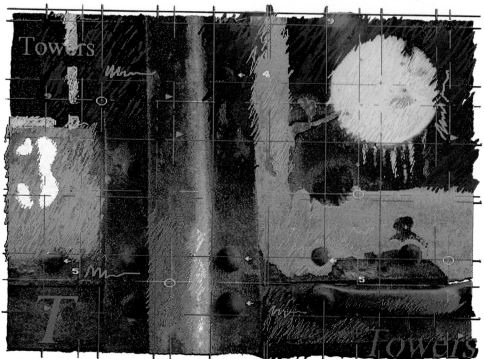

◀

Artist
John Derry
Time Arts
Santa Rosa, California

Towers, experimental image.

This is my first attempt at merging photography with computer-generated painterly effects. The computer allowed me to preview numerous color combinations and compositions before making a final decision. — *John Derry*

• 386 AT-class PC computer; Lumena/8 software; output on Matrix PCR film recorder.

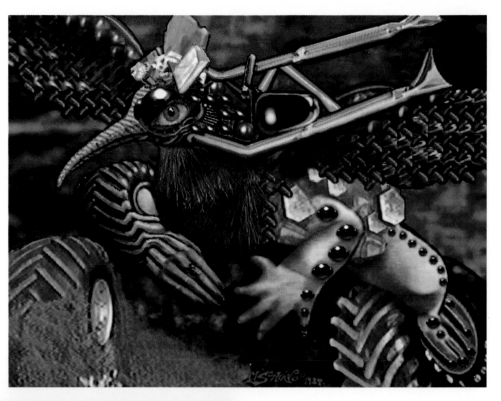

▲
Artist
Marian Schiavo
Arts on Fire
Douglaston, New York

The Gnarly Landpiper, experimental image also exhibited in SIGGRAPH 1988 show.

Only with a computer could I so deftly combine a Land Rover with a sandpiper to create this "landpiper." I feel that its custom pipes and treaded wings, forearm drive and hubbed kneecaps would not have had the same unsettling qualities if done in a different medium.
— *Marian Schiavo*

• MS-DOS-based computer with Truevision TARGA 16 graphics board; Lumena and Island Graphics TIPS software; output on Matrix PCR film recorder and hand-held camera shot off screen.

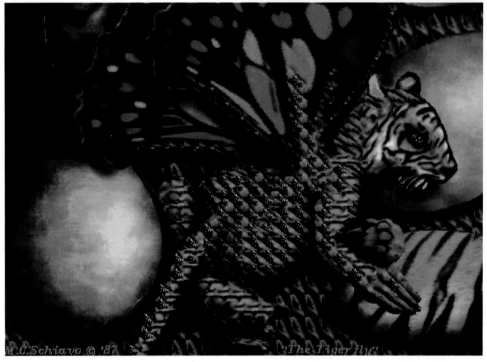

Artist
Marian Schiavo
Arts on Fire
Douglaston, New York

The Tigerfly, experimental image published commercially in print and for promotion.

This was my first complex piece done completely on the computer. Creating the scales of the tigerfly's skin from my fingers, rings, and fingernails was a personal breakthrough in texture-making.
—*Marian Schiavo*

• MS-DOS-based computer with Truevision TARGA 16 graphics board; Lumena and Island Graphics TIPS software; output on Matrix PCR film recorder and hand-held camera shot off screen.

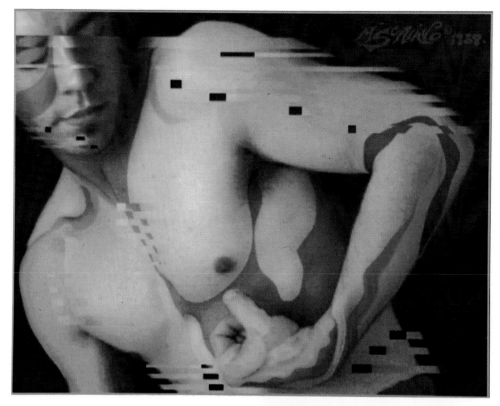

◄

Artist
Marian Schiavo
Arts on Fire
Douglaston, New York

Tattoo, experimental image also published in magazine and calendar form.

I loved this video-digitized shot of my model, but when I called it up to work with it, it came up as a bad file. With only one original, I had to incorporate the bad sectors into the design, which gave me an interesting effect. — *Marian Schiavo*

• MS-DOS-based computer with Truevision TARGA 16 graphics board; Flamingo Graphics LogoEditor software; output on Matrix PCR digital film recorder.

►

Artist
Marian Schiavo
Arts on Fire
Douglaston, New York

Strange Bird, self-portrait.

I don't think that this strange self-portrait would have its peaceful and serene quality or seem so natural if it were done any other way than by computer. — *Marian Schiavo*

• MS-DOS-based computer with Truevision TARGA 16 graphics board; Island Graphics TIPS software; Matrix PCR digital film recorder used for slide output and hand-held camera shot off screen.

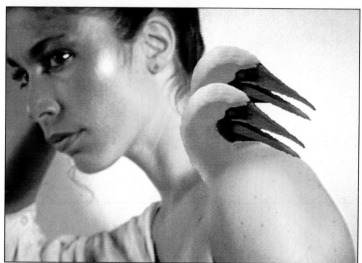

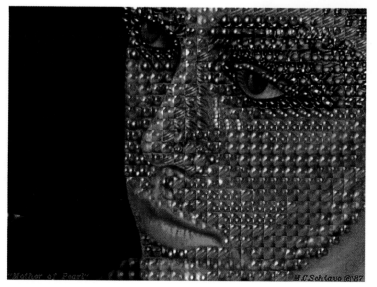

◄

Artist
Marian Schiavo
Arts on Fire
Douglaston, New York

Mother of Pearl, experimental image exhibited in a 16x20-inch brushed aluminum backlit light box.

Using the size, lines, and natural color of scanned objects such as beads, shells, and alligator skin to create contour, each object was delicately computer-airbrushed into place. Gracefully fusing hundreds of inanimate objects into the skin of a woman's face without ever disturbing her expression is difficult at best. — *Marian Schiavo*

• MS-DOS-based computer with Truevision TARGA 16 graphics board; Island Graphics TIPS software; Matrix PCR digital film recorder used for slide output and hand-held camera shot off screen.

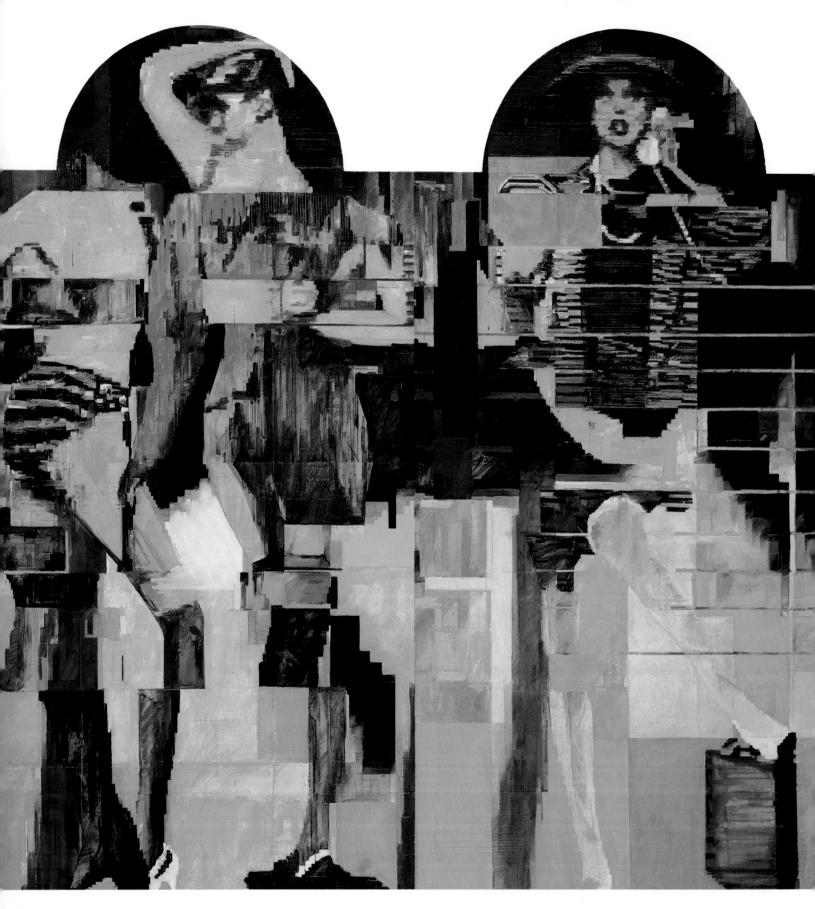

Artist
Jeremy Gardiner
Pratt Institute
Brooklyn, New York

Three Graces, fine artwork.

This image was originally created using the computer as a sketch tool. The original computer sketch is a unique thermal mosaic made of forty-eight 11x17-inch pieces. The final version exists as paint on canvas.

• CGL Images II system and software; output on IRIS 1044 inkjet printer and Matrix QCR film recorder.

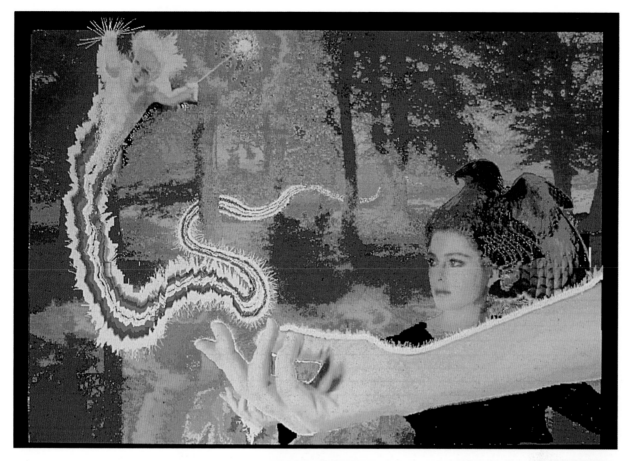

▲
Artist
John Ashley Bellamy
Art Images
Dallas, Texas

Druid Invocation, experimental image.

The computer gives you the ability to electronically coordinate many different images and place them in either surreal or realistic environments at will. It encourages you to push your imagination to the limit. The computer generates colors of practically infinite variety, some of which cannot be found outside of a computer monitor.
— *John Ashley Bellamy*

• Wasatch computer graphics system and software; output on Matrix film recorder.

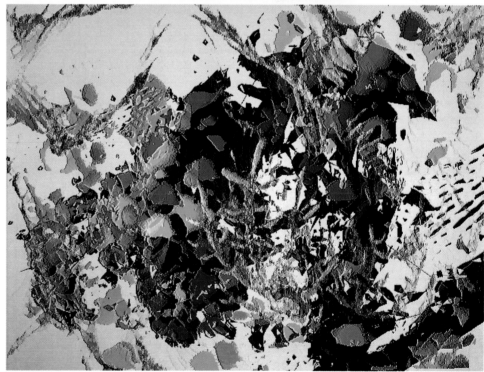

Artist
Marsha J. McDevitt
Advanced Computing Center
for the Arts and Design
Ohio State University
Columbus, Ohio

Opening, experimental image.

The most dramatic aspect of using a computer to create this image was the ability to interact spontaneously with image processing software. — *Marsha J. McDevitt*

• Sun 4/260 workstation with Parallex framebuffer, Barneyscan; Ohio State University proprietary software; output on Solitaire film recorder.

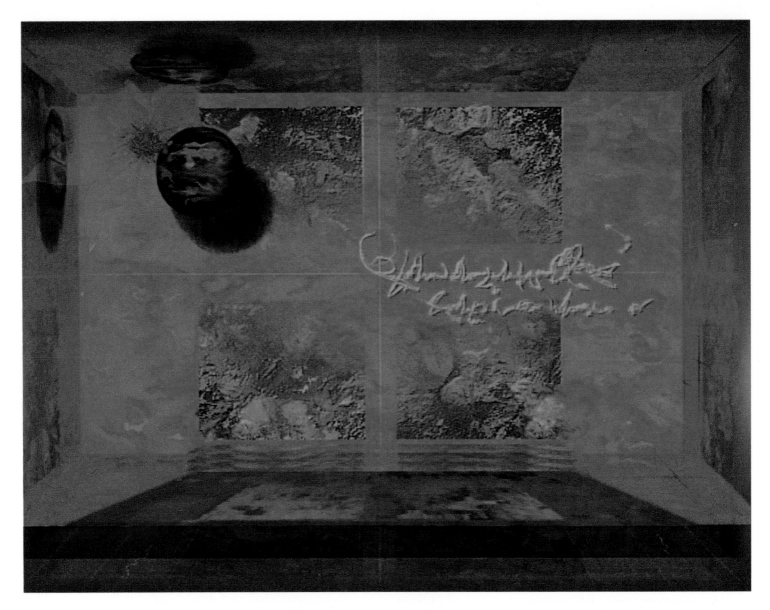

Designer
John S. Banks
Rising Star Graphics
Chicago, Illinois

Three experimental pieces used to demonstrate the studio's computer graphics capabilities.

The most unique quality about these tools is that the image is transformational. I can treat a photograph as if it were made out of wet paint. Nothing is ever solid or committed. — *John S. Banks*

• 386 PC computer with Truevision TARGA 16 graphics board and scanner; Radiant, Lumena, and Crystal software; output to 35mm slide on digital film recorder.

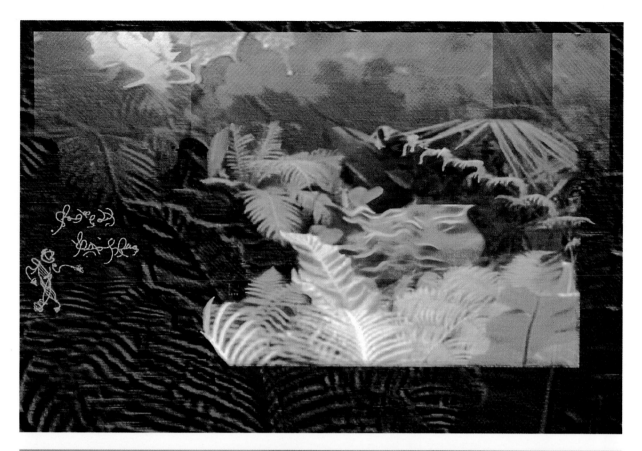

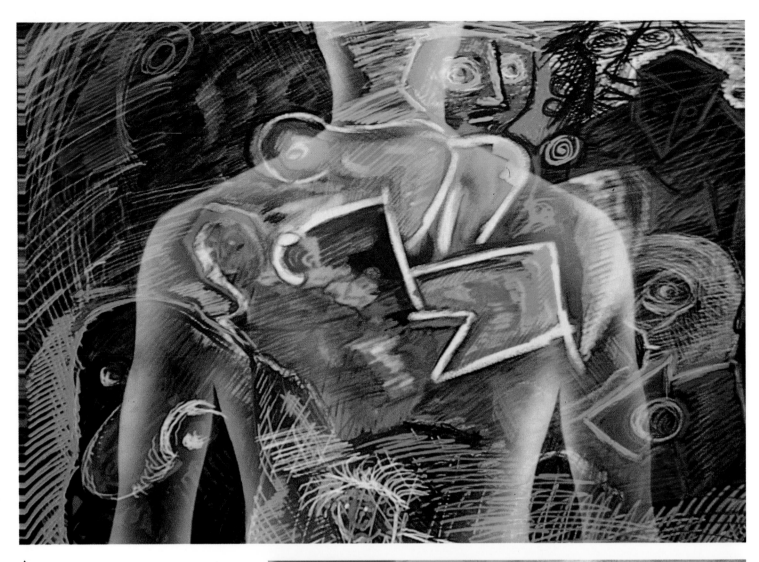

▲
Illustrator
Micha Riss
New York, New York

A Day in an Artist's Life, portfolio piece.

• Quantel Paintbox videographics system; output on Matrix 3000 film recorder. Piece was produced freehand on a high-end videographics system.

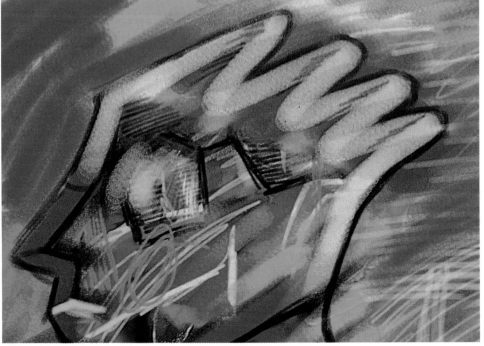

Illustrator
Micha Riss
New York, New York

Face, portfolio piece.

• Quantel Paintbox videographics system; output on Matrix 3000 film recorder. Piece was produced freehand on a high-end videographics system.

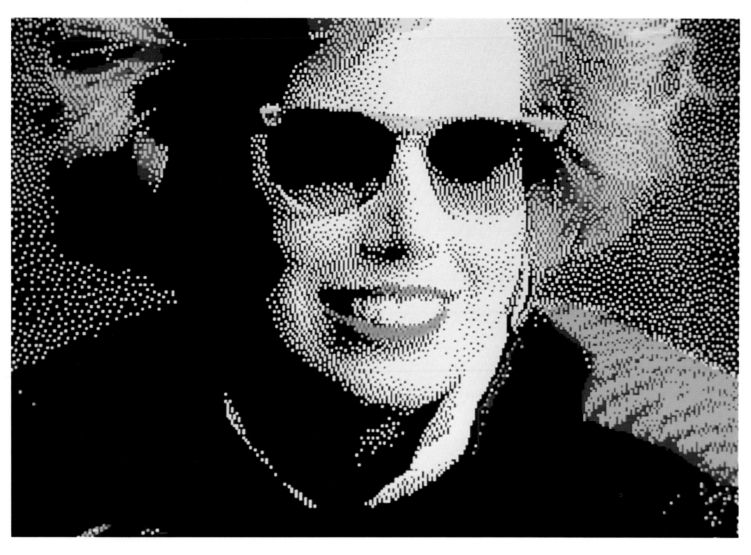

Photographer/Illustrator
Alan Brown
Photonics Graphics/PhotoDesign
Cincinnati, Ohio

Traci, experimental self-promotion image.

● Apple Macintosh IIx computer, Canon Electronic Still Video Camera, and MacVision Digitizer; PhotoMac, MacVision, and Conductor software; output on Agfa Matrix Slidewriter film recorder. The artist overlayed bit-mapped textures on an original scanned photograph and then applied transparent colors in another layer, allowing the texture to be seen through them.

Artist
Peter Voci
Fine Arts Department
New York Institute of
Technology
Old Westbury, New York

Bob, electronic painting exhibited internationally.

The computer becomes transparent to the artist when the aesthetic concerns are in focus. You are always ready to experiment without hesitation with a computer graphics system. — *Peter Voci*

• CGL Images II+ computer graphics system and software; output on IRIS 3024 printer and Matrix QCR film recorder.

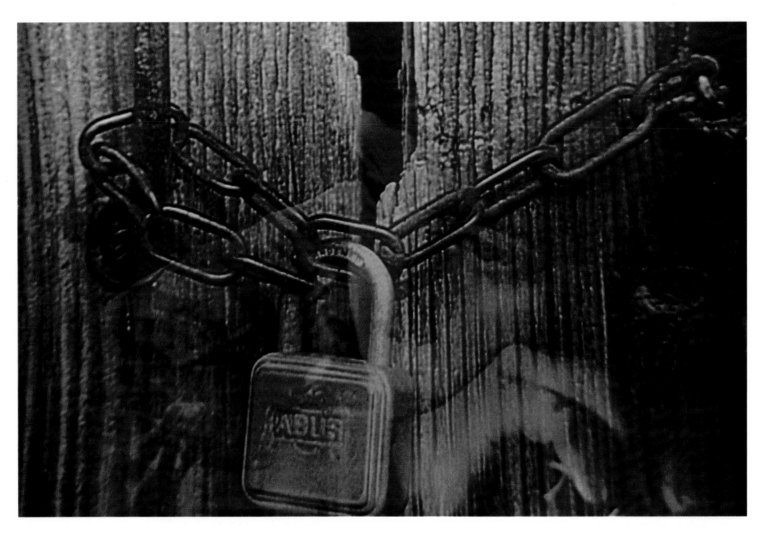

Artist
Maureen Nappi
Maureen Nappi, Inc.
New York, New York

Child Abuse, fine art image displayed as 20x24-inch color transparency on a 4-inch deep light box.

Through means of the computer, I was able to create a unique and personal hybrid of expression — a cross between painting and photography. If the piece weren't computer-generated, it wouldn't have been possible within any realistic technical, time, or budgetary considerations. — *Maureen Nappi*

• Quantel Paintbox videographics system and software; Grass Valley Group GVG-300 Video switcher, Ampex Digital Optics real time image processors; Teletronics VI square communications control system, Sony BVH-2000 videotape recorders; output on Dunn film recorder.

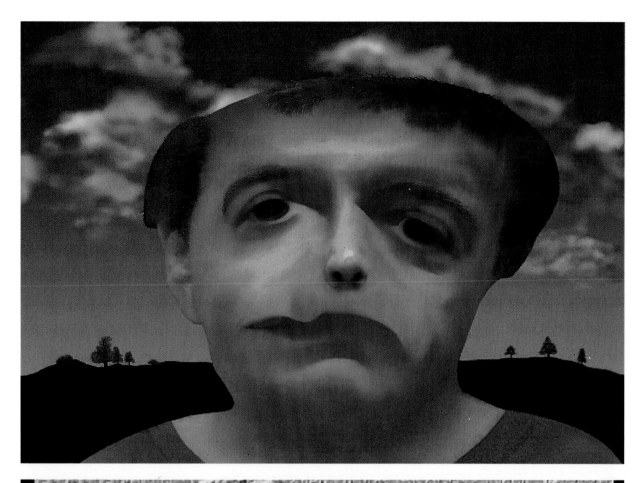

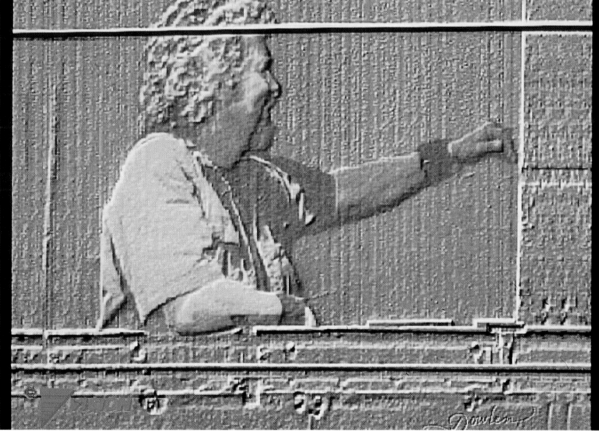

Artist
James Dowlen
Santa Rosa, California

Rich, imagery resulting from software experimentation.

• Everex 286 computer with Vision Technologies graphics board; Lumena, Color Scheme II, and Topas 3-D software; output on Matrix PCR film recorder. A photographic image was scanned, then embossed by computer methods to create a portrait.

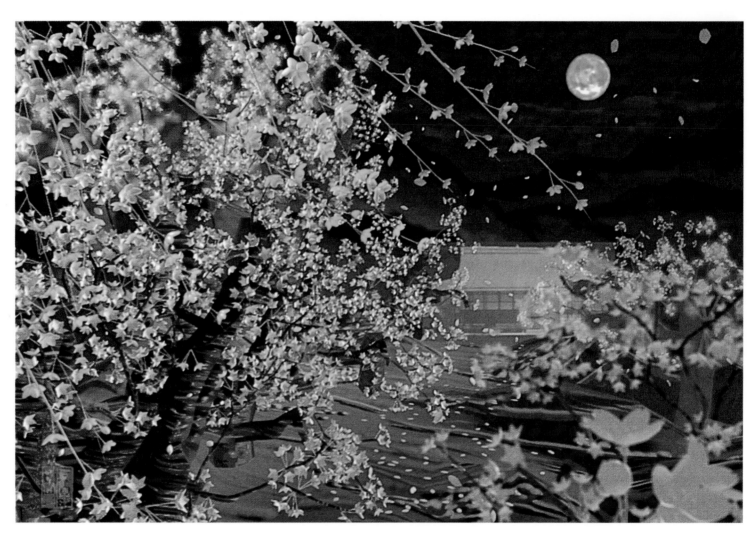

Artist
Naoko Motoyoshi
High-Tech Lab
Tokyo, Japan

A Moonlit Spring Night at Ma-ma Temple, fine artwork.

● IRIS 3030, PIXAR, and Symbolics hardware; WaveFront, PIXAR, and DDS proprietary software; output on Matrix QCR film recorder. The images were solely computer-generated. Approximately 800,000 polygons in ten separate files were merged to express the movements of weeping cherry trees and their petals.

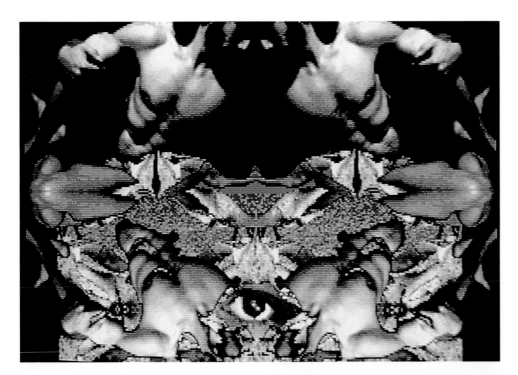

Artist
Jo Ann Gillerman
Viper Optics
Oakland, California

Tantra, fine artwork.

• Amiga computer and A-Squared Live digitizer; DeluxePaint II and A-Squared Live software; shot off screen with camera. A color video camera was used to input a photographic image, which was then manipulated in both form and color.

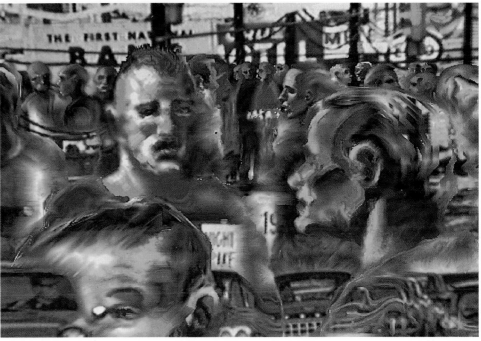

Artist
Sandro Corsi
University of Wisconsin
Department of Art
Oshkosh, Wisconsin

Broken Conversation, exhibition piece in SIGGRAPH 1988 show.

An original photograph was the source of this digitally painted image. The photograph's color palette was used to paint the figures — no other colors were added. The foreground imagery was obtained by dragging and smearing the background image. The computer was crucial in bringing out hidden shapes from the chaotic background in the original photograph. — *Sandro Corsi*

• IBM-AT computer with Truevision TARGA 16 frame buffer; Lumena 16 software; output on Matrix PCR film recorder.

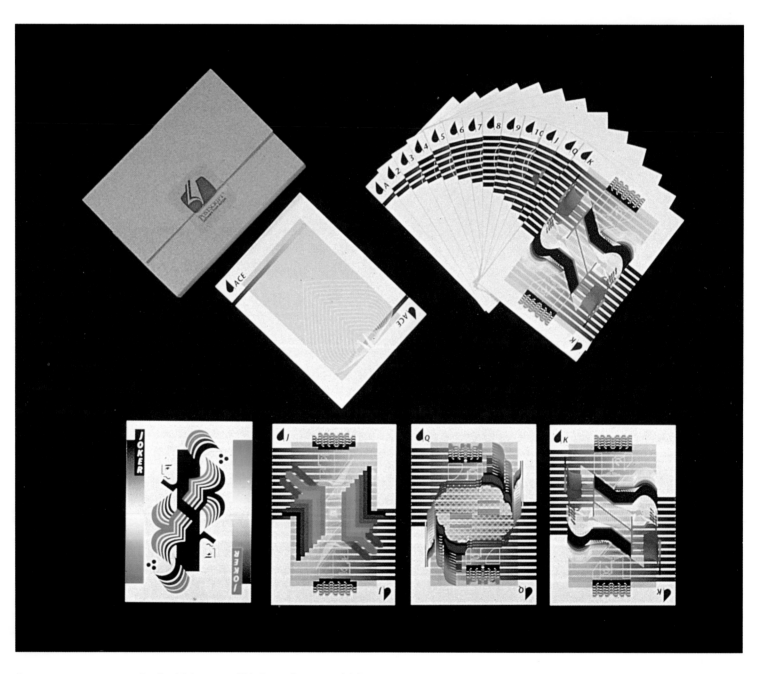

Designer
Ruth Kedar
Ruth Kedar Designs
Palo Alto, California

Client
Adobe Systems, Inc.
Mountain View, California

Suit of cards belonging to an Adobe Systems, Inc. promotional deck.
These and all other cards in the deck display the capabilities of Adobe
Illustrator software; each suit is designed by a different artist.

• Apple Macintosh II computer; Adobe Illustrator 88 and Aldus
FreeHand software; output on Tektronics thermal transfer color
printer.

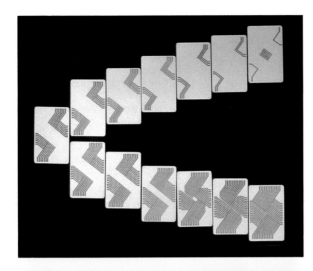

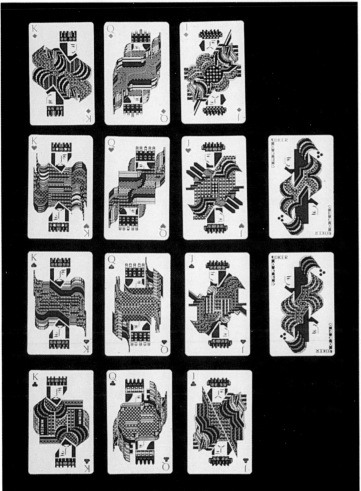

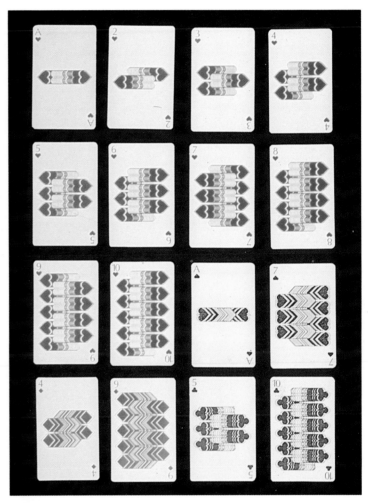

Designer
Ruth Kedar
Ruth Kedar Designs
Palo Alto, California

Experimental decks of cards.

A pattern is generated for each card based on its numerical value; this process utilizes the properties inherent to the medium. It generated new and exciting visual expression in a vehicle (playing cards) that has been around for 800 years. — *Ruth Kedar*

• Apple Macintosh 512 computer; Fullpaint software; output on LaserWriter printer.

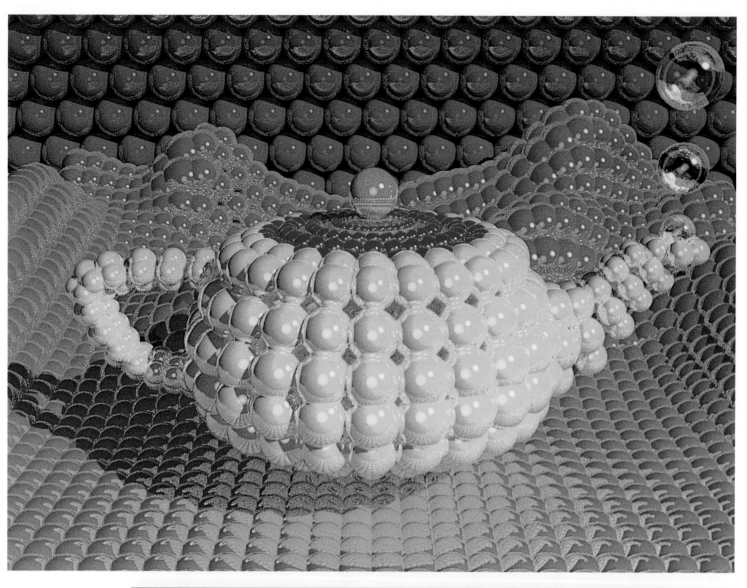

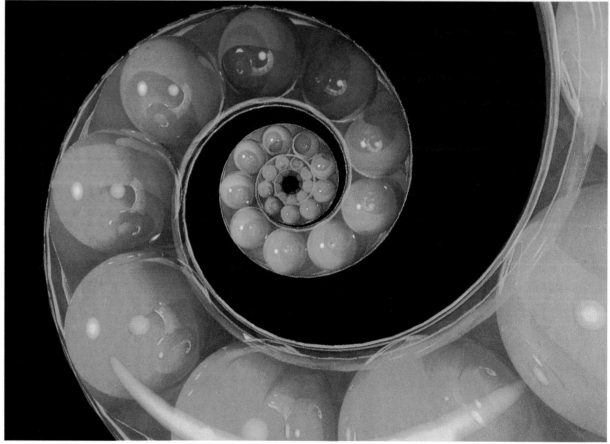

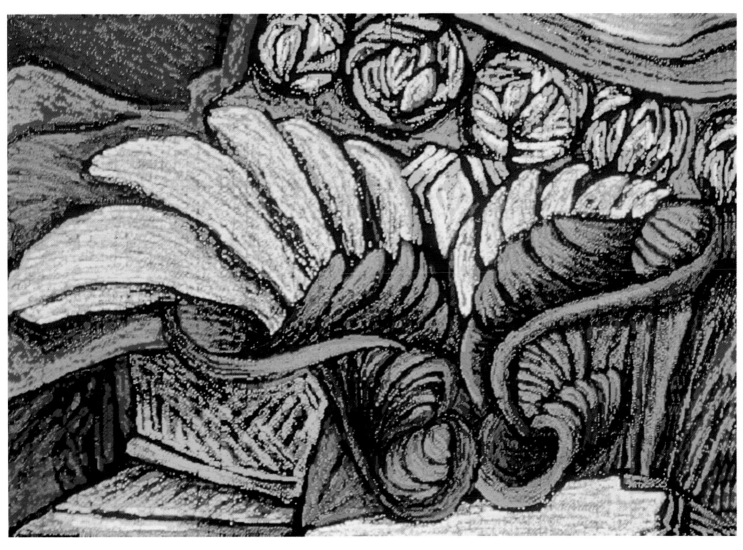

◄◄▲
Artist/Programmer
Melvin L. Prueitt
Computer Graphics Group
Los Alamos National Laboratory
Los Alamos, New Mexico

Spherical Universe, image created using ultra-sophisticated technology.

• Cray supercomputer; personal programming; output on Dicomed film recorder.

◄◄
Artist/Programmer
Melvin L. Prueitt
Computer Graphics Group
Los Alamos National Laboratory
Los Alamos, New Mexico

Spheres in a Spiral, image created using ultra-sophisticated technology.

• Cray supercomputer; personal programming; output to Dicomed film recorder.

Artist
Annette Weintraub
New York, New York

Outreach, fine artwork.

• Apple Macintosh II computer and Abaton 300 scanner; Letraset Imagestudio and Electronic Arts Studio 8 software; output on Montage Slide Printer and QMS Colorscript 100 thermal printer. The artist scanned black-and-white charcoal drawings into the computer. Her work employs electronic equivalents of pastel chalk on charcoal paper surface and glazing on canvas. The computer is able to recreate analogs of the entire range of painterly textures and tools.

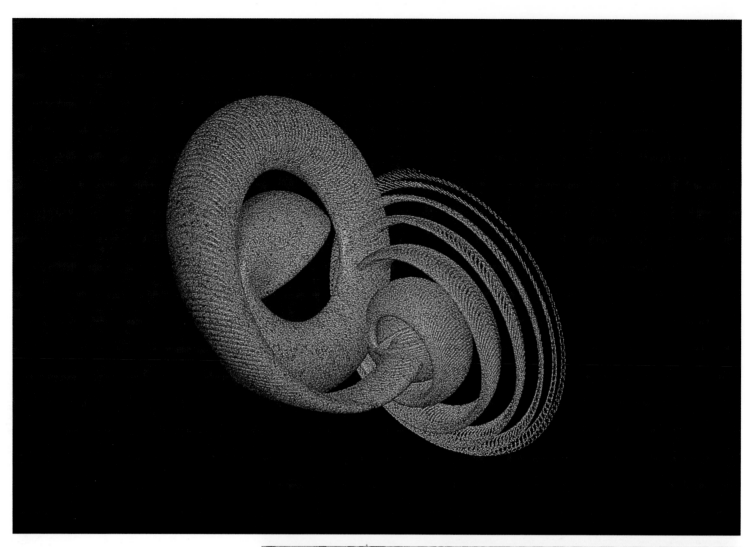

Artist
William Latham
IBM UK Scientific Centre
Winchester, England

Two images in a series from the exhibition "The Conquest of Form."

• IBM 3090 computer; Winsom and Esme software; Honeywell PCR film recorder.

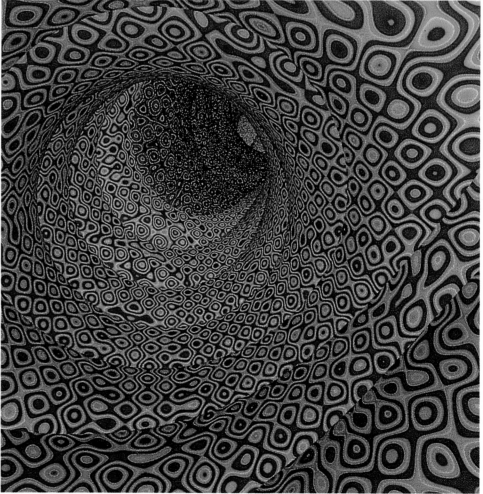

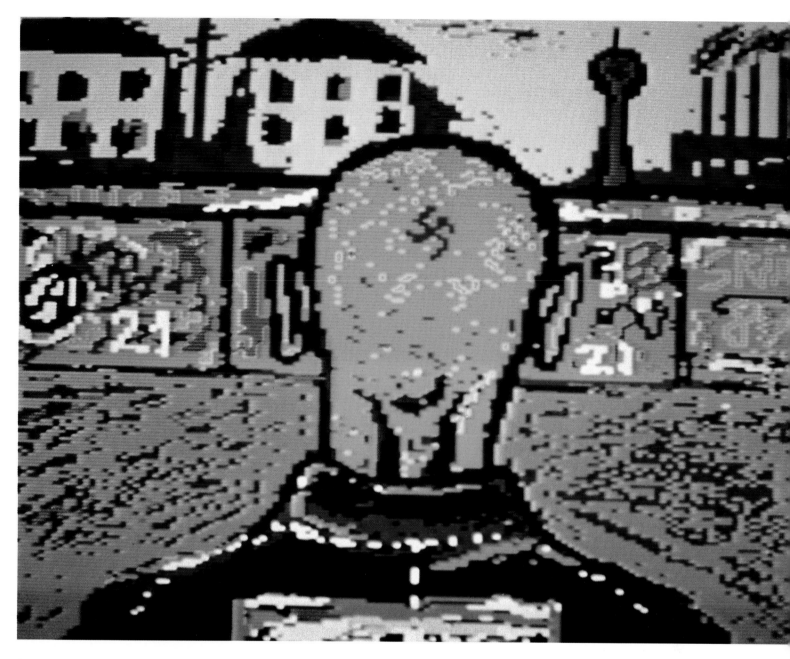

Artist
Alan Luft
Madison, Wisconsin

Kreuzberg #1, fine artwork.

I was inspired to create a drawing that was in sharp contrast to the high-tech feeling of the computer. — *Alan Luft*

- Apple II computer; Dazzle Draw software; photographed off monitor.

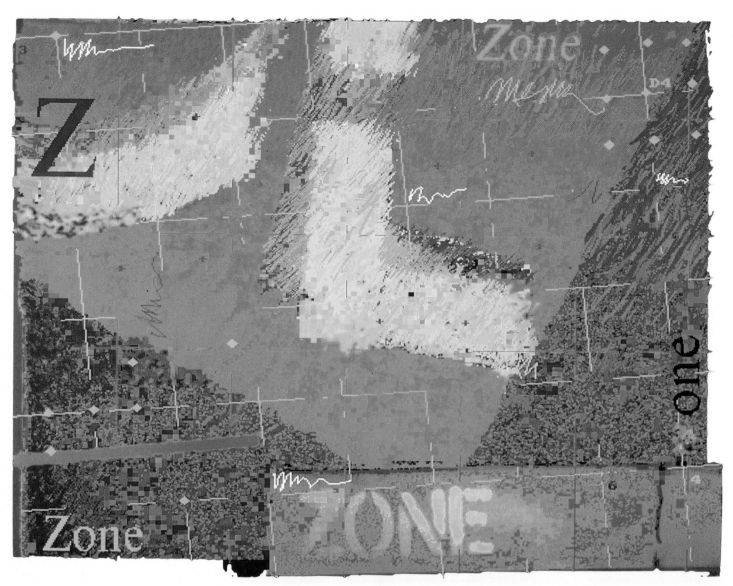

Artist
John Derry
Time Arts
Santa Rosa, California

Zone, experimental self-promotion image.

This image comes out of a long-held interest in NASA's Landsat satellite, which photographs the Earth from space. I started by taking a variety of hand-held photographs of interesting features of the pavement. The computer let me create a collage of the elements and play with color relationships. Some are close to the original, others are radically different. — *John Derry*

- 386 AT-class PC computer; Lumena/8 software; output on Matrix PCR film recorder.

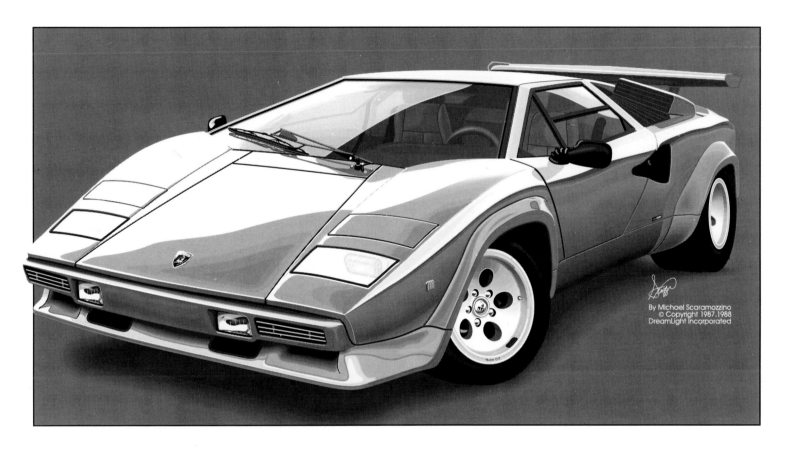

By Michael Scaramozzino
© Copyright 1987.1988
DreamLight Incorporated

Artist
John Derry
Time Arts
Santa Rosa, California

International Orange, experimental self-promotion image.

The idea was to take a variety of photographic details of the Golden Gate Bridge and make a collage to create an impression of the famous landmark without actually showing the full image. The pressure-sensitive Wacom tablet allowed for a blurring of photograph with pencil and pastel techniques. — *John Derry*

- 386 AT-class PC computer; Lumena/32 software; output on Matrix PCR film recorder.

Designer
Michael Scaramozzino
Dreamlight, Inc.
Providence, Rhode Island

High Performance, experimental self-promotional poster.

We were able to work on details at 1600% magnification, giving us unbelievable control over the realism of the illustration. The detail and sharpness of the image could not be matched traditionally. An airbrush's sharpest line is very soft compared to the laser output of a typesetter. — *Michael Scaramozzino*

- Apple Macintosh Plus computer with 1MB of memory and a 20MB hard disk drive, Nutmeg® full-page display and Summagraphics tablet; Adobe Illustrator 1.1 software; output on Varityper 4300 Imagesetter.

DESIGN

New Look

In Computer

Information

Systems

Direct mail brochure to promote publisher's textbook.

Designer
Phylane Norman
Condon Norman Design
Chicago, Illinois

Client
Dryden Press
Hinsdale, Illinois

• Apple Macintosh computer; Aldus PageMaker and Adobe Illustrator
88 software; output on Linotronic Imagesetter.

Designer
Lucinda Cameron
Cameron Design
Rieher, Switzerland

Client
McKesson
San Francisco, California

Brochure and folder for board of directors meeting.

The software and color thermal printer enabled me, within time and budget constraints, to show the client very accurate representations of what the final product would look like. — *Lucinda Cameron*

• Apple Macintosh II computer; Adobe Illustrator 88 software; output on QMS color thermal printer, LaserWriter NTX, and Linotronic Imagesetter; type was traditionally set.

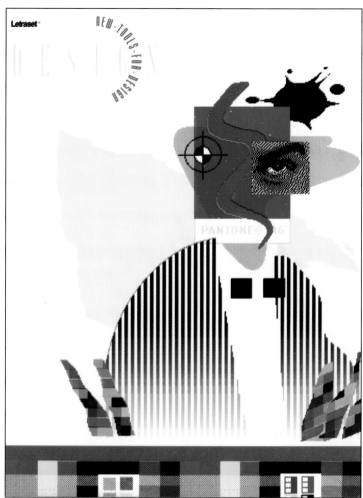

Designer
Tim Thompson
Graffito, Inc.
Baltimore, Maryland

Client
Questech, Inc.
Falls Church, Virginia

Annual report for science, engineering, and management firm.

I used a photo-illustration technique to enhance existing photography through stretching, enlarging, and manipulating color intensity. Sections of final enhanced photos were enlarged and used as frames for the inset photography. — *Tim Thompson*

• Lightspeed DS 20 computer for imagery and design, Apple Macintosh II computer system for headline typography; Adobe Illustrator 88 software; ink-jet printer for comp output and Hell Chromacom system for pre-press.

Designer
Clement Mok
Clement Mok Designs
San Francisco, California

Client
Letraset
Paramus, New Jersey

One piece from an integrated system of printed materials for graphic design software workshops.

• Apple Macintosh II computer and Apple Scanner; Letraset Imagestudio and Aldus PageMaker software; output on Linotronic Imagesetter.

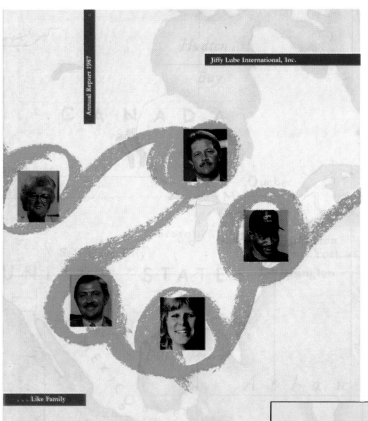

Designer
N. David Crowder
Crowder Design
Arnold, Maryland

Client
Jiffy Lube
Baltimore, Maryland

Corporate annual report.

We were able to scan in a map used as a light background and, within minutes, change the color intensity four times until all elements were perfectly balanced. — *N. David Crowder*

• Sun Microsystems 3/160M workstation with video camera; Lightspeed 20 computer graphics system and software; output on both color thermal printer and digital film recorder.

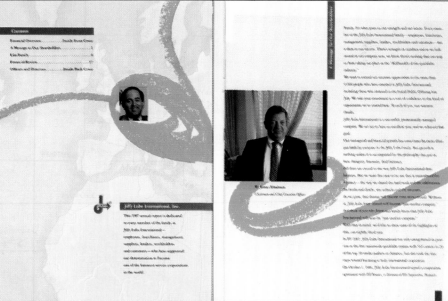

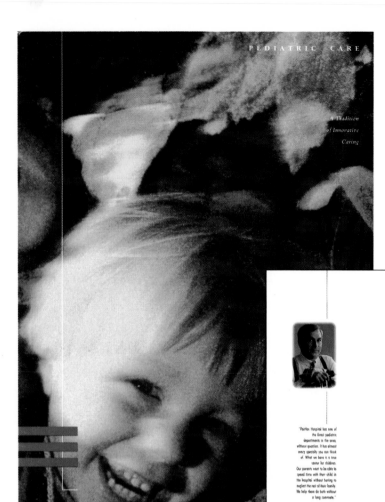

P E D I A T R I C C A R E

*A Tradition
of Innovative
Caring*

FAIRFAX HOSPITAL
FAIRFAX HOSPITAL SYSTEM

Designer
Don Sparkman
Sparkman & Bartholomew
Washington, D. C.

Client
Fairfax Hospital
Fairfax, Virginia

Brochures for hospital's obstetrics and pediatrics departments.

We used Polaroid 35mm film for a grainy photographic effect. The most dramatic aspect of working on the computer was being able to substitute various photos in the layout while our client viewed the images on a monitor in our conference room. — *Don Sparkman*

• Lightspeed System 10 and software; JVE 110 Input Scanner; output on Seiko thermal printer and Matrix 3000 film recorder.

Northern Virginia's only full-service pediatric department at Fairfax Hospital offers everything for sick children, from the premature newborn to the young adult. There are specialists on staff to meet almost any medical need, including physicians specializing in pediatric emergency and trauma care, critical care, infectious disease, pulmonary disease, cardiac surgery, hematology and oncology, neonatology, infant apnea, physical medicine and rehabilitation, and speech and hearing therapy. There even is a facial rehabilitation program for those needing pediatric plastic surgery.

Fairfax Hospital is a teaching center affiliated with premier medical schools in Washington, D.C. and in Virginia. Having medical students and residents in the hospital encourages our physicians to stay abreast of the latest techniques and developments in their fields.

Along with a dedicated, specially trained staff of pediatric nurses, the pediatric department includes a pediatric clinical specialist, a social worker, an art therapist and child life specialists. All of the staff work together with the physicians as a team, providing individualized medical, nursing and emotional care to meet the needs of each child.

Together, this team of professionals provides children and their families with the expert care and support they need.

"Fairfax Hospital has one of the finest pediatric departments in the area, without question. It has almost every specialty you can think of. What we have is a true center for children.

Our parents want to be able to spend time with their child in the hospital without having to neglect the rest of their family. We help them do both without a long commute."

Dakota A. Young, M.D.
Pediatrician
Springfield, Va.

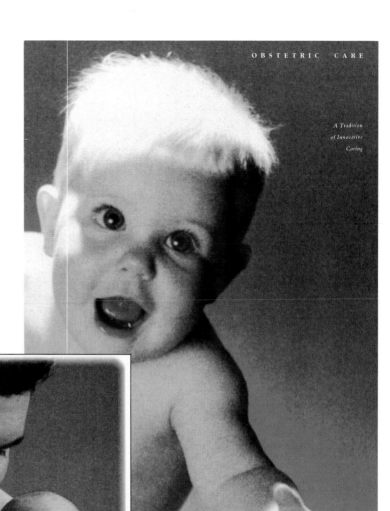

*A Tradition
of Innovative
Caring*

HOSPITAL

In 1961, Fairfax Hospital's very first patients were a new mother and her baby. That event always has been a symbol for the importance we place on expectant parents, their babies and their families.

As obstetric care has evolved, we have evolved with it. Today, our patients enjoy not only the technology and experience of a regional medical center but also the empathy and support of a highly skilled, dedicated and caring staff of nurses, physicians and other healthcare professionals—who believe in putting our patients first.

This blend of traditional values, dedicated people and advanced medical technology allows Fairfax Hospital to offer our obstetric patients real choices in planning the birth of their newest—and very precious—family member. We think that is the reason more physicians and their patients choose Fairfax Hospital's obstetric services than those of any other hospital in the entire metropolitan Washington area.

"It was really important to us to be involved in the decisions about our baby's birth. And at Fairfax Hospital, we were. The nurses here worked with our doctor and with us. We respect them because they respected us."

Annette and Mark Ryplan
New parents of Ambre Louise

For further information:

Doctor's Appointment Desk (Physician Referral)	321-5500
Expectant Parent Classes	698-3293
Genetics & IVF Institute	698-7355
High-risk Pregnancy Program	698-5550
New Brother-New Sister Program	698-3293
New Mothers' Support Group	698-3293
Patient Representative	698-2808
Special Delivery (Early Discharge Program)	698-3293
Vitality (Community Education Programs)	698-3481

Fairfax Hospital has always been the premier obstetric hospital for Northern Virginia, and I can't think of a happier designation. But we're much more than that. We work closely with the patient and family to meet their needs. That's what family-centered care is all about, and that's what we are—a center for family care."

Mary Beth Wotton, RN
Patient Representative

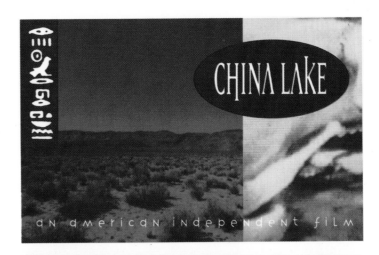

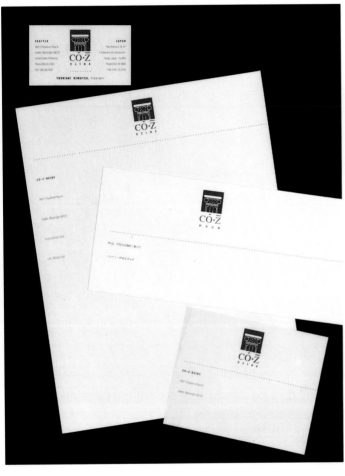

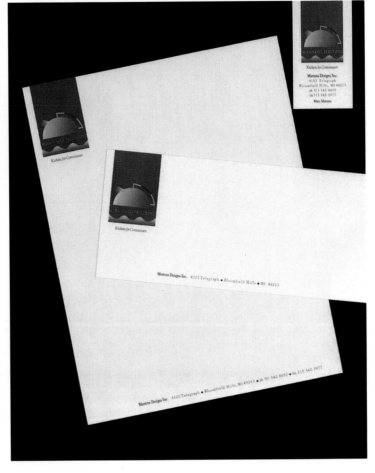

Designers
Glenn Mitsui
Jesse Doquilo
Studio MB
Seattle, Washington

Client
CO·Z
Ashiya, Japan

Identity program for furniture and accessories showroom.

Designing the logo on the system enabled us to change the size and thickness of the logo and apply it to seven different pieces of the identity system. — *Glenn Mitsui*

• Apple Macintosh II computer; Aldus FreeHand software; output on Apple LaserWriter IINTX and Linotronic Imagesetter.

Designer
Joan Sutton
Corbin Design
Traverse City, Michigan

Client
Martens Designs, Inc.
Bloomfield Hills, Michigan

Business materials and logo for kitchen design company.

• Apple Macintosh SE computer; Aldus FreeHand and PageMaker software; output directly to film on Linotronic Imagesetter. The design used no traditional methods; the screens were software-generated.

◄

Designers
Rudy Vanderlans
Zuzano Licko (type)
Emigré Graphics
Berkeley, California

Client
Cairo Cinemafilms
San Francisco, California

Business card from a set of identity and promotional materials for American independent film, "China Lake."
• Apple Macintosh Plus computer; Apple MacWrite and Letraset Ready, Set, Go software, type design in Altsys Fontographer software; output on Linotronic Imagesetter; traditional halftone.

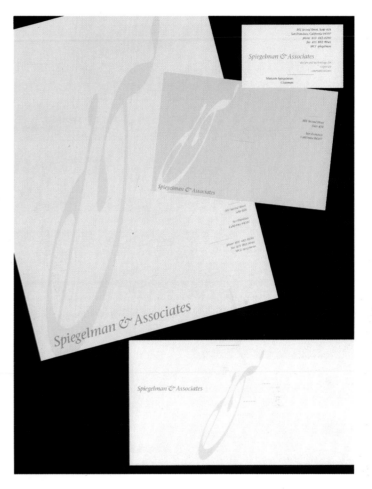

Designer
Tony Gable
Gable Design Group
Seattle, Washington

Client
Kenny G
Los Angeles, California

Stationery for contemporary jazz musician, Kenny G.
• Apple Macintosh SE computer; Aldus FreeHand and PageMaker software; output on Linotronic Imagesetter.

Designers
Marjorie Spiegelman
Ann Abele
Michael LaBash
Spiegelman & Mandel, Inc.
San Francisco, California

Self-promotional identity program for graphic design studio that focuses on corporate communications.

The software enabled us to stretch a Galliard ampersand into a new, exciting graphic element. Type could be manipulated very quickly on the computer, and the designer had control throughout the process.
— *Marjorie Spiegelman*

▼

Designer
Zuzana Licko
Emigré Graphics
Berkeley, California

Signs of Type, Emigré Graphics type catalog.

The Emigré typefaces have their origin in the geometric letterform experiments of Albrecht Dürer and Herbert Bayer and apply their type concepts to digital technology. The designer feels calligraphy-based letterforms are inappropriate to computer technology.

• Apple Macintosh Plus computer; Altsys Fontographer and Letraset Ready, Set, Go software; output on Apple LaserWriter printer.

abcdef
ghijklm
nopqrst
uvwxyz

Signs of Type

Emigre Graphics Type Catalog

primitive Lines
Variex Regular

digital technology has advanced the state of graphic art by a quantum leap into the future, thereby turning designers back to the most primitive of graphic ideas. because the computer is an unfamiliar medium, designers must reconsider many basic rules previously taken for granted. this brings excitement and creativity to aspects of design that have been forgotten since the days of letterpress. with computers, many alternatives can be quickly and economically reviewed, which dramatically changes the design process. the

Variex Light

speed of computerized production seldom results in a faster turn out of successful designs, but does enable the artist to spend more time evaluating the options. thus, today's designers must learn to discriminate intelligently among all of the choices, a task requiring a thorough understanding of fundamentals.

a A b b c d d
e f g g H i j k
L L M N o p p
q a r r s s t u
v w x y y z z
Variex Regular

a A b b c
d d e f g
g H i j k L
L M N o p
p q a r r s
s t u v w
x y y z z
Variex Light

Variex Letterforms
have been reduced
to the basic power-
ful gestures of
primitive writing
hands. elements
from capitals and
lower case are
combined into a
single alphabet.
relying on a single
set of characters
eliminates the
redundancy of upper
and lower-case
symbols. several
alternative charac-
ters are provided for
headline applica-
tions where optimal
letter combinations
are crucial.

stroke characters
require fewer data
points and
therefore take up
much less memory
space than do
outline characters.
two separate
outlines are
usually needed to
describe the
delicate tapering
shapes of
traditional letter-
forms.

stroke character outline character

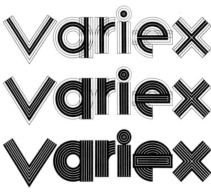

the variex family is based on the
most primitive of marks: the line.
each character is defined by center-
lines of uniform weight, from which
the three weights are also derived.

◀

Designer
Zuzana Licko
Zuzana Licko Design
San Francisco, California

Matrix, high-resolution typeface for the Apple Macintosh computer.

Derived from a bit-mapped font, this typeface was designed to use very little computer memory. The points that define it are limited to essentials and the 45-degree serifs create the smoothest looking diagonal that a digital printer can generate. Geometry is used as the foundation for this design as opposed to the imitation of classic calligraphy forms.

• Apple Macintosh Plus computer; Altsys Fontographer software; output on Apple LaserWriter printer.

▼

Designers
Rudy Vanderlans
Zuzana Licko
Emigré Graphics
Berkeley, California

Logotype for *GlasHAUS* magazine, a San Francisco-based source of information on international style, fashion, and entertainment.

• Apple Macintosh Plus computer; Letraset Ready, Set, Go software; Apple MacWrite and MacPaint and Fontographer software; output on Apple LaserWriter printer.

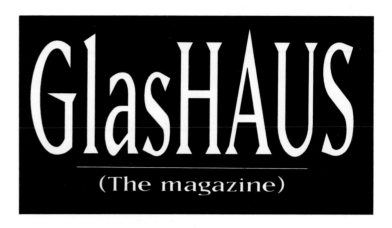

Algorithmic Effects

Matrix Condensed

Algorithmic stretching and obliquing effects are performed by computer calculations. When traditional typefaces are squeezed or slanted by this method, delicate forms often become disproportioned, since these automatic effects do not include the optical corrections that an artist makes when letterforms are condensed Matrix Extended
or italicized by hand.

But it is entirely possible to design original digital typefaces specifically to maximize the use of these effects, which save memory space by building an entire family from a single base font. Matrix Condensed

aAbBcCd
DeEfFgG
hHiIjJk
KlLmMn
NoOpPq
QrRsStT Matrix Condensed
uUvVwW
xXyYzZ

a A b B c C d D e E
f F g G h H i I j J k
K l L m M n N o O p
P q Q r R s S t T u U
v V w W x X y Y z Z Matrix Extended

a A b B c C d D e E
f F g G h H i I j J k
K l L m M n N o O p
P q Q r R s S t T u U
v V w W x X y Y z Z Matrix Regular

Matrix Regular

To ensure legibility for text applications, Matrix adapts classical elements to a digitally economical format. Thus, the points required to define the letterforms are limited to the essentials. For example, the 45 degree diagonal serif requires the least number of points and is the smoothest diagonal that digital printers can generate. Matrix responds well to algorithmic manipulations because its forms are harmonious with the digital grid on which these effects are based.

Matrix Condensed

(Left) Matrix regular. (Right) Condensing the same face by 50% emphasizes the verticals and diminishes the distinctions between the various letterforms. Algorithmically altered typefaces thus often appear more unified than the original typeface design. The more severe the function, the more emphasized is the algorithmic effect as an increasingly dominant design element.

Matrix Bold

a A b B c C d D e E
f F g G h H i I j J k
K l L m M n N o O p
P q Q r R s S t T u U
v V w W x X y Y z Z Matrix Bold

Designer
Louis Fishauf
Reactor Art & Design
Toronto, Canada

Client
Reactor Artwear
Toronto, Canada

Athletic Icons, self-marketed T-shirt design.

• Apple Macintosh computer; Adobe Illustrator 88 software; output on Linotronic Imagesetter.

▼

Designer
Louis Fishauf
Reactor Art & Design
Toronto, Canada

Typographic design for studio newsletter masthead.

• Apple Macintosh computer; Adobe Illustrator 88 software; output on Linotronic Imagesetter.

▶

Designer
Louis Fishauf
Reactor Art & Design
Toronto, Canada

Experimental typographic design.

● Apple Macintosh computer; Adobe Illustrator 88 software; output on Linotronic Imagesetter.

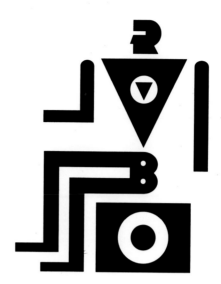

Designer
Louis Fishauf
Reactor Art & Design
Toronto, Canada
Client
Vortex Comix
Toronto, Canada

Logotype title design for poster and four-part comic book series,
Radiant City.

● Apple Macintosh computer; Adobe Illustrator 88 software; output on Linotronic Imagesetter.

omni**PAGE**™

Designer
Clement Mok
Clement Mok Designs
San Francisco, California

Client
Caere Corp.
Los Gatos, California

Logo for optical character reading software.

● Apple Macintosh II computer; Adobe Illustrator software; output on Linotronic Imagesetter.

pillar

▲

Designer
Clement Mok
Clement Mok Designs
San Francisco, California

Client
Pillar Corp.
Hayward, California

Logo for financial management software system geared to executives.

● Apple Macintosh II computer; Adobe Illustrator software; Apple LaserWriter for proofs, output on Linotronic Imagesetter.

CLARIS™

Designer
Clement Mok
Clement Mok Designs
San Francisco, California

Client
Claris Corp.
Cupertino, California

Logo for new software company formed from Apple Computer, Inc., software division.

● Apple Macintosh II computer; Adobe Illustrator software; Apple LaserWriter for proofs, output on Linotronic Imagesetter.

C A C T U S

FABRICS

▲

Designer
Paul Woods
Woods + Woods
San Francisco, California

Client
Adobe Systems, Inc.
Mountain View, California

Cactus Fabrics logo.

This logo was commissioned to demonstrate the masking and texture capabilities of an Adobe Illustrator upgrade where textures can be dropped into text or shapes. The client released a disk full of these patterns to designers.

• Apple Macintosh II computer; Adobe Illustrator 88 software; Apple LaserWriter IINTX and QMS Colorscript 100 for proofs, output on Linotronic Imagesetter.

CONNECTSM

Designer
Clement Mok
Clement Mok Designs
San Francisco, California

Client
Connect, Inc.
Cupertino, California

Logo for electronic mail and information services company.

• Apple Macintosh II computer; Adobe Illustrator software; output on Linotronic Imagesetter.

Designer
Nancy Bellantone
Movidea, Inc.
Boston, Massachusetts

Client
Andiamo!
Boston, Massachusetts

Logo for a small boutique, used for signs, outside banners, advertising, and stationery.

Stretching, squeezing, and resizing type was much easier to do on the computer. Traditionally, each change would be a separate camera shot. I was able to manipulate each letter both separately and differently. All variations were saved and output as sketches.
— *Nancy Bellantone*

• Apple Macintosh II computer; Aldus FreeHand software; output on QMS-PS810 LaserPrinter.

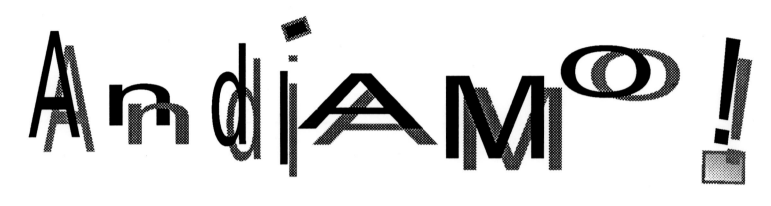

Designer
Phylane Norman
Condon Norman Design
Chicago, Illinois

Client
Majestic Industries
Elkkton, Maryland

Logo for packaging.

• Apple Macintosh computer; Adobe Illustrator 88 and Aldus PageMaker software; Apple LaserWriter Plus for proofs, output on Linotronic Imagesetter.

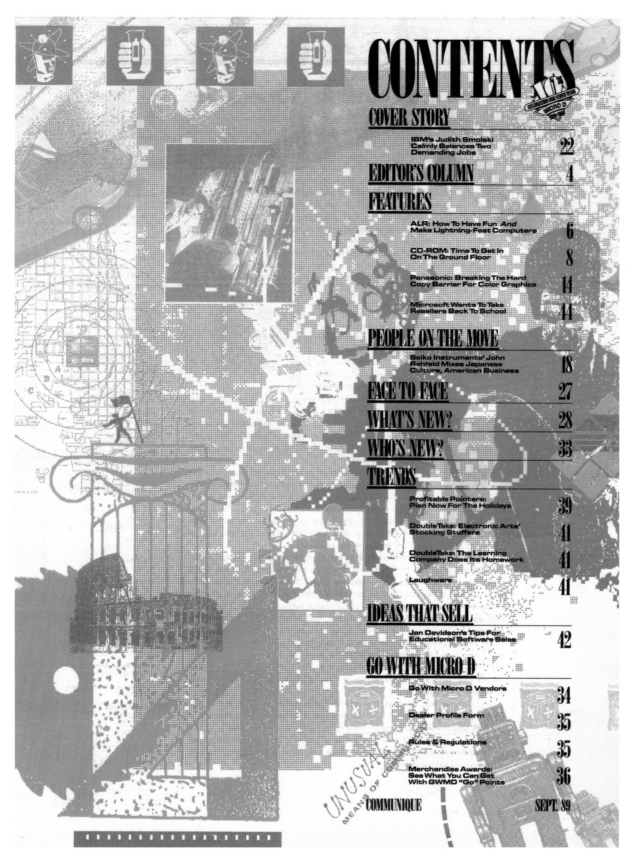

CONTENTS

COMMUNIQUE SEPT. 89

Designers
Ingram Micro D Design Staff
Santa Ana, California

Illustrator
Johnee Bee
The Johnee Bee Show
Irvine, California

Client
Ingram Micro D
Santa Ana, California

Contents page for *Communique* magazine.

Typography is layered over the illustration to create an image several layers deep. The computer's ability to preview an image was important since several typefaces were used in unison. The four-color, tabloid-size illustration underlying the typography is composed of scanned images that are repeated, altered, and layered as transparent objects in a low-resolution paint program.

• Apple Macintosh II computer, Abaton Scanner 300S; Aldus PageMaker and Abaton C-Scan software; output on Linotronic Imagesetter.

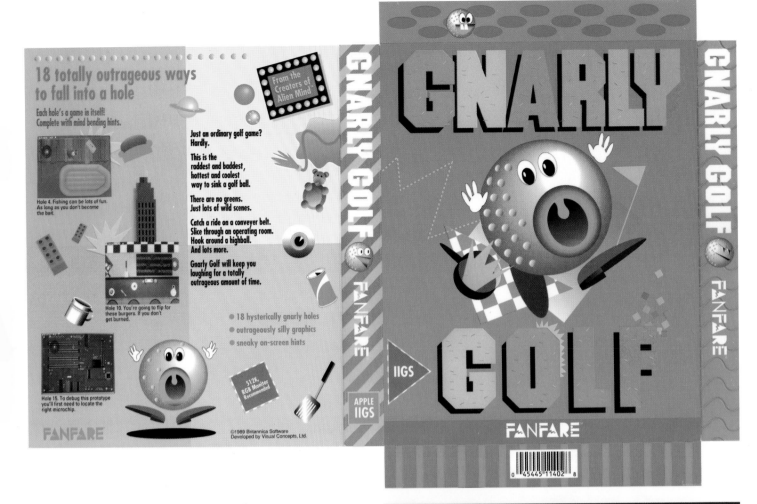

18 totally outrageous ways to fall into a hole

Each hole's a game in itself! Complete with mind bending hints.

From the Creators of Alien Mind™

Hole 4. Fishing can be lots of fun. As long as you don't become the bait.

Hole 10. You're going to flip for these burgers. If you don't get burned.

Hole 15. To debug this prototype you'll first need to locate the right microchip.

Just an ordinary golf game? Hardly.

This is the raddest and baddest, hottest and coolest way to sink a golf ball.

There are no greens. Just lots of wild scenes.

Catch a ride on a conveyer belt. Slice through an operating room. Hook around a highball. And lots more.

Gnarly Golf will keep you laughing for a totally outrageous amount of time.

● 18 hysterically gnarly holes
● outrageously silly graphics
● sneaky on-screen hints

512K RGB Monitor Recommended

©1989 Britannica Software
Developed by Visual Concepts, Ltd.

FANFARE

GNARLY GOLF FANFARE™

IIGS

APPLE IIGS

GNARLY GOLF FANFARE™

FANFARE

0 45445 11402 8

▲
Designer
Paul Woods
Woods + Woods
San Francisco, California

Client
Britannica Software
Division of Encyclopaedia
Britannica
Chicago, Illinois

Gnarly Golf, computer game package.

● Apple Macintosh II computer with color monitor; Adobe Illustrator 88 and Adobe Separator software; QMS Colorscript 100 for test colors, Apple LaserWriter IINTX for proofs, Linotronic Imagesetter used for color separations.

▶
Designer
Paul Woods
Woods + Woods
San Francisco, California

Client
Adobe Systems, Inc.
Mountain View, California

Indian Springs bottled water packaging designed to launch Adobe Illustrator 88 software.

The rainbow of colors on these labels exists because I was able to run exhaustive tests on the computer screen to visualize the color combinations. It was nice not using messy art materials. I didn't have to wash plaka off my hands. — *Paul Woods*

● Apple Macintosh II computer with color monitor; Adobe Illustrator 88 and Adobe Separator software; QMS Colorscript 100 for proofs, Linotronic Imagesetter used for color separations.

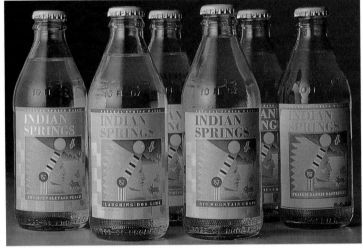

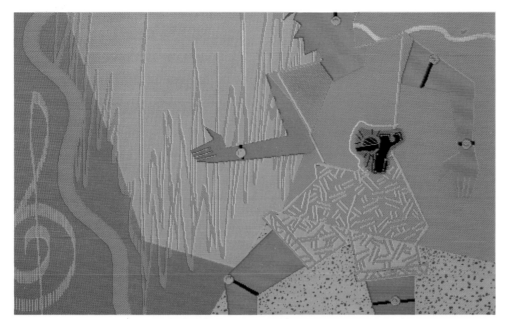

Illustrator
Sharmen Liao
Alhambra, California

Client
Jeffrey Spear Design
Santa Monica, California

Watch Man, packaging illustration for new toy called "Body Rap."

This project called for a very flat, graphic look, yet full of movement and action since the toy was meant to be worn all over the body, creating music and a beat for dancing as the toy is hit. The computer really gave it this exciting quality. —*Sharmen Liao*

• IBM-AT computer with 24-bit Truevision TARGA graphics boards; AT&T Truevision software; output as 4X5 transparency to film recorder.

Designer
Bev Kirk
Cincinnati, Ohio

Packaging designed as studio sample.

Three dimensionality was never rendered so realistically by hand as it is with the computer's color shading tools. The positioning capabilities let me lay down multiple layers of artwork with precision. Look closely at the motif above the type; it replicates the larger design exactly, in scale, detail, and color. — *Bev Kirk*

• Aesthedes Computer Design workstation; output on a Xerox Versatec color thermal printer.

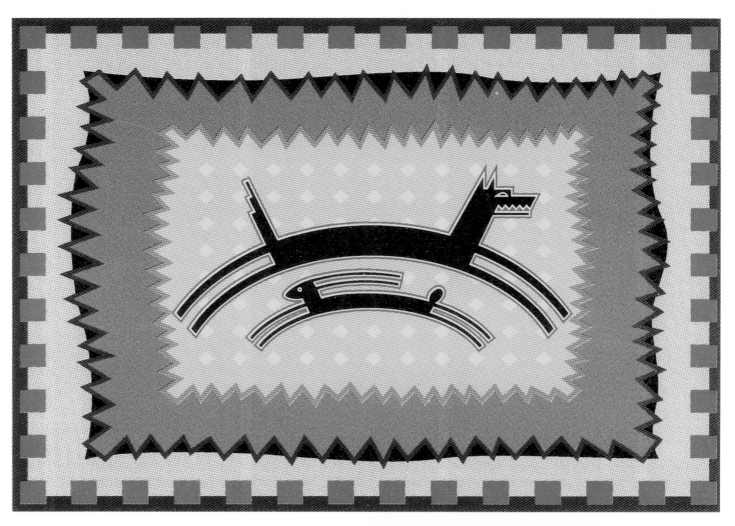

Designer
Louis Fishauf
Reactor Art & Design
Toronto, Canada

JackRabbit Rug, first-place winner in Anglo-Oriental Rug Design Competition. The piece has been licensed to a French company for mass production.

- Apple Macintosh II computer; Adobe Illustrator 88 software; output on QMS Colorscript 100 thermal printer.

Designer
Louis Fishauf
Reactor Art & Design
Toronto, Canada

Gal Pattern Rug, entry for Anglo-Oriental Rug Design Competition.

- Apple Macintosh II computer; Adobe Illustrator 88 software; output on QMS Colorscript 100 thermal printer.

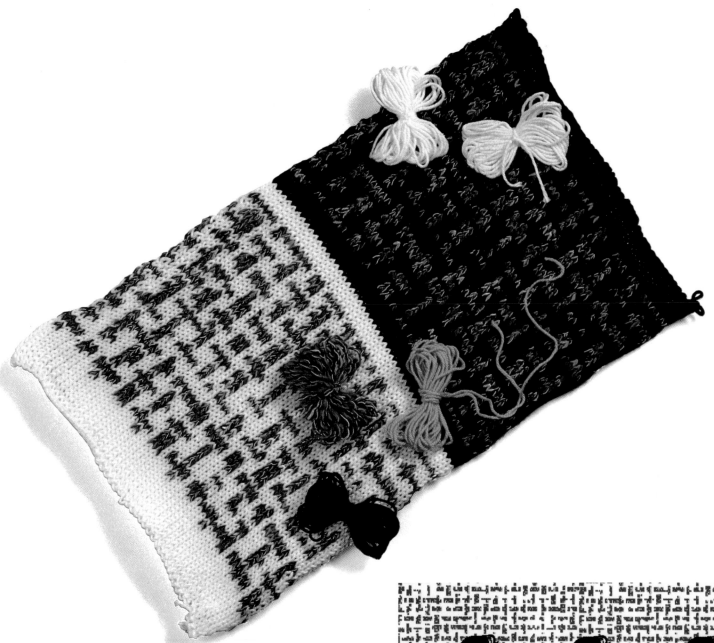

Designer
Susan Lazear
Cochenille Design Studio
Orinda, California

Experimental project using the computer to translate woven fabric to a knit fabric for sweaters.

It took approximately five minutes to translate the weave into knit. I was able to knit "interactively" with the computer, watching my progress on the monitor. I mixed the colors on screen with an airbrush tool to simulate multicolored yarns. —*Susan Lazear*

• Amiga computer with Sharp scanner; Deluxe Paint, Deluxe Photolab, and Digiview software; proofed on Hewlett Packard Paintjet printer, final output to an electronic knitting machine with BitKnitter software.

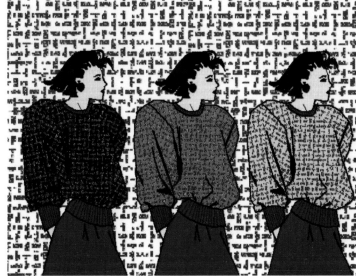

Artist
James Dowlen
Santa Rosa, California

Client
Vision Technologies
Fremont, California

Jazz Sax, cover art for computer paint system software package.

• Everex 286 computer with Vision Technologies graphics board, Howtek color scanner; Time Arts Lumena software; output on Matrix PCR film recorder.

© Vision Technologies.

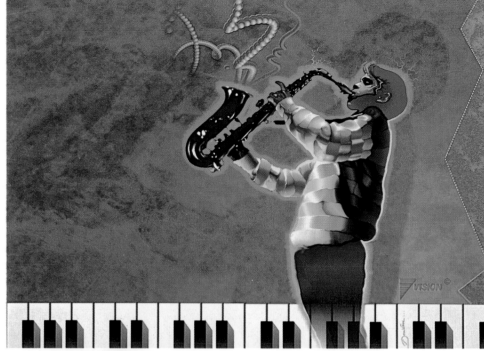

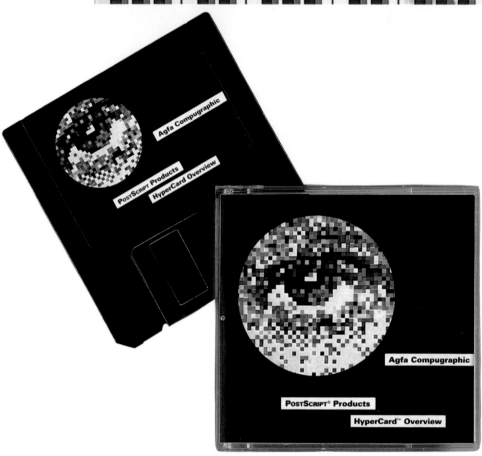

Designers
Nat Connacher (packaging)
James A. Waldron (hypercard media)
Burns, Connacher & Waldron
New York, New York

Client
Agfa Compugraphic
Wilmington, Massachusetts

Electronic catalog package and label.

• Apple Macintosh computer; Graphispaint, Versascan, QuarkXpress, and Digital Darkroom software; output on Linotronic Imagesetter and Compugraphic 9400PS typesetter. A new PostScript Imagesetter was used in the final production.

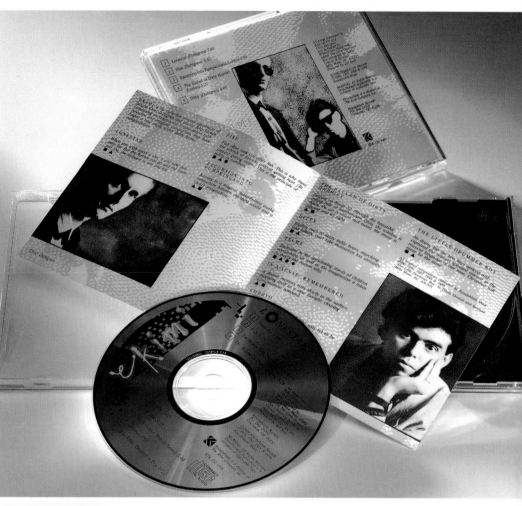

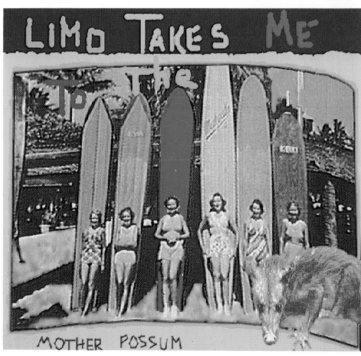

▲
Illustrator/Photographer
Alan Brown
Photonics Graphics/PhotoDesign
Cincinnati, Ohio

Designer
Keith Kleespies
Cincinnati, Ohio

Client
Krysdahlart Productions
Cincinnati, Ohio

Compact disc and cassette packages.

• Apple Macintosh IIx computer, Canon Electronic Slide Video Camera, MacVision Digitizer; MacVision and Photomac software; Linotronic Imagesetter used for color separations. A photograph of the musicians was digitized in low resolution to form the basis for an electronic illustration. The same digitized photograph is then screened back and used as background texture.

Designer
Carol Flax
Carol Flax Studios
Los Angeles, California

Photographer
Richard H. Stewart
National Geographic magazine
Washington, D.C.

Experimental album cover.

• MS-DOS-based computer with Truevision TARGA 16 graphics board; Island Graphics TIPS and INDA software; output as thermal print and shot off monitor. Stock shots were scanned as the basis for the collage.

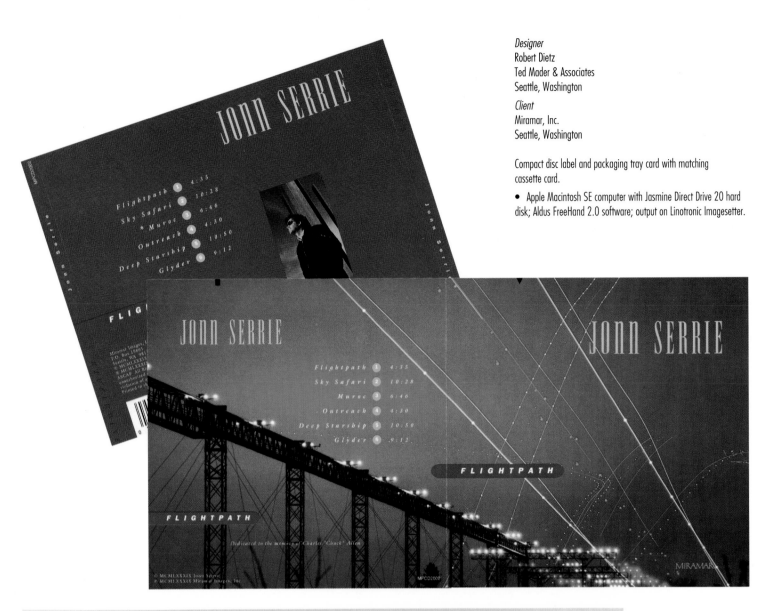

Designer
Robert Dietz
Ted Mader & Associates
Seattle, Washington

Client
Miramar, Inc.
Seattle, Washington

Compact disc label and packaging tray card with matching cassette card.

• Apple Macintosh SE computer with Jasmine Direct Drive 20 hard disk; Aldus FreeHand 2.0 software; output on Linotronic Imagesetter.

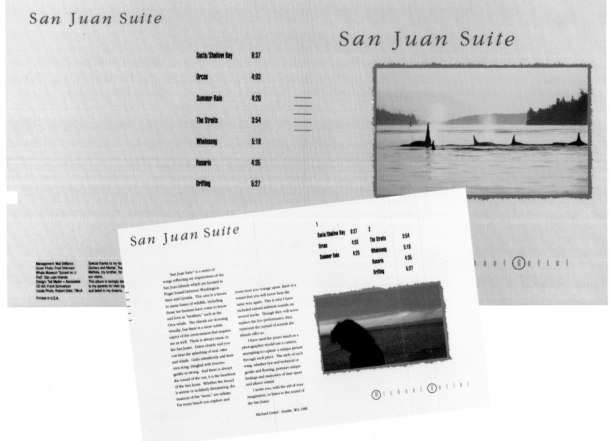

Designer
Robert Dietz
Ted Mader & Associates
Seattle, Washington

Client
Spilman Printing
Sacramento, California

Paper airplane to promote printing company.

• Apple Macintosh SE computer with Jasmine Direct Drive 20 hard disk; Aldus FreeHand software; output on Linotronic Imagesetter.

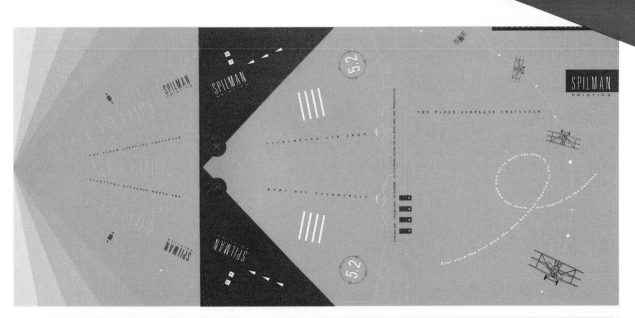

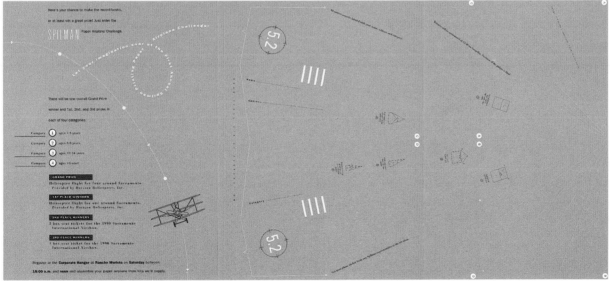

◀
Designer
Robert Dietz
Ted Mader & Associates
Seattle, Washington

Client
Sounding Records
Renton, Washington

Compact disc and audio cassette packaging.

We could have produced this traditionally, but we chose the computer for its cost effectiveness and facility with design experimentation. — *Robert Dietz*

• Apple Macintosh SE computer with Jasmine Direct Drive 20 hard disk; Aldus FreeHand 2.0 and PageMaker 3.0 software; output on Linotronic Imagesetter.

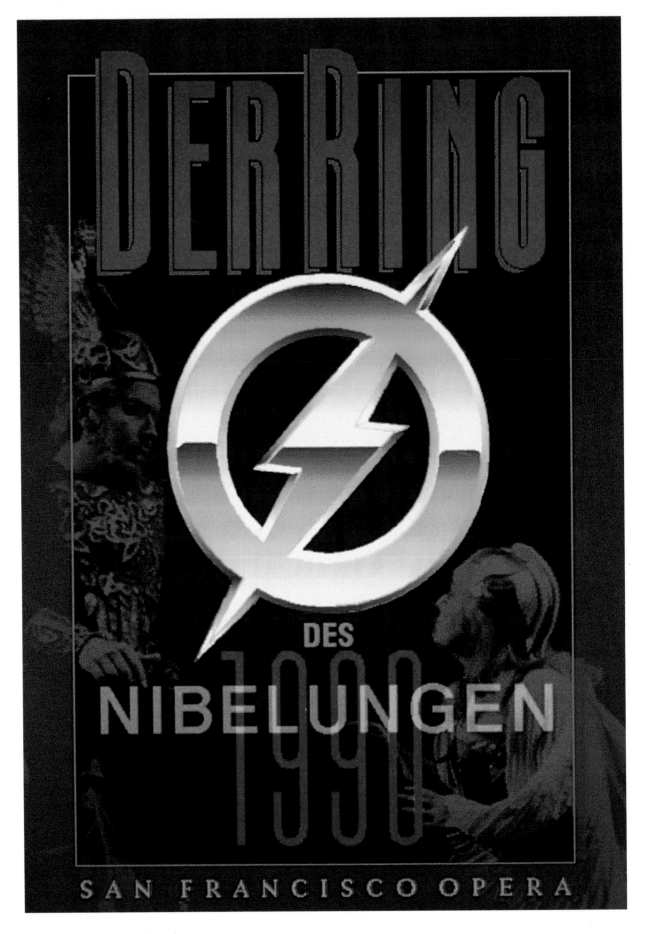

Designers
Primo Angeli
Mark Crumpacker
Primo Angeli, Inc.
San Francisco, California

Client
San Francisco Opera
San Francisco, California

Opera poster.

If done traditionally, this piece would have consisted of color over-
lays, airbrushing, flat color, and more. This kind of multiple media
combination is often hard to read as a single visual. The computer
made it possible to visualize the poster in one medium. — *Ray
Honda (of Primo Angeli, Inc.)*

• Apple Macintosh IIx computer, Spectrum 24 videocard; SuperMac
PixelPaint Professional software; output on QMS Colorscript 100
printer and Montage film recorder.

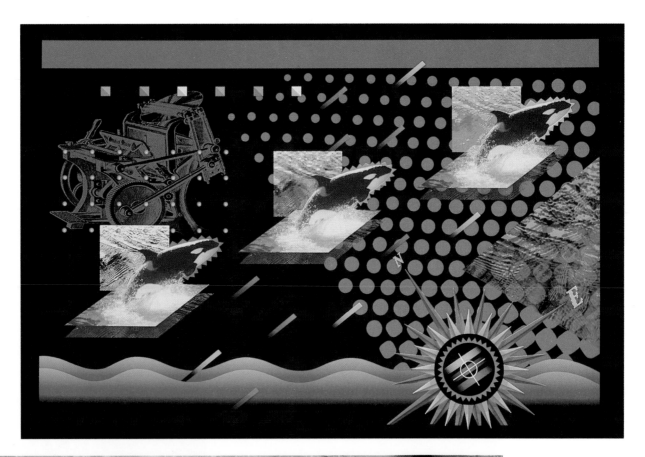

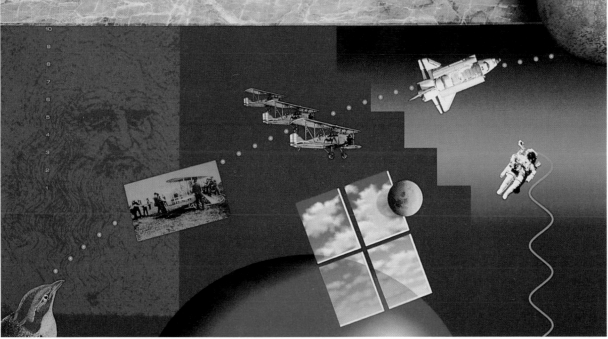

▲

Designers
Jeff Brice
Jesse Doquilo
Glenn Mitsui
Studio MB
Seattle, Washington

Client
Orca Bay Printing
Bellevue, Washington

Promotional poster for printer.

• CGL Images II computer graphics system with Eikonix scanner and Ikegami video camera; Apple Macintosh II computer; Aldus FreeHand software; output on Celco film recorder, Apple LaserWriter IINTX, and Linotronic Imagesetter.

Designers
Jeff Brice
Jesse Doquilo
Glenn Mitsui
Studio MB
Seattle, Washington

Vision of Flight, self-promotional poster.

This poster was almost entirely computer-generated, allowing us to make bold and inspired changes as we rendered the final composition. The computer was flexible enough to free up our creativity throughout the entire process. We were able to composite photos, moving and scaling them as we worked, even overlaying the clouds, planet, and gradation.— *Jeff Brice*

• CGL Images II computer graphics system with Eikonix scanner and Ikegami video camera; Apple Macintosh II computer; Aldus FreeHand software; output on Celco film recorder, Apple LaserWriter IINTX, and Linotronic Imagesetter.

Designer
Tim Thompson
Graffito, Inc.
Baltimore, Maryland

Client
Maryland Academy of Sciences
Baltimore, Maryland

Poster to promote black-tie fundraiser.

The fundraiser was titled "One Step Beyond Imagination," so it was important that the computer-manipulated image evoke a futuristic feel. — *Tim Thompson*

• Lightspeed Page Layout System 20 computer graphics system; output on Laser ink-jet printer.

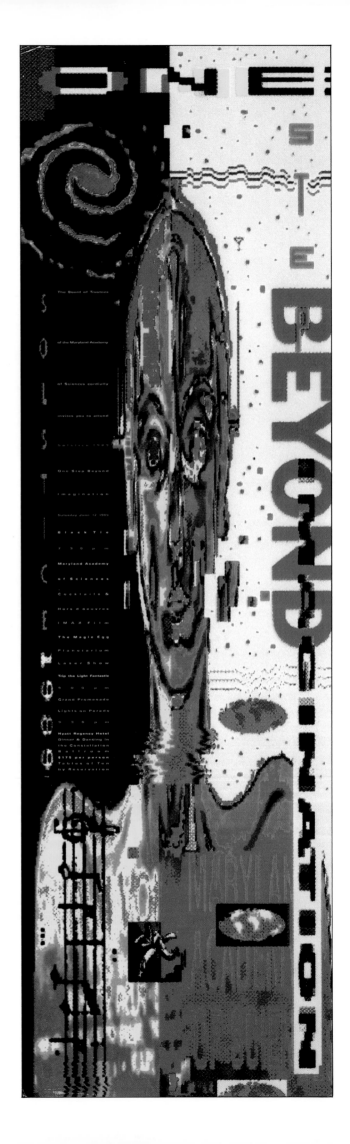

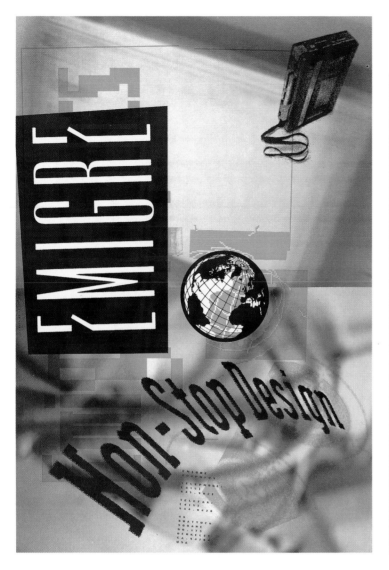

Designer
Rudy Vanderlans
Emigré Graphics
Berkeley, California

Non-Stop Design, poster originally published as magazine pull-out section to attract readers and clients.

● Apple Macintosh Plus computer; Claris MacWrite, Ann Arbor Softworks, and Fullpaint software; output on Apple LaserWriter printer.

Designer
Paul Woods
Woods + Woods
San Francisco, California

Printer/Pre-press Collaboration
Graphic Impressions
San Francisco, California

Client
AIGA
San Francisco, California

Upcoming events poster.

● Apple Macintosh II computer; Adobe Illustrator 88 software; output on Apple LaserWriter IINTX, QMS Colorscript 100 used for color proofs.

Photographer/Illustrator
Alan Brown
Photonics Graphics/PhotoDesign
Cincinnati, Ohio

Designers
Lori Siebert
Kelly Kolar
Siebert Design Associates, Inc.
Cincinnati, Ohio

Client
Kings Mill Charity Horse Show
Cincinnati, Ohio

Poster promoting a benefit horse show.

• Apple Macintosh IIx computer, Rasterops 324 framebuffer, and 3/4-inch videotape deck; Truevision and Photomac software; color 4x5-inch transparencies shot off a 19-inch monitor to produce pixel-based images. Final product is a blend of computer and hand methods. Videotape was combined with square pixels off screen for texture.

Designers
Glenn Mitsui
Jesse Doquilo
Jeff Bruce
Studio MB
Seattle, Washington

Client
Wing Luke Asian Museum
Seattle, Washington

Poster for museum exhibit.

We brought some of the costumes from the exhibit to our studio so we could video scan details of the materials to use as the titled background. We were able to composite scans and drawn images on the screen to visualize the finished piece. The dragon was entirely drawn on the system. — *Glenn Mitsui*

• Apple Macintosh II computer and CGL Images II system; Aldus FreeHand software; output on Linotronic Imagesetter and Celco film recorder.

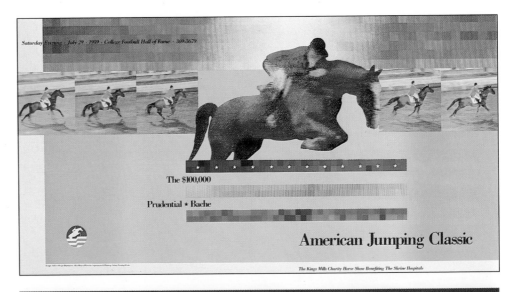

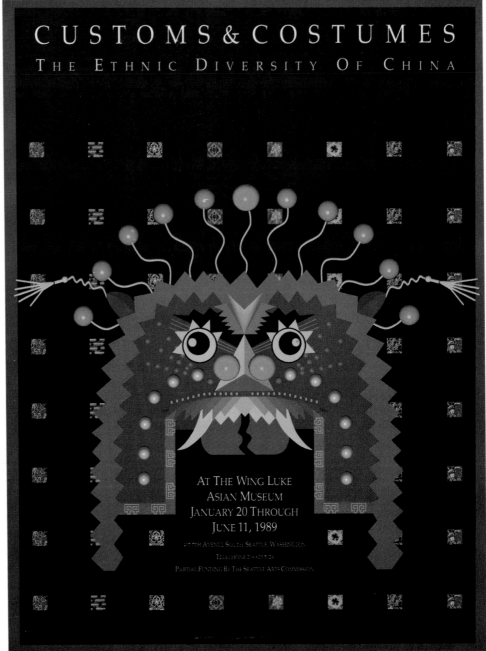

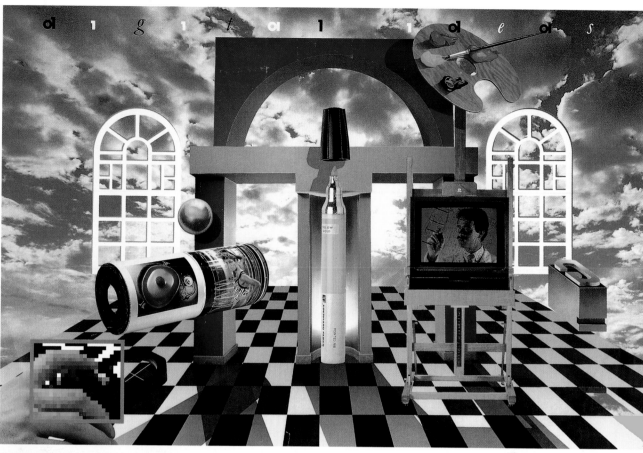

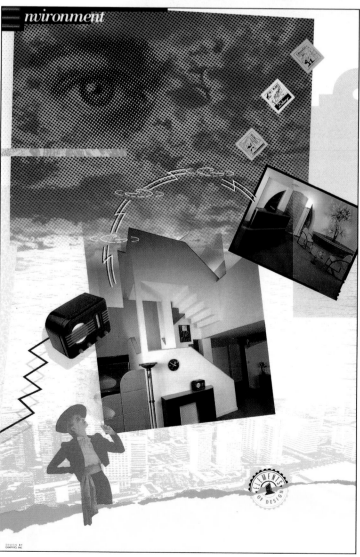

▲

Designer
Tim Thompson
Graffito, Inc.
Baltimore, Maryland

Self-promotional poster.

Being able to retouch, enhance, clone, vignette, mask, intensify, subdue, or change the colors via computer demonstrates our studio's marriage of computer-aided design with electronic pre-press.
— *Tim Thompson*

● Lightspeed 20 color computer graphics system; ouput on laser plotter.

Designer
Tim Thompson
Graffito, Inc.
Baltimore, Maryland

Self-promotional poster.

The picture-to-picture merging and pixel cloning would be virtually impossible without the technology of the electronic page make-up system. — *Tim Thompson*

● Lightspeed 20 color computer graphics system; output on laser plotter.

Designer
Robert Burns
Illustrator
Michael Crumpton
Burns, Connacher & Waldron
New York, New York

Client
National Park Service
U.S. Department of the Interior
Harper's Ferry, Virgina

Four-color posters to increase awareness of drug use in the national park system.

Our ability to produce these posters within a four-day deadline was the most dramatic aspect of this project. All illustrations and separations were computer generated. — *Robert Burns*

• Apple Macintosh II computer; Adobe Illustrator 88 and Aldus PageMaker software; output on QMS Colorscript color thermal printer for comps and Linotronic Imagesetter.

There's a Cancer threatening
our Parks and Public Lands

**Don't Let Drugs
Spoil The Scenery**

**Report Suspected
Drug Activity or Use to:**

U.S. Department of the Interior

There's a Cancer threatening
our Parks and Public Lands

**Help Stop
Drug Trafficking**

**Report Suspected
Drug Activity or Use to:**

U.S. Department of the Interior

Designer
Vicki Putz
Vicki Putz Design
Falmouth, Massachusetts

Client
ACM SIGGRAPH
New York, New York

One poster in a series for SIGGRAPH 1989 show of computer graphics and animation.

• Apple Macintosh IIx computer; Aldus FreeHand software; Compugraphic 9600 laser typesetter and Hell 399 ERS laser scanner. The poster was printed on translucent stock allowing it to be posted on top of another poster in the series so underlying images could show through.

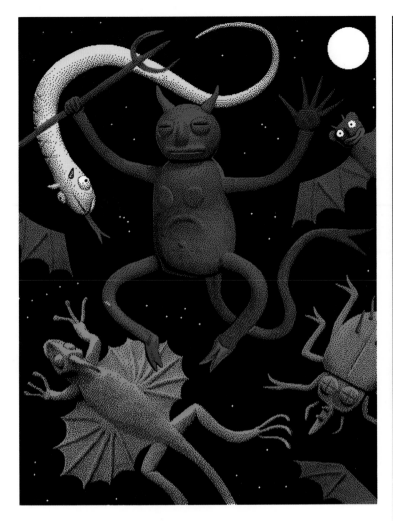

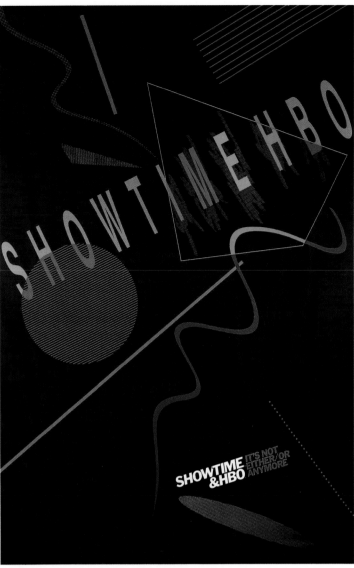

Illustrator
Scott Baldwin
Chestnut Ridge, New York

Self-promotional poster.

● Apple Macintosh Plus computer, RCA video camera with MacVision digitizer; SuperPaint and MacVision software; Apple LaserWriter IINT for black-and-white print. The artist began this silkscreen by making clay models, which he then scanned into the computer.

Designer
Javier Romero
Javier Romero Studio
New York, New York

Client
Showtime/The Movie Channel
New York, New York

Showtime HBO advertising and promotional poster.

● Apple Macintosh Plus computer; FullPaint software; output on Apple LaserWriter printer.

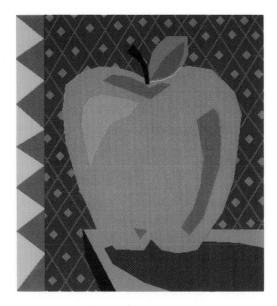

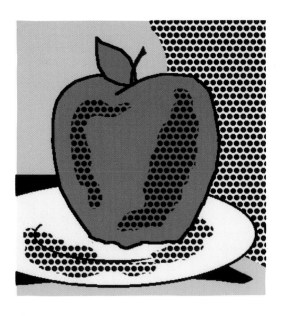

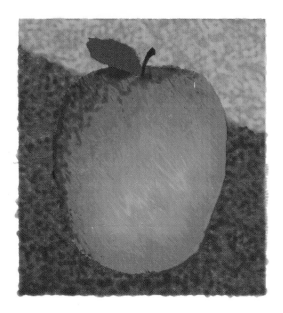

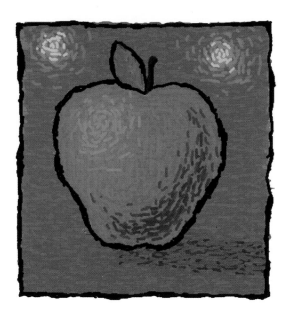

Artist
John Derry
Time Arts
Santa Rosa, California

Client
Imageset
San Francisco, California

Apple Suite, promotional poster for pre-press house.

It was fun coming up with eight different, well-known painting styles to pay homage to the apple in this piece. The pixels are visible due to the low resolution. This was intentional to allow the "computerness" of the imagery to show. — *John Derry*

● Apple Macintosh II computer; Electronic Arts Studio 8 software; output on Scitex.

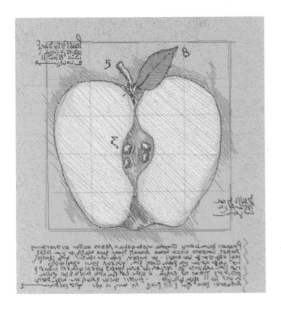

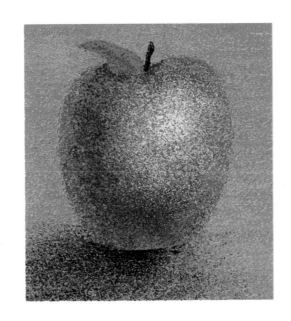

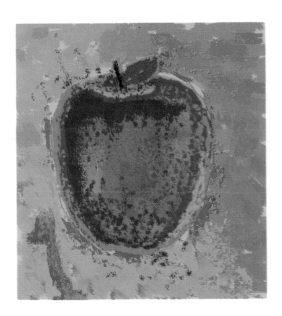

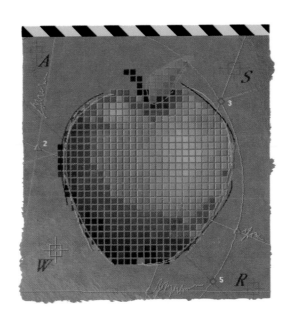

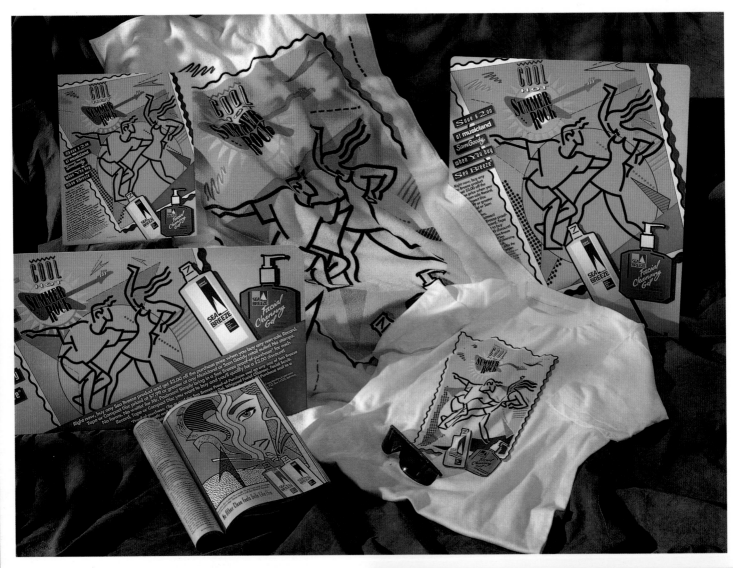

▲

Designer
Javier Romero
Javier Romero Studio
New York, New York

Client
Clairol, Inc.
New York, New York

Sea Breeze "Cool Hot Summer Rock" campaign.

• Apple Macintosh II computer; Adobe Illustrator 88 software; Linotronic Imagesetter used for color separations. Colors and typefaces were mixed on screen to preview the final effect.

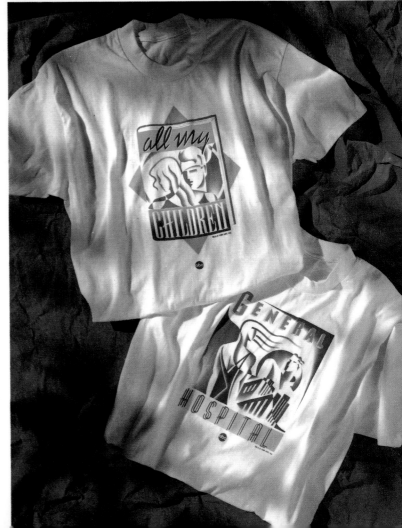

▼

Designer
Javier Romero
Javier Romero Studio
New York, New York

Client
Iberia Airlines
Tapsa Agency
Madrid, Spain

Two-page magazine spread promoting tourism.

• Apple Macintosh II computer; Adobe Illustrator 88 software;
Linotronic Imagesetter used for color separations.

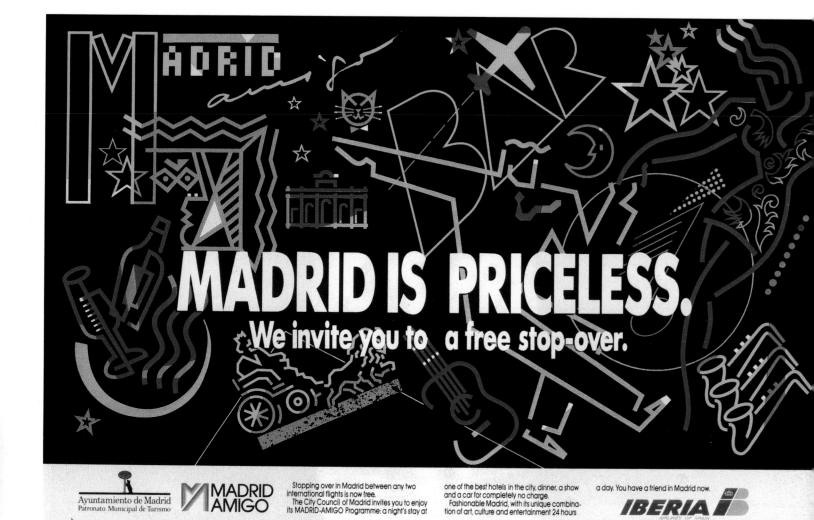

MADRID

MADRID IS PRICELESS.
We invite you to a free stop-over.

Ayuntamiento de Madrid
Patronato Municipal de Turismo

MADRID AMIGO

Stopping over in Madrid between any two
international flights is now free.
The City Council of Madrid invites you to enjoy
its MADRID-AMIGO Programme: a night's stay at

one of the best hotels in the city, dinner, a show
and a car for completely no charge.
Fashionable Madrid, with its unique combina-
tion of art, culture and entertainment 24 hours

a day. You have a friend in Madrid now.

IBERIA dla
AIRLINES OF SPAIN

WARM TO THE EXPERIENCE.

◄

Designer
Javier Romero
Javier Romero Studio
New York, New York

Client
ABC Television
New York, New York

T-shirts spotlighting afternoon soap opera programming.

• Apple Macintosh II computer; Adobe Illustrator 88 software;
Linotronic Imagesetter used for color separations. Silkscreened in
several colors, these shirts use Illustrator's blend tool to create
airbrush-like color gradation.

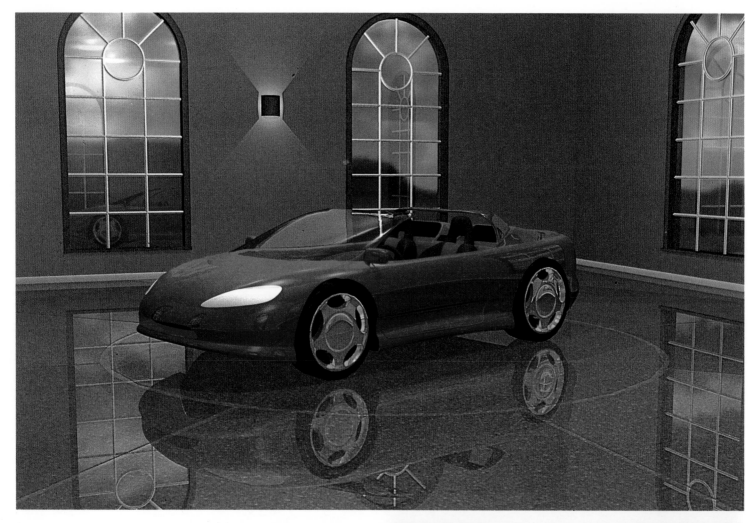

Designers
Stanley Liu (styling)
Gary Mundell (image)
Alias Research, Inc.
Toronto, Canada

Sportscoupe, self-promotion for Alias software.

• Silicon Graphics 4D/120 GTX workstation; Alias™/2, Alias Ray Tracing, and Alias DesignPaint™ software; output on high-resolution film recorder. The ray tracing software made accurate light reflections and refractions possible. The coupe displays automotive styling features in the software, which now is widely used by car manufacturers.

Designers
Gary Mundell
Paul Roy
Damir Frkovic
Alias Research, Inc.
Toronto, Canada

Rosedale, self-promotion for Alias software.

• Silicon Graphics 4D/120 GTX workstation; Alias™/2, Alias 3D, Alias Ray Tracing, and Alias Natural Phenomena software; output on film recorder. Alias Ray Tracing achieved true reflections and refractions of the house interior. Alias Natural Phenomena made the solid wood grain textures in the door, the interior banister, the brick, the floor, and the old-fashioned leaded glass panes.

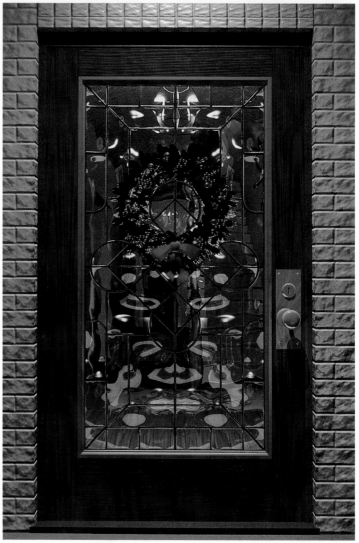

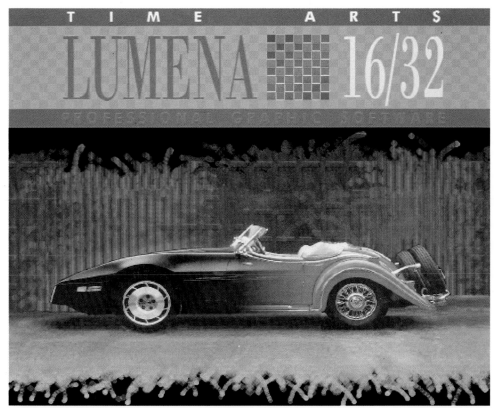

TIME ARTS

LUMENA 16/32

PROFESSIONAL GRAPHIC SOFTWARE

Designer
John Derry
TIme Arts
Santa Rosa, California

Client
Time Arts
Santa Rosa, California

Transcar, promotion for upgraded software.

The ability to transform a classic car design into a modern, photorealistic one would be difficult to achieve in traditional media.
— *John Derry*

• Compaq 386 computer; Lumena/32 software; output on Matrix PCR film recorder. The software's text and graphic ability created the graphic above the car.

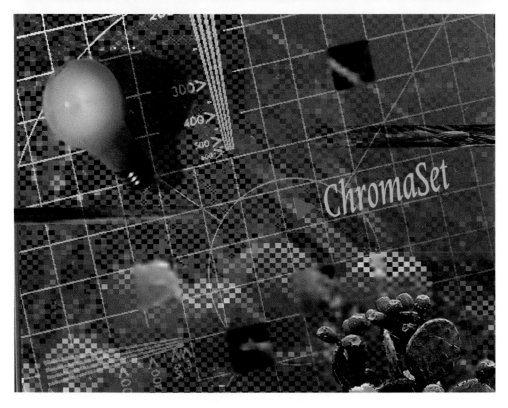

ChromaSet

Designer
John Derry
Time Arts
Santa Rosa, California

Client
Chromaset
San Francisco, California

Promotion for pre-press service.

I am fascinated with the computer's ability to blur various media. This series attempts to blur the distinction between photography and painting. The viewer must make a choice: Is this a painterly-looking photograph or a photographic-rendered painting?...It's both!
— *John Derry*

• Compaq 386 computer; Lumena/32 software; output on Mitsubishi G650 thermal printer.

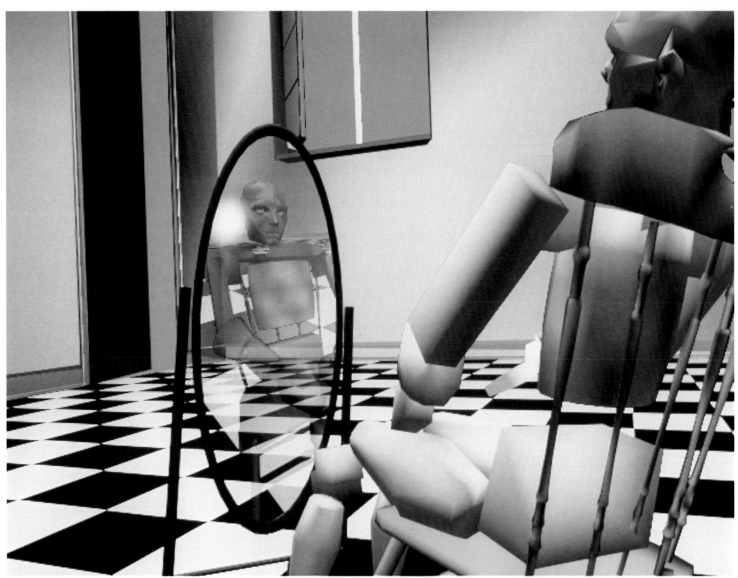

Designer
Craig Caldwell
Flagstaff, Arizona

Client
ACM SIGGRAPH
New York, New York

Looking In, publicity for international computer graphics organization.

The manipulation and composing of the background, middle ground, foreground, and objects could have very quickly consumed the energy needed for creative decision making if not for the computer.
— *Craig Caldwell*

• VAX 780 computer, Marc II framebuffer; TWIXT and proprietary software; film recorder used to image slides.

Illustrator
Johnee Bee
The Johnee Bee Show
Irvine, California

Client
Saddleback BMW
Irvine, California

Direct mail promotional cards to high-end clients.

• Apple Macintosh IIx computer; Adobe Illustrator 88 software and Aldus FreeHand software; Linotronic Imagesetter used for color separations.

Animator
Barbara Tutty
TSI Video
London, England

Client
BMW Films
London, England

Television commercial.

Traditional methods were used to prep this computer animation. The labels needed to remain legible no matter how much movement the bottle went through; this could only be assured using computer methods.

- Silicon Graphics 4D20, 4D50, 4D80 hardware; Digipix software from Digital Pictures; output on videotape.

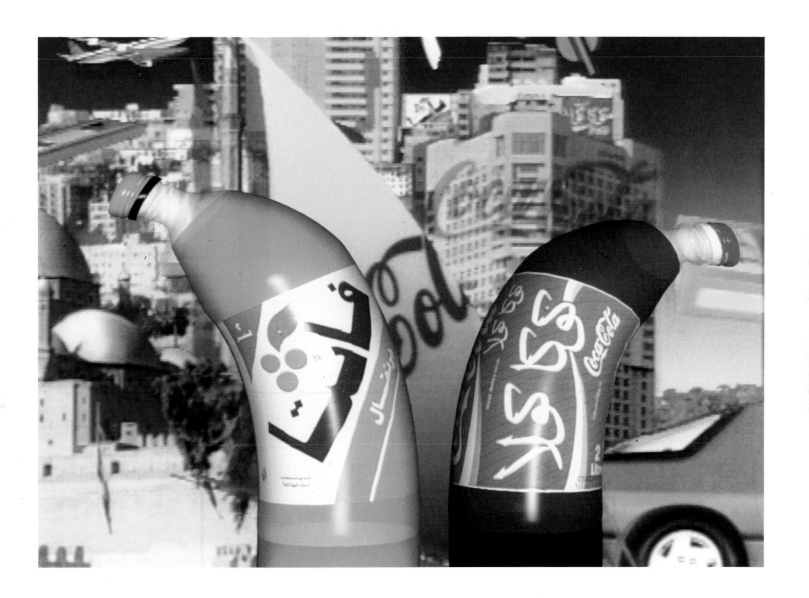

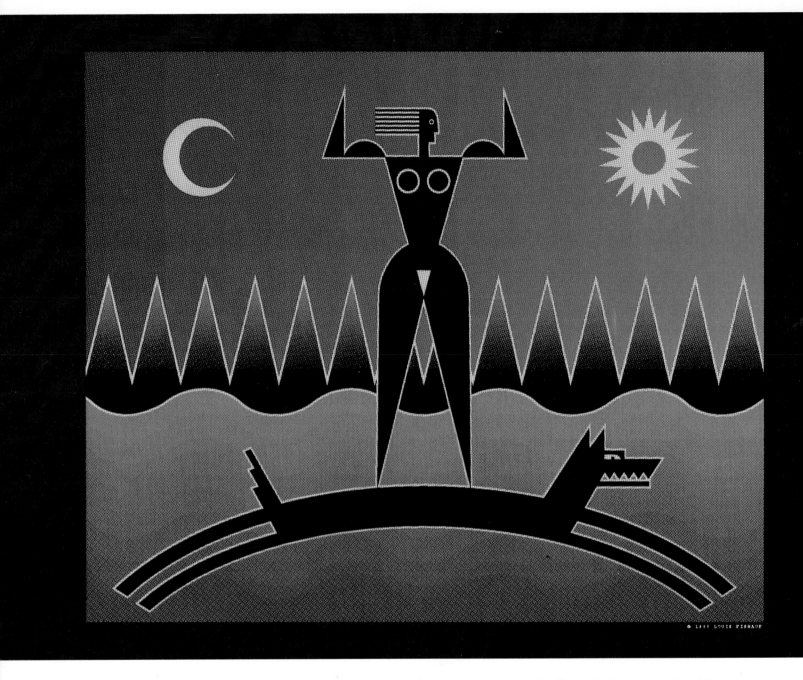

Designer
Louis Fishauf
Reactor Art & Design
Toronto, Canada

Client
Adobe Systems, Inc.
Mountain View, California

Dog Woman, print advertisement in graphics publications.

● Apple Macintosh computer; Adobe Illustrator 88 software; output on Linotronic Imagesetter and QMS Colorscript 100.

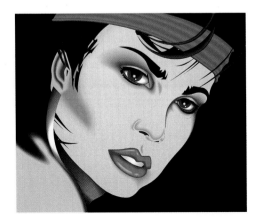

Designer
Phillip W. Lepine
Advanced Computer Graphics
Amherst, New York

Direct mail self-promotion.

● Dicomed D80 Imaginator system and software; output on Dicomed D148 film recorder.

Designer
Jay Nilson
Emerald City Productions
Boston, Massachusetts

Emerald City, self-promotional image.

I was able to "tweak" the look on various parts of the image individually and then compose them jointly. In animation, the city "grows" out of the circuit board. A metamorphosis of that type, along with the various motions and lighting, would be difficult to achieve in any medium other than the computer. — *Jay Nilson*

• Compaq 386 computer, Cubicomp frame buffer, Truevision TARGA 24 graphics board, Sony video camera; Cubicomp Picturemaker, Island Graphics TIPS and Ron Scott's Qutilities software; output on Matrix QCR-2 film recorder.

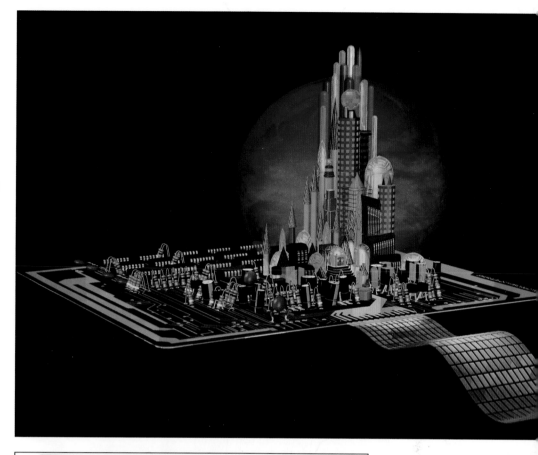

Designer
Jonathan Herbert
Computer Illustration
Brooklyn, New York
Client
Henszey & Albert
New York, New York

Advertisement in *W*, women's magazine.

• Indtech 286 computer, Truevision TARGA 24 graphics board; Island Graphics TIPS, RIO, TOPAS, QFX, and ASAVISION software; output on Shinko Chc-335 thermal printer. The haunting photographic image is retouched on screen. Color is subtracted and a ghosted image is superimposed over the photograph.

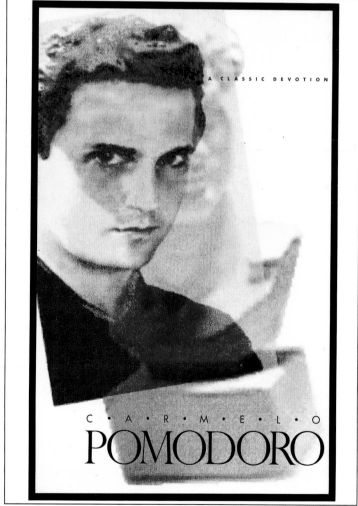

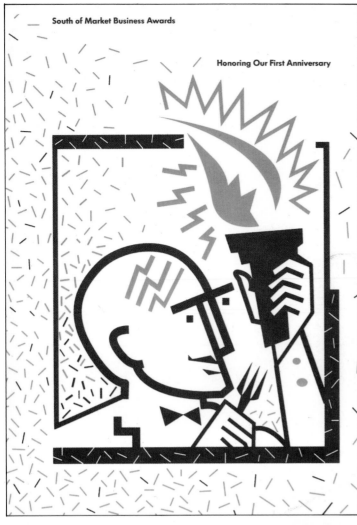

South of Market Business Awards

Honoring Our First Anniversary

Designer
Paul Woods
Woods + Woods
San Francisco, California

Client
South of Market Business
Association
San Francisco, California

Business awards luncheon invitation.

• Apple Macintosh II computer; Adobe Illustrator software; output on Apple LaserWriter printer.

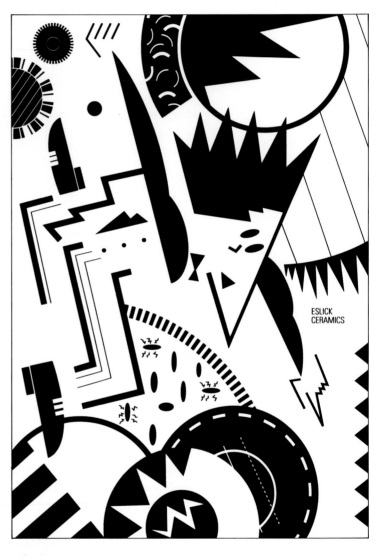

ESLICK CERAMICS

Designer
Pattie Belle Hastings
Atlanta, Georgia

Self-promotional brochure.

• Apple Macintosh II computer; Adobe Illustrator and Aldus PageMaker software; output on Apple LaserWriter IINT printer.

Designer
Paul Woods
Woods + Woods
San Francisco, California

Client
Eslick Ceramics
San Francisco, California

Direct mail announcements for annual sale.

I transferred images from the ceramics into computer graphics, and the look of the card is actually very similar to the ceramics' texture, shapes, and images. — *Paul Woods*

• Apple Macintosh II computer; Adobe Illustrator 88 software; output on Apple LaserWriter printer.

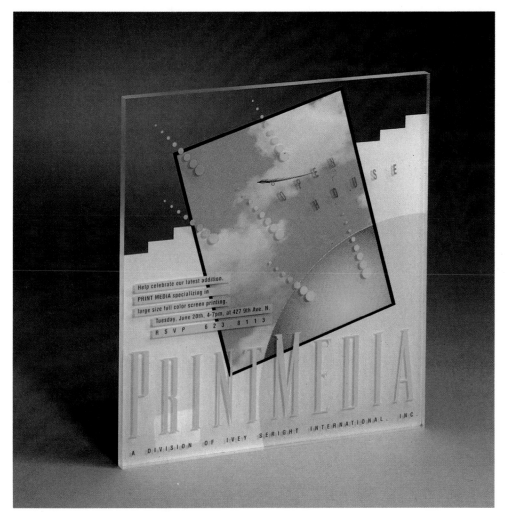

Designers
Jesse Doquilo
Glenn Mitsui
Jeff Brice
Studio MB
Seattle, Washington

Client
Ivey Seright International, Inc.
Seattle, Washington

Three-dimensional Plexiglas invitation to client's open house.

• Apple Macintosh II computer, CGL Images II system; Aldus FreeHand software; output on Celco film recorder, Linotronic Imagesetter used for final output. Clouds were drawn on the CGL paint system, then output to 8x10 film. Halftone film was made of the color transparency and merged with seven pieces of Linotronic film output as final mechanical art for silkscreener.

Designers
Glenn Mitsui
Jesse Doquilo
Studio MB
Seattle, Washington

Direct mail self-promotion.

• Apple Macintosh II computer; Aldus FreeHand software; Apple LaserWriter IINTX used for proofing, Linotronic Imagesetter used for final output.

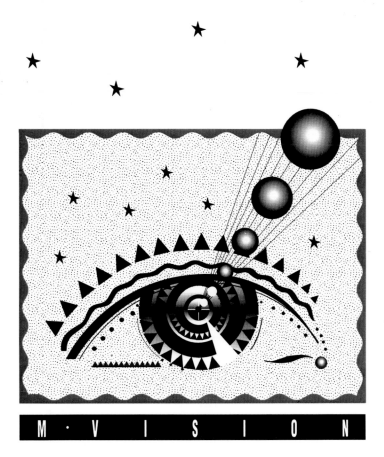

M Design

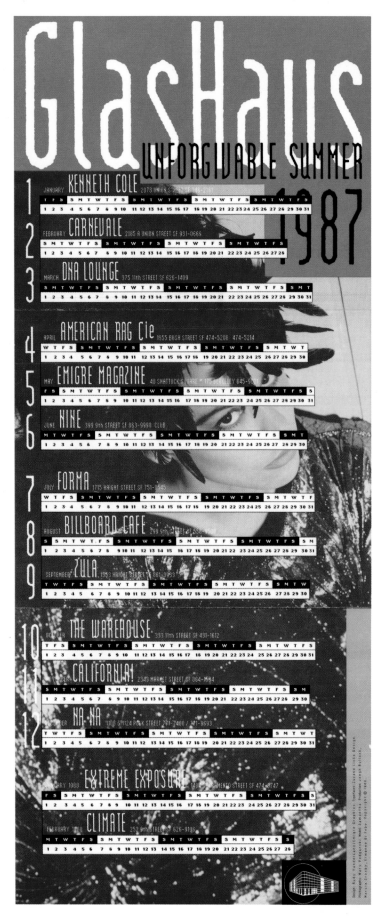

GlasHAUS

UNFORGIVABLE SUMMER 1987

1 JANUARY KENNETH COLE 2078 UNION STREET SF 346-2161

2 FEBRUARY CARNEVALE 2185 A UNION STREET SF 931-0669

3 MARCH DNA LOUNGE 375 11th STREET SF 626-1409

4 APRIL AMERICAN RAG Cie 1055 BUSH STREET SF 474-5208 474-5214

5 MAY EMIGRE MAGAZINE 48 SHATTUCK SQUARE #175 BERKELEY 845-9021

6 JUNE NINE 399 9th STREET SF 863-9990 CLUB

7 JULY FORMA 1715 HAIGHT STREET SF 751-0545

8 AUGUST BILLBOARD CAFE 299 9th STREET SF 558-8300

9 SEPTEMBER TULA 1553 HAIGHT STREET SF 861-3931

10 OCTOBER THE WAREHOUSE 393 11th STREET SF 431-1612

11 NOVEMBER CALIFORNIA! 2349 MARKET STREET SF 864-1364

12 DECEMBER NA-NA 1708 G/1124 POLK STREET 771-7400 / 771-9693

EXTREME EXPOSURE 1400 SACRAMENTO STREET SF 474-0747

CLIMATE 252 9th STREET SF 626-9100



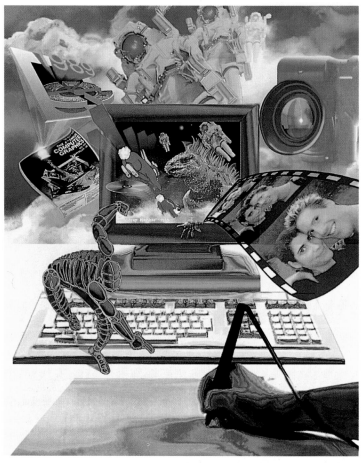

Designer
Audrey Fleisher
Saatchi & Saatchi Advertising
New York, New York

Client
Computer Graphics
New York, New York

Not Just Pie in the Sky, trade show promotion.

Both flat and three-dimensional objects were digitized with a video camera. The graphics tablet, hand, and stylus were "real objects." Other elements were created using flat art as the source. Then all the pieces were combined on the computer and "painted" together.
— *Audrey Fleisher*

• CGL Images II+ system and software; output on Matrix PCR and Dicomed film recorder.

Designers
Rudy Vanderlans
Zuzana Licko
Emigré Graphics
Berkeley, California

Calendar that previews and promotes upcoming issues of *GlasHAUS,* a magazine of the arts published by the designers.

• Apple Macintosh Plus computer; Fontographer and MacWrite software; output on Apple LaserWriter printer; manual layout.

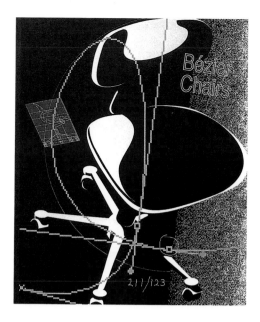

Designer
Michael Renner
The Understanding Business
San Francisco, California

Clients
Adobe Systems, Inc.
Mountain View, California
Apple Computer
Cupertino, California

Experimental poster demonstrating computer and software capabilities.

• Apple Macintosh Plus and Apple Macintosh II computers; pre-release version of Adobe Illustrator software; output on Linotronic Imagesetter.

▼

Designer
Michael Renner
The Understanding Business
San Francisco, California

Clients
Adobe Systems, Inc.
Mountain View, California
Apple Computer
Cupertino, California

Experimental catalog spreads demonstrating computer and software capabilities.

Producing sample art in late 1986 was a magical experience because of the ability to realize visual ideas in the most direct manner — right on the screen — all without losing any of the traditional qualities of line, color, and composition. — *Michael Renner*

• Apple Macintosh Plus and Apple Macintosh II computers; pre-release version of Adobe Illustrator software; output on Linotronic Imagesetter.

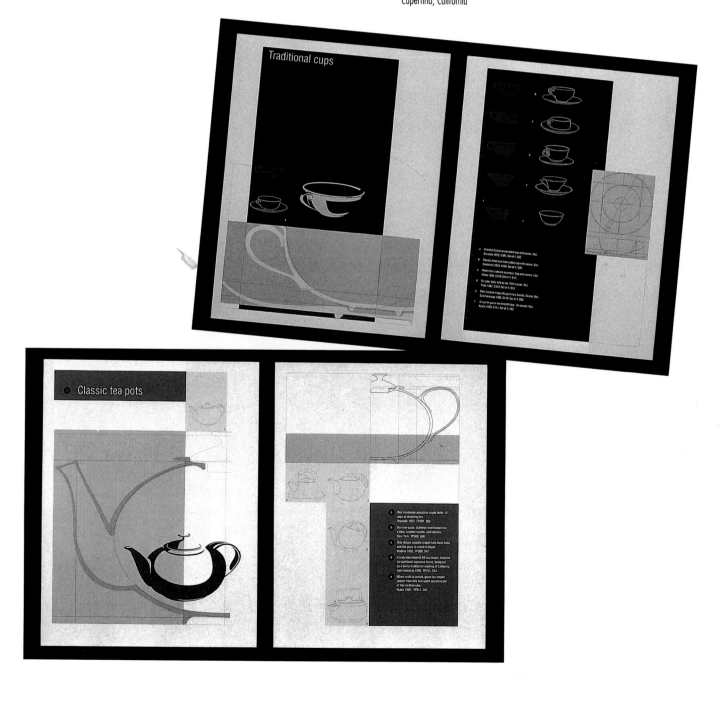

Designers
John A. Waters
Carol Bouyoucos
Ronald Leighton
Robert Kellerman
Dana Gonsalves
Waters Design Associates, Inc.
New York, New York

Client
Westvaco Corp.
New York, New York

Visual Chemistry, exhibition catalog and paper promotion.

• Lightspeed computer graphics system, Apple Macintosh II computer; Lightspeed 2.2 and Quark 2.0 software; output on LaserWriter II, Linotronic Imagesetter, and Fuji 3000 printer.

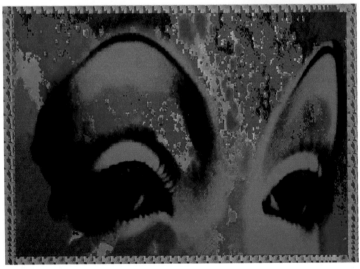

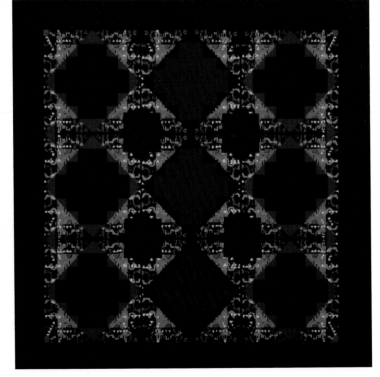

Designer
Dana Gonsalves
Waters Design Associates, Inc.
New York, New York

Client
Westvaco Corp.
New York, New York

Blue Eyes, illustration from *Visual Chemistry* brochure.

The value of advanced technology is that it expands our options. The difficulty is that we still have to make a choice. — *Dana Gonsalves*

• Lightspeed computer graphics system, Apple Macintosh II computer; Lightspeed 2.2 and Quark 2.0 software; output on Apple LaserWriter II, Linotronic Imagesetter, and Fuji 3000 printer.

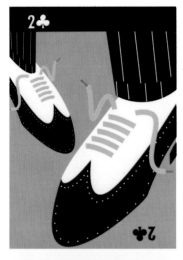

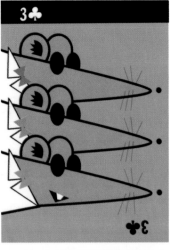

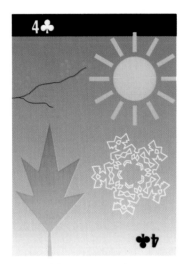

Designer
Paul Woods
Woods + Woods
San Francisco, California

Client
Adobe Systems, Inc.
Mountain View, California

Promotional playing cards.

• Apple Macintosh II computer; Adobe Illustrator 88 software; output on Linotronic Imagesetter printer.

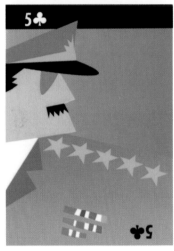

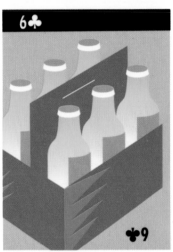

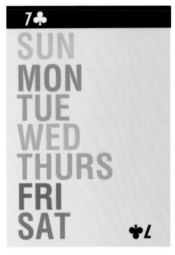

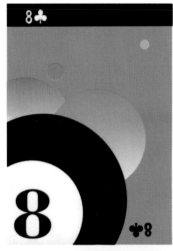

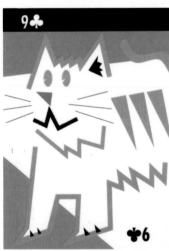

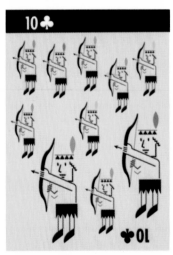

◄

Designer
Carol Bouyoucos
Waters Design Associates, Inc.
New York, New York

Client
Westvaco Corp.
New York, New York

Brightly Colored Quilt, illustration from *Visual Chemistry* brochure.

I began work on a series of computer-generated quilts in response to a popular notion that "computer art" is like Day-Glo paint on black velvet — the medium is more of a focal point than the subject. — *Carol Bouyoucos*

• Lightspeed computer graphics system, Apple Macintosh II computer; Lightspeed 2.2 and Quark 2.0 software; output on Apple LaserWriter II, Linotronic Imagesetter, and Fuji 3000.

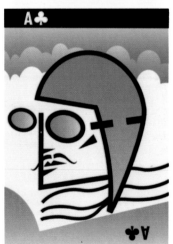

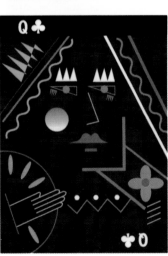

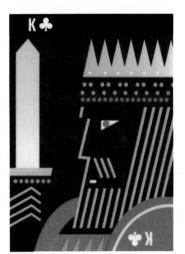

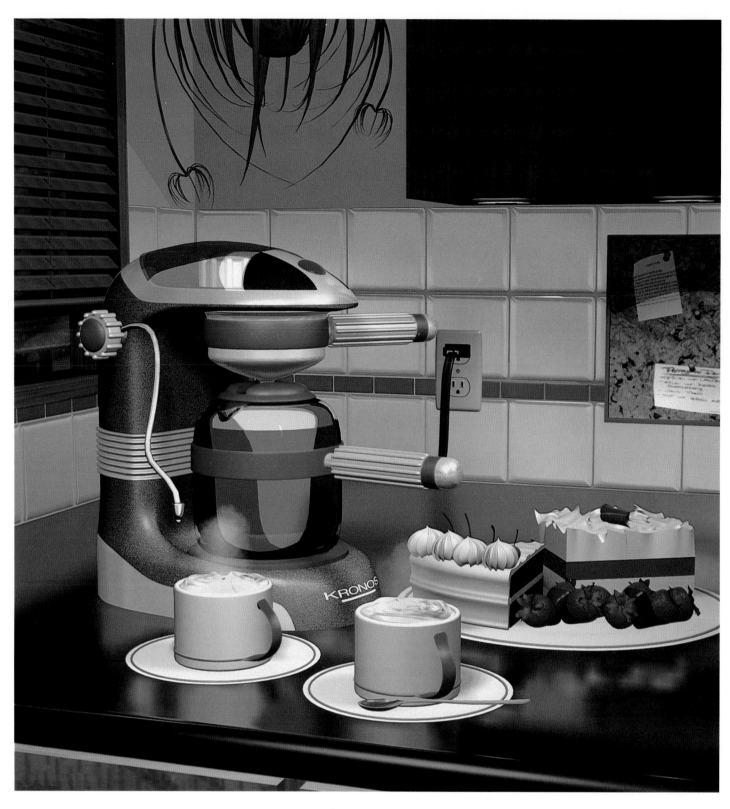

Designers
Stanley Lui (modeling)
Paul Roy (scene)
Alias Research, Inc.
Toronto, Canada

Client
Computer Graphics
World Magazine
Westford, Massachusetts

Espresso and Dessert, magazine cover illustration of proposed design for new espresso maker.

This illustration shows complex modeling techniques. Desserts were modeled and rendered with bump and displacement maps to add texture. Steam over the coffee cups was made possible with the software's "natural phenomena cloud" procedure.

• Silicon Graphics IRIS 4D workstation; ALIAS™/2 software; film output by Ariel Computer Productions, Inc., of Toronto, Canada.

Designer
Chris Wise
The ARG Group
New York, New York

Client
The North Face
Berkeley, California

Four-color annual catalog of outdoor clothing and equipment.

Having control is the best part of computers. On this project, I was able to use the rules sparingly but with exact placement to give the high-tech, high quality image that The North Face is known for. — *Chris Wise*

• Apple Macintosh II computer; Aldus FreeHand and PageMaker software; output on Linotronic Imagesetter.

Designer
David Curry
David Curry Design, Inc.
New York, New York

Client
Art in American Annual Guide
New York, New York

Cover for national guide to galleries, museums, and artists.

• IBM-PC computer, Microsoft Mouse, and Hewlett Packard Scanjet scanner; Aldus PageMaker, Micrografix Designer, PC Paintbrush, Windows, and Spinfont software; Laserjet II with Lasermaster card used for proofs, Linotronic Imagesetter for final output.

Designers
Robert Dietz
Ted Mader
Ted Mader & Associates
Seattle, Washington

Illustrator
Scott Campbell
Aldus Corp.
Seattle, Washington

Client
Bioscan
Edmonds, Washington

Software promotional brochure package.

This was a very complicated job, technically. We were working with a very knowledgeable computer software company and had to become just as knowledgeable to understand the product and how to present it. — *Robert Dietz*

• Apple Macintosh SE and IBM PC computers with video input; Aldus Snapshot, Aldus PageMaker and Aldus FreeHand software; output on Apple LaserWriter IINTX and Linotronic Imagesetter.

what is the human factor?

collaboration has new meaning.

who is a computer artist?

computer-mediated, viewer-controlled, interactive media challenges traditional forms of representation.

computers are a public phenomena.

what are the current computational myths?

have computers democratized creativity?

how we gather, observe, record, and distribute information has changed the manner in which we conceptualize and share ideas.

content is understood in terms of information.

the art is more important than the tool.

is there a computer-media aesthetic?

human/machine interface is on aesthetic issue.

have new artistic issues emerged?

computer tools are never artistically adequate or finite.

is there a semantic or computer ideas and symbols?

the artist's frame of reference serves as an aesthetic context and is observed in the work of art.

what is computer art?

joel slayton
cadre institute, sjsu

iii

opening
keynote
speaker

Issues in three dimensional rendering, computer animation and constraint based simulation will be discussed relative to human/machine interface design.

Mark Cutter

Manager, Multi-Media Technology for the Advance Technology Group at Apple Computer

Mr. Cutter received his Master's degree in Computer Science from the University of California, Berkeley. He has been with Apple Computer since 1980, assisting the development of both the Apple Lisa and Macintosh computers. He is the author of the MacDraw graphics program, as well as its predecessor, LisaDraw. Mr. Cutter has been involved with the Advanced Technology Group at Apple since it was founded in 1984, and has researched rendering algorithms and architectures for computer graphics. He is currently interested in emerging capabilities for desktop multi-media.

3

keynote address

session title: Artificial Intelligence in the Arts
location: Music bldg. rm. 150
time: 2-3:30pm
description: The panel includes architects and artists from academia and industry. They will discuss rule systems derived from shape grammars and constraint-based knowledge. The issues will include formal properties of shape grammars and how they are distinguished from symbol systems, how the languages that shape grammars define are useful for critical analysis of existing styles in art and architecture and are useful for developing new styles, and how constraint-based compositional rules are useful for shape placement in computer-aided design.

chair:
Laura Scholl,
AI Scientist, ModaCAD, Inc., involved in the development of a constraint-based tool for the fashion industry, also produced contraint-based animation at Whitney/Demos Productions, designed expert systems at Inference Corp. and taught at the MIT Media Lab
co-chair:
Ray Lauzzana,
Editor of FAST and the FINEART Forum, professor of computer graphics, University of Massachusetts, clients have included Universal Studios, Technicolor, and American Zoetrope

speaker/panelist:
Terry W. Knight, UCLA
Ray Lauzzana, University of Massachusetts
Laura Scholl, ModaCAD Inc.,
George Stiny, UCLA

19

saturday sessions

Designer
Veronica Ramirez
CADRE Institute
Fremont, California

Client
The National Computer Graphics
Association
Fairfax, Virginia

Conference brochure.

I appreciated being able to publish a complete book with a single tool, at a lower cost than by traditional methods and with a medium that is uniform in nature. — *Virginia Ramirez*

• Apple Macintosh II computer and Apple Scanner; Aldus PageMaker, Aldus FreeHand, Digital Darkroom, Electronic Arts Studio 8, Adobe Illustrator, and Superpaint software; output on Apple LaserWriter and Linotronic Imagesetter.

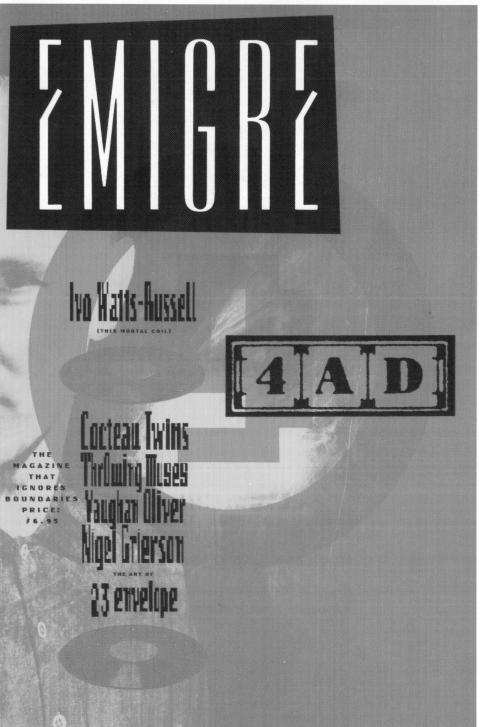

Designers
Rudy Vanderlans
Zuzana Licko (type)
Emigré Graphics
Berkeley, California

Client
de Tienne Associates
San Francisco, California

Interior design firm's promotion for dining exhibit.

• Apple Macintosh Plus computer; Letraset Ready, Set, Go software; Apple MacWrite and Fontographer software: output on Apple LaserWriter.

▶

Designers
Rudy Vanderlans
Zuzana Licko (type)
Emigré Graphics
Berkeley, California

Cover of *Emigré*, arts magazine published by the designers.

• Apple Macintosh Plus computer; Letraset Ready, Set, Go software and Apple MacWrite and Fontographer software; output on Apple LaserWriter.

Designers
Michael Renner
Lindy Cameron
Lori Barnett
The Understanding Business
San Francisco, California

Client
Adobe Systems, Inc.
Mountain View, California

Computer company annual report.

• Apple Macintosh SE computer; Adobe Illustrator, Aldus PageMaker, and Just Text® software; output on Linotronic Imagesetter.

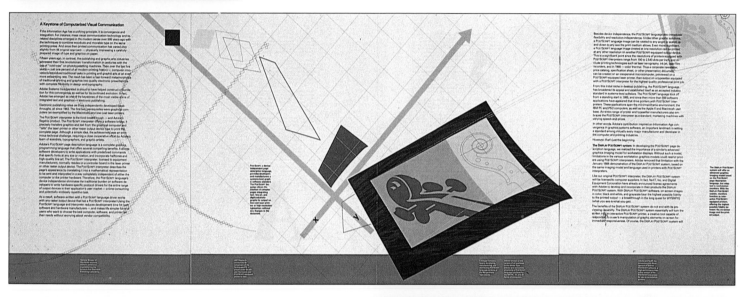

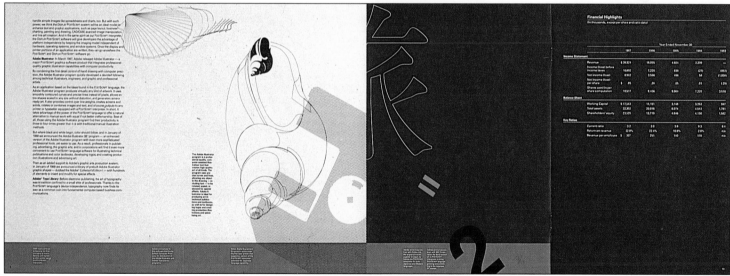

Designer
Michael Renner
The Understanding Business
San Francisco, California

Client
Pacific Bell Systems
San Francisco, California

Cover and spreads from the Pacific Bell *SMART Yellow Pages.*

The ease of using screened areas and the ability to separate colors enabled us to choose overprinting as a design and communication device. We established a standard format for all the pages. These master pages, in the form of computer files, allowed us to systemize the design specification and keep a consistent visual vocabulary throughout the project. — *Michael Renner*

• Apple Macintosh II computer; Adobe Illustrator 88 and Aldus PageMaker software; output on Linotronic Imagesetter.

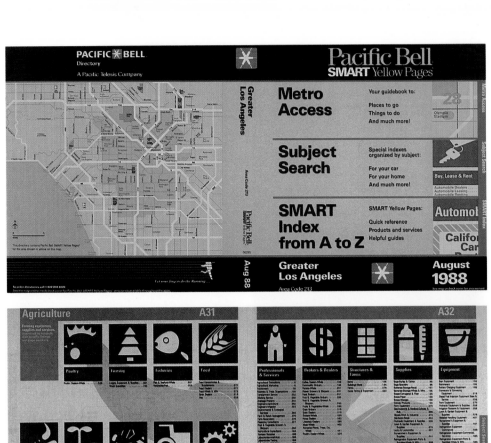

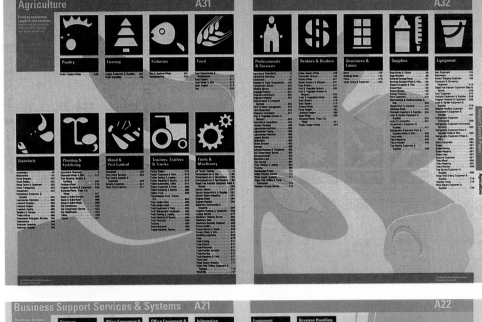

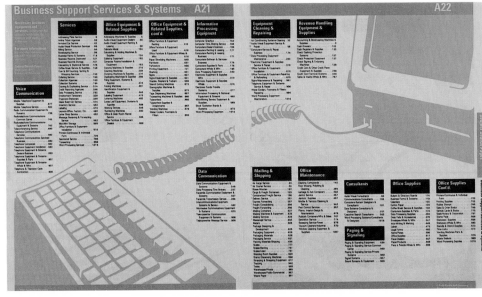

Illustrator
Charlie Athanas
Legs Akimbo
Chicago, Illinois

Client
First Publishing
Chicago, Illinois

Cover and two-page color spread from the first computerized comic book.

• Apple Macintosh Plus computer with Summagraphics tablet; Fullpaint software; original art output on Apple LaserWriter, handcolored by Olyoptics color separator and printed by offset.

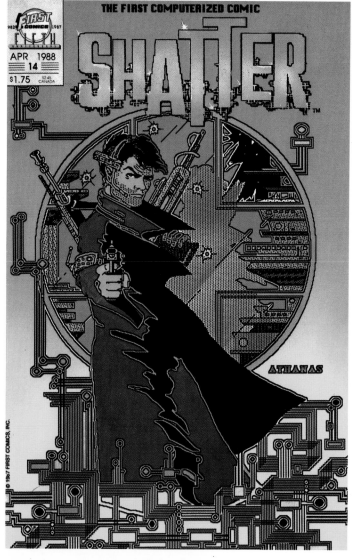

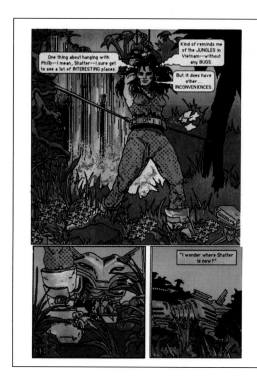

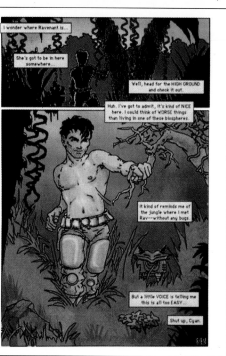

ELECTRONIC MEDIA

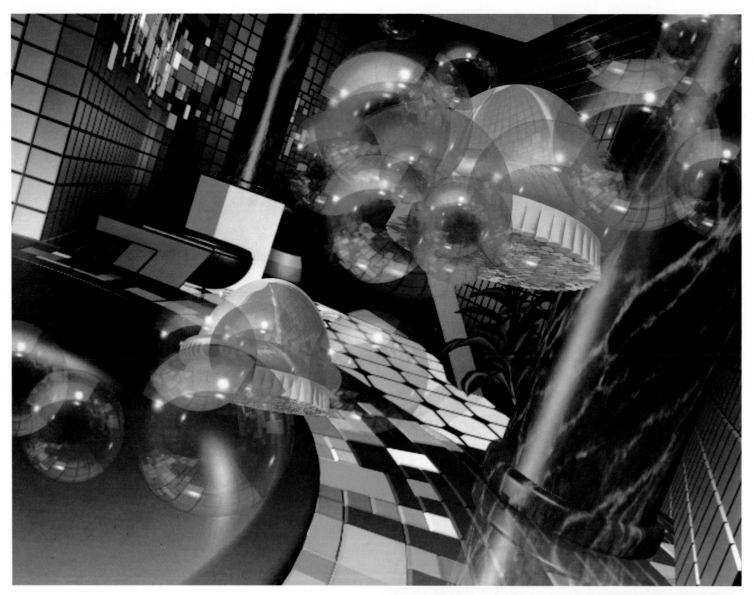

Designer
Ruedy W. Leeman
Cranston-Csuri Productions
New Albany, Ohio

Client
Dow Chemical
Greenville, South Carolina

"Scrubbing Bubbles," television commercial for cleaning product.

It is a challenge to give objects life. I attained a dramatic look by designing the colors and lighting with an Italian marble effect. The commercial was completely animated on computer and no hand work was involved. — *Ruedy W. Leeman*

• VAX 780 computer and Sun 2 workstation; TWIXT, Scn-Assembler, and CCP proprietary software; output on Celco film recorder.

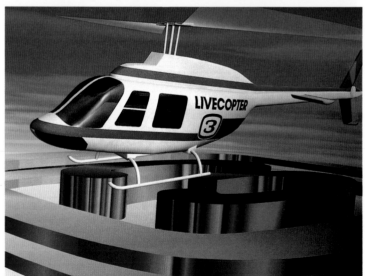

Designer/Animator
Ruedy W. Leeman
Cranston-Csuri Productions
New Albany, Ohio

Client
KCRA
Sacramento, California

Television commercial for news program.

It would have been impossible to fly close to the helicopter and get the same visual effect. Computers gave us control over the timing, lighting, and color. They enabled us to attain a realistic reflection of clouds in the window of the helicopter, as well as the soft background of clouds, and to insert the Channel 3 logo into the sequence.
— *Ruedy W. Leeman*

• VAX 780 computer, Evans & Sutherland PS 300 and Sun 2 workstations; TWIXT, Scn-Assembler, Film Scan, and CCP proprietary software; output to 1-inch videotape and Celco film recorder.

Director/Designer
Scott Miller
Scott Miller & Associates
New York, New York

Client
VH1/MTV Networks
New York, New York

Puzzle, three stills from VH1 network identification.

• Quantel Paintbox Videographics system and Bosch FGS-4000; proprietary software. The multi-layered animation was composited with seven simultaneous tape playbacks.

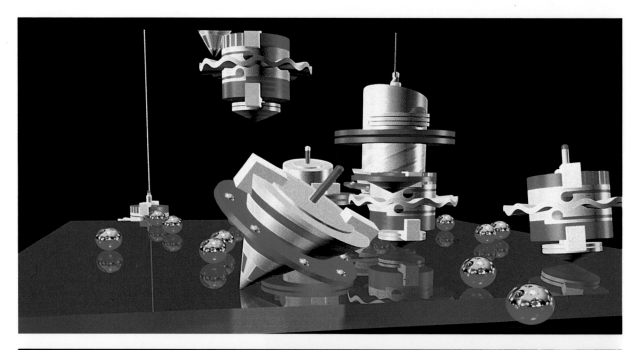

Director/Designer
Scott Miller
Scott Miller & Associates
New York, New York

Animator
Terry Mui
Filigree Films
New York, New York

Client
VH1/MTV Networks
New York, New York

Marble City, identification for music/video station.

- Apollo workstation; Intelligent Light software and proprietary software; output on Sony Recorder BHV 2500.

Director/Designer
Scott Miller
Scott Miller & Associates
New York, New York

Animator
Steve Goldberg
Pacific Data Images
Sunnyvale, California

Client
Satellite Music Network
Nashville, Tennesee

Tops, identification for music/video station.

• Silicon Graphics 4D series system; proprietary software; output on Abbekas digital disk recorder.

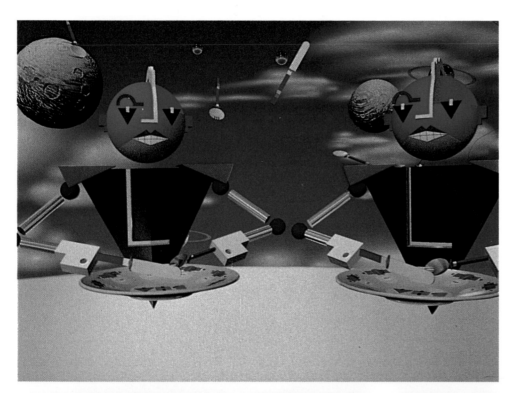

Designers
Scott Miller
James Houff
Scott Miller & Associates
New York, New York

Animators
Tetsu Ishimaki
Mi Kyung Kim
Filigree Films
New York, New York

Client
VH1-MTV Networks
New York, New York

TV Dinner, identification for music/video station.

• Apollo workstation; Intelligent Light software and proprietary software; output on Sony Recorder BHV 2500.

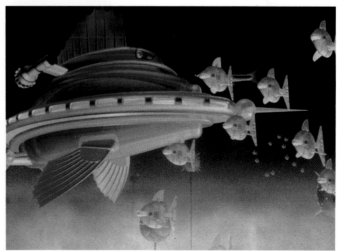

Designer
Scott Miller
Scott Miller & Associates
New York, New York

Animator
Adam Chin
Pacific Data Images
Sunnyvale, California

Client
VH1/MTV Networks
New York, New York

Windup, identification for music/video station.

• Silicon Graphics 4D series system; proprietary software; output on Abbekas digital disk recorder.

Designer
Scott Miller
Scott Miller & Associates
New York, New York

Designer
Joe Palrang

Animators
Steve Goldberg
Roger Gould
Pacific Data Images
Sunnyvale, California

Client
VH1/MTV Networks
New York, New York

Cruiser, identification for music/video station.

• Silicon Graphics 4D series system; proprietary software; output on Abbekas digital disk recorder.

Animator/Designer
Louis Schwartzberg
Energy Productions, Inc.
Los Angeles, California

Client
Baskin-Robbins
Los Angeles, California

Television commercial for ice cream franchise.

● Quantel Paintbox Videographics system; output to videotape. Traditional methods were used to originate footage. Then the computer system was used to input the footage, which was overlaid in up to fifty layers.

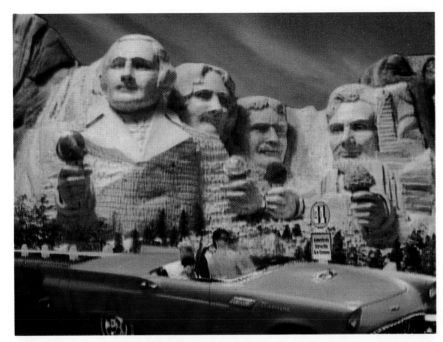

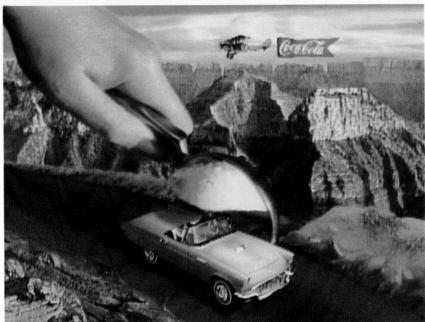

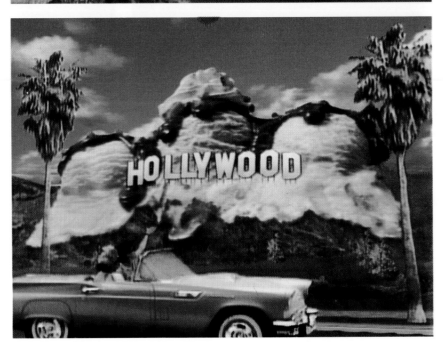

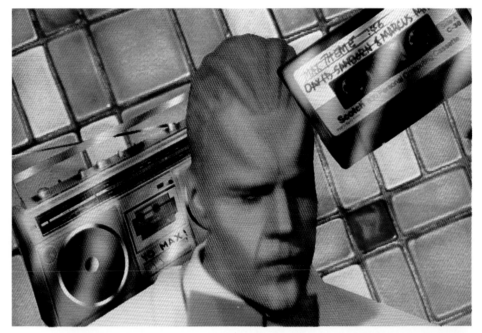

Designer/Director
Maureen Nappi
Maureen Nappi, Inc.
New York, New York

Client
Cinemax/HBO
New York, New York

"Max Headroom," animated television series title.

I realized my creative desire of placing Max in both a painterly and humorously challenging animation. Since the opening was in the context of moving imagery, the element of time and the precise control and pacing of Max, along with the surrounding elements, was critical. — *Maureen Nappi*

• Quantel Paintbox videographics system, Grass Valley Group GVG-300 video switcher, Ampex Digital Optics real time image processors, Teletronics VI square communications control system; Quantel software; output on Sony BVH-2000 videotape recorder.

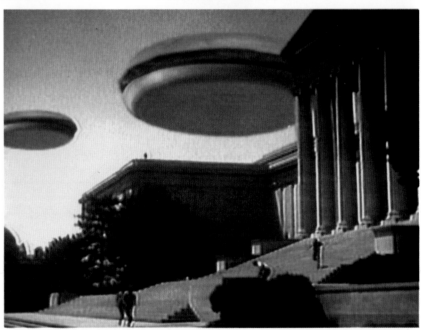

Designer
Cliff Moorhead
Napolean Videographics
New York, New York

Client
W.B. Doner for Arby's Restaurants
Baltimore, Maryland

"Burger Alert," restaurant chain television commercial for roast beef sandwiches.

The challenge of the commercial was to match the film grain and look of the commercial footage to the 1956 film "Earth vs. The Fying Saucers." Specially designed burger models were mounted on rigs and shot with Ultimatte, retouched and animated on Paintbox, and then the film's grain was stamped onto their surfaces.

• Quantel Paintbox Videographics system; input from and output to Ampex VPR-3 1-inch videotape.

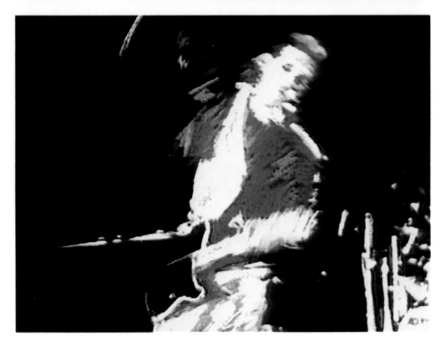

Designer
Bob Hill
Napolean Videographics
New York, New York

Pete Townsend, in-house promotion.

The key was to capture the energy of Townsend's performance. By rotoscoping and enhancing the colors and motion while creating a stark backdrop, the essence of his driving guitar-playing comes through. The ability to make changes on the fly and see the animated results immediately gave the Paintbox a clear advantage over traditional animation.

• Quantel Paintbox Videographics system; Pro-5 software; output on Ampex VPR-3 1-inch video recorder.

Video Artist
Rich Yasick
Production Masters, Inc.
Pittsburgh, Pennsylvania

Still from in-house promotional videotape demonstrating animation capabilities.

Actual, live video was quickly and effectively transformed into a "painted" look. A computer-generated texture brush was created to achieve the desired dry-brush look. The colors stayed clean and did not muddy when overlapped or mixed. — *Rich Yasick*

• Ampex Video Art Paint System (AVA-3); recorded on Sony Mavigraph UPC5000.

▶
Animators
Ex Machina
Paris, France
Client
Tuileries 89
Paris, France

Nine-minute animated film to commemorate the bicentennial of the French Revolution.

The charge was to recreate Paris as it looked two hundred years ago during the French Revolution. It had to include buildings and places that no longer exist. The challenge was to give a realistic old look to buildings with a tool more appropriate to clean, high-tech looks. — *Anna-Karin Quinto (of Ex Machina)*

• Silicon Graphics workstation; Explore TDI software; output on 35mm film.

Designers
C. Cicconetti
E. Gasparini
M. Mastretta
E. Morten
Automa S.C.R.L.
Genoa, Italy

Client
Ministry of Culture
Italy

Verso Genoa Medievale, interactive animated videodisk depicting medieval Genoa for general public viewing during a festival.

• Silicon Graphics system; Explore TDI, RIO, and Island Graphics TIPS software; output on videotape, mastered on videodisk.

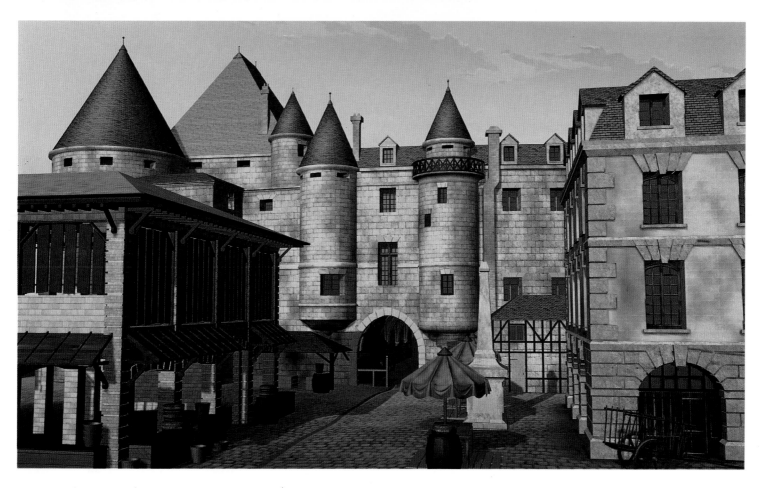

Animator
Bill Kroyer
Kroyer Films, Inc.
Burbank, California

Technological Threat, still from animated film depicting a cartoon wolf going berserk when his job secruity is threatened by computer-animated robots.

The film combines three-dimensional sets used for the environment with computer-generated, two-dimensional animation. One computer animator did the work of twenty traditional animators. Animation cels were generated on the computer and plotted as ink drawings. Cels were painted from the plots and animated using traditional cel animation techniques.

• Silicon Graphics IRIS 3120 workstation; Wavefront Prevue, Kroyer Films Model, and Render proprietary software; output on Hewlett Packard 7550A plotter.

Designers
Holly Hurwitz
HBO/MTV Network
New York, New York
Henry Baker
Patti Bellucci
BXB, Inc.
New York, New York

Stills from television show opening of "HBO Comedy Hour."

The computer's speed and cleanliness were a dramatic help in the design of this video sequence. The colors are more vibrant when created on a computer than those achieved by traditional methods. The piece was completed in one-thirtieth of the usual time span.

• Quantel Harry, Paintbox, and Encore hardware; Quantel computer

▼

Designer/Paintbox
Mark Stover
Animator
Jim Polk
Post Production Services
Cincinnati, Ohio

Woody, in-house promotion.

This was my first attempt at applying traditional character-based animation techniques to the realm of three-dimensional computer animation. It featured a ray-traced look at the world of the graphic artist, in the natural light of the studio.
— *Mark Stover*

• Quantel Paintbox Videographics system, Silicon Graphics and Sun Microsystems graphic workstations; Wavefront Technologies and Quantel software; output on Sony BVH 2500 on videotape.

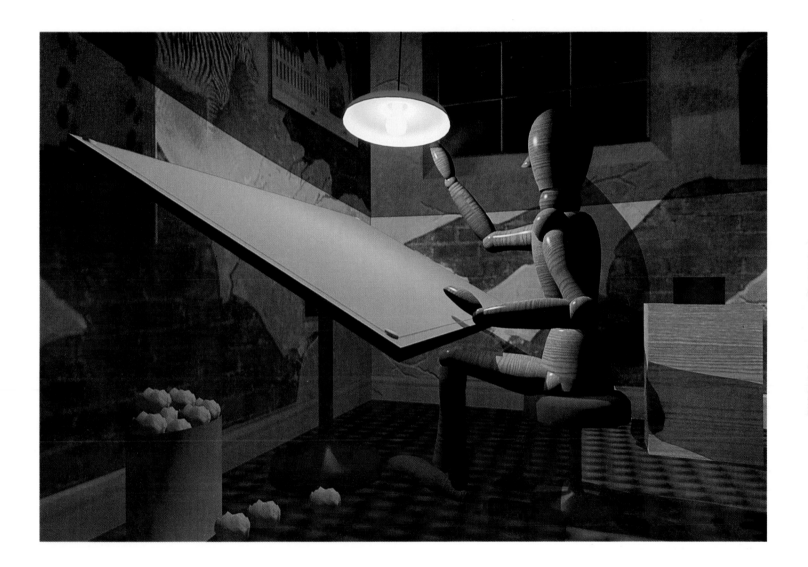

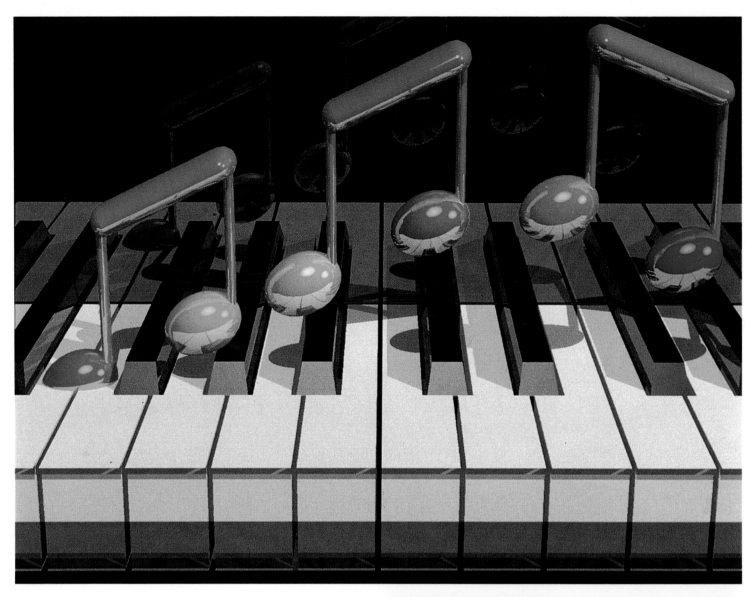

Designer/Programmer
Melvin L. Prueitt
Los Alamos National Laboratory
Los Alamos, New Mexico

Experimental electronic image.

• Cray supercomputer; proprietary software; output on Dicomed film recorder.

Designers
Daniel Thalmann
Swiss Federal Institute
of Technology
Lausanne, Switzerland
Nadia Magnenat-Thalmann
University of Geneva
Geneva, Switzerland

Relax, experimental image.

• Raster Technology and Silicon Graphics IRIS workstations; Human Factory software; Dunn film recorder for slide output. Original software algorithm was used to draft realistic shadows in either an interior or exterior space.

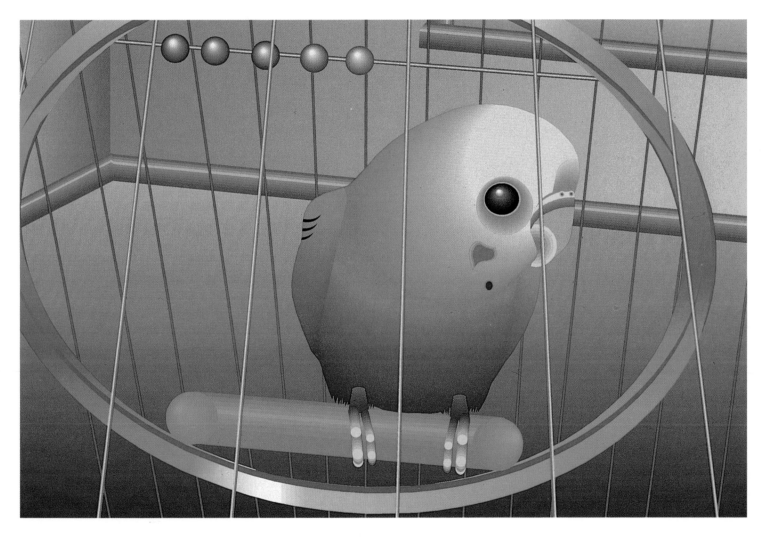

Designer
Kim Schneider
Slide Craft, Inc.
Cincinnati, Ohio

Self-promotional slide graphic.

• Genigraphics 100C and 100D+ system; output to film recorder. Ten files, 941 colors, and five exposures were required to execute this image. A high-end system was used to build the bird out of polygons.

PERMISSIONS

Passion and Paradise, Space Adventure, and illustrations from *MacWorld* magazine pp. 6 & 8 © Ron Chan.

James Brown © Howard Mandel, 1989, New Media Design Group.

Illustration from *Outside Business Magazine*, illustrations from *MacWeek* magazine p. 11, illustrations pp. 12 & 13, and *Lil' Boats* © Mick Wiggins.

Draw the Cowboy and illustration from *U.S. News & World Report* © Steve McKinstry, 1989.

The Two Faces of Schizophrenia and *Heartless Intellectual* by J. Patrick Sedlar, © The Detroit News.

Crayons, Artist: Erol Otus, Software: © Island Graphics Corporation, 1989. All rights reserved.

Illustrations p. 18, BMW direct mail promotional cards p. 116, *The Real McCoys,* and *Waiting for Laser Printer* © Johnee Bee.

High Tech Spy, Self-Portrait, File Cabinet, Frog Skull, Porch in Quogue, and Pomodoro ad p. 119 © Jonathan Herbert.

Capitello by Francesca Besso © RGB Computer Graphics Service, Milan, Italy in care of Tuilia Rednelli.

Water Strider and *Trombones* by Daniel Langlois © SOFTIMAGE, 1988.

Sea Horse, Rich, and *Jazz Sax* by James Dowlen © Vision Technologies, a division of Everex Systems, Inc.

The Anchorman © Jeremy Gardiner; *Three Graces* © Jeremy Gardiner, 1989, courtesy NYNEX Art Collection.

The Ultimate Computer and *Landscape with a Woman* © Serban Epure, Frankfurt Gips Balkind.

Illustrations depicting David Byrne, Pete Townsend, and Cyndi Lauper, album cover for Shalva Berti, *A Day in an Artist's Life,* and *Face* © Micha Riss.

Photographs of Pete Townsend and David Byrne (used in illustrations by Micha Riss, p. 28) © 1990 by Arthur L. Field, 1990, Rock Wire Service.

Photograph of Cyndi Lauper (used in illllustration by Micha Riss, p. 29) © John Bellisimo, 1988, L.G.I.

Xmas Card © John Derry, 1988; *Coffee* © John Derry, 1989; *Sacramento Street #3* © John Derry, 1988; *Towers* © John Derry, 1985; *International Orange* © John Derry, 1989; *Zone* © John Derry, 1985; *Apple Suite* © John Derry, 1988. *Shoes* by John Derry © Chromaset/Imageset, 1987; used with permission; *Transcar* © by John Derry, 1987; and Chromoset ad p. 113 © John Derry, 1987.

Poster p. 107 — left and *Switching to Hypercard* © Scott Baldwin.

Illustration p.31 © Jim Thompson.

Romeo and Juliet, Birdwomen, Traci, packaging illustration p. 95, and poster illustration p. 102 by Alan Brown, © Photonics Graphics and PhotoDesign, 1989.

The Mirror © Lawrence W. Lee, 1989; reprinted courtesy of Harbinger House, Inc.

New Mexico and *Watch Man* © Sharmen Liao.

Illustration p. 36 — top © Denis A. Dale. 1985; thanks to Colorgraphics, Inc. of Madison, Wisconsin for use of the Artstar Computing System.

Interior of airplane © Data Motion Arts, Inc., Designers: Saul Rubin and Tony Caio.

Dave's 5 & 10 © Bert Monroy.

Hello Cyan, Nice. Colloidal Armor? by Charlie Athanas from *Shatter* comic books © First Publishing, Inc., 1987. Cover and two page spread from Shatter #14 by Charlie Athanas © First Publishing, Inc. 1987.

Robot Voices and illustration for *Encyclopaedia Britannica* © John Craig, 1989.

Tubes Artist: Avril Harrison and Software: © Island Graphics Corporation, 1989. All rights reserved.

Telephone Network by Judson Rosebush, Duffy White, George Tsakas, Joe Pasquala, Larry Elan, Elyse Weintraub, Gene Miller and Gail Goldstein, Courtesy of and © by Judson Rosebush Co., 1985.

Icons and pages, pp. 44-45, and cover and spreads, p.132, from the Pacific Bell *SMART Yellow Pages* by Michael Renner © Pacific Bell. Poster and catalog spreads p. 121 and annual report p. 129 © Michael Renner.

Face © Carolyn L. Lockett, 1989.

Love this face and *Two Zebras* © Rachel Gellman.

Flamingo Graphics poster © Marian Schiavo, 1989; *The Gnarly Landpiper, The Tigerfly, Tatoo, Strange Bird* and *Mother of Pearl* © Marian Schiavo; 4x5 digital Solitaire Imaging 2 courtesy of Speed Graphics.

Druid Invocation © John Ashley Bellamy (2200 N. Haskell, Dallas, TX 75204, (214) 827-2032).

Opening © Marsha J. McDevitt, The Advanced Computing Center for the Arts and Design, The Ohio State University.

Images pp. 58-59 © John S. Banks, 1987-89.

Child Abuse © Maureen Nappi, 1988.

Bob © Peter Voci, N.Y.I.T. Media & Arts.

A Moonlit Spring Night at Ma-ma Temple © Naoko Motoyoshi.

Tantra © Jo Ann Gillerman.

Broken Conversation © Sandro Corsi, 1987.

Suit of cards p. 64 by Ruth Kedar © Adobe Systems, Inc., 1988. All rights reserved. Analog Cards p. 65 © Ruth Kedar, 1989. All rights reserved. The Analog (TM) deck is a trademark of Ruth Kedar Designs.

Experimental image p. 148, Spherical Universe, and *Spheres in a Spiral* © Melvin L. Prueitt, Computer Graphics Group, Los Alamos National Laboratory.

Outreach © Annette Weintraub, 1989.

Two images p. 70 from "Conquest of Form" exhibition © William Lantham and IBM UKSC, 1989.

Kreuzberg #1 © Alan Luft.

High Performance © Dreamlight Inc., 1987, 1988.

Direct mail brochure p. 74 and Zero Channel logo © Phylane Norman.

Brochure and folder p. 75 © Lucinda Cameron.

Questech Annual Report, Maryland Academy of Sciences poster and self-promotional posters p. 105; used with permission from Grafitto, Inc.

Page from workshop materials p. 78 and OmniPage, Pillar, Connect, and Claris logos © Clement Mok.

Jlffy Lube Annual Report © N. David Crowder.

Fairfax Hospital Brochures pp. 78-79 © Donald H. Sparkman, Jr.

Materials for corporate identity program p. 80, Orca Bay poster, Wing Luke Museum poster, invitation for client and self-promotion piece p. 119, and Vision of Flight poster © Studio MB.

Business materials and logo p. 80 © Joan Sutton.

Identity program for Spiegelman & Associates p. 81 © Spiegelman & Associates, 1989.

Stationery for Kenny G p. 81 © Tony Gable.

Film announcement for "China Lake", *GlasHAUS* logo, *Non-Stop Design* poster, *GlasHAUS* calendar, and *Emigre* magazine cover, and DeTienne Associates promotion p. 128 © Emigre Graphics.

Matrix typeface and *Signs of Type* catalogue © Zuzana Licko/Emigre Graphics.

Cactus Fabrics logo, *Gnarly Golf* and Indian Spring packages, poster p. 101 — left direct mail piece p. 118 — right, awards luncheon invitation p. 120 — top left, and Adobe promotional playing cards p. 123 © Paul Woods.

Package design © Beverly C. Kirk, 1988. This package design concept was totally created the Aesthedes design computer at the studio of Seta, Appleman & Showell, Inc.

Andiamo logo © Nancy Bellatone.

Contents page from *Communique* © Ingram Micro D, Inc., 1990. All rights reserved.

JackRabbit Rug, *Gal Pattern Rug*, *Dog Woman*, *Athletic Icons* and *Radiant City* logo, Robo logo, and Reactor logo © Louis Fishauf.

Knit fabric and sample clothing p. 93 © Susan Lazear, 1987. All rights reserved.

Electronic catalog package and label p. by Nat Connacher & James Waldron. The Agfa/Compugraphic Hypercard stack appears courtesy of Agfa/Compugraphic. AGFA & the Agfa rhombus are registered trademarks of Agfa-Gevaert, AG. Hypercard is a trademark of Apple Computer, Inc.

Experimental album cover, "Limo Takes Me to the Mall," © Carol Flax, 1988.

CD and tape packaging p. 96, paper airplane promotion p. 97, and brochure p. 126 © Ted Mader & Associates.

Opera poster p. 98 by Primo Angeli and Mark Crumpacker, © Primo Angeli, Inc.

The Park Service posters pages 104-105 by Robert Burns & Michael Crumpton appear courtesy of the National Park Service, U.S. Department of the Interior. The buffalo is a registered trademark of the U.S. Department of the Interior.

Poster p. 106 © Vicky Putz. The artwork shown represents a juried show for the ACM SIGGRAPH 1989 Computer Graphics Theater. The rights to any and all artwork are owned by the person(s) responsible for creating that artwork.

Poster p. 107 — right, Sea Breeze Ad campaign p. 110, ABC TV T-shirt p. 110, and Iberia Airlines ad p. 111 © Javier Romero.

Sportscoupe and *Rosedale* © Alias Research, Inc. Espresso and Dessert Modeling: Stanley Liu, Scene: Paul Royu © Alias Research, Inc., 1989.

Looking In © Craig Caldwell.

Television commercial p. 115 © Barbara Tutty, TSI Video. All rights reserved.

Self-promotion © Phillip W. Lepine.

Emerald City by Jay Nilsen © 1988 Emerald City Prodductions.

Self-promotional brochure p. 120 — bottom left © Pattie Belle Hastings.

Not Just Pie in the Sky © Audrey Fleisher, 1989.

Visual Chemistry catalog, Westvaco Promotion by John Waters, Carol Bouyoucos, Ronald Leighton, Robert Kellerman, Dana Gonsalves © Waters Design Associates, Inc.

The North Face Catalog, Designer: Christopher Wise (Kellogg Design), Art Director: Derrin Brew (The North Face) © The North Face, used by permission.

Art in America Annual and Art in America Identity Program, © David Curry Design.

National Computer Graphics conference publication © CADRE Institute, San Jose State University.

"Scrubbing Bubbles" and "Channel 3" commercials © VCCP Rudy W. Leeman (7971 Dublin-Granville Rd., New Albany, OH 43054, (614) 855-7229).

Tops, Technical Director: Rex Grignon, Director/Designer: Scott Miller, © MTV Networks, Inc. 1989; *Puzzle*, Executive Design Director: Ron Pearl, Director/Designer: Scott Miller, © MTV Networks, Inc.; *Marble City* Director/Designer: Scott Miller, © MTV Networks, Inc., 1988; *TV Dinner*, Technical Director: Terry Mix, Designer: Scott Miller, © MTV Networks, Inc., 1989; *Cruiser* © Designers: Scott Miller & Joe Palrang, © MTV Networks, Inc., 1989; and *Windup* © Designer: Scott Miller, © MTV Networks, Inc., 1989.

Television commercial © Louis Schwartzberg.

"Max Headroom" by Maureen Nappi Productions © Chrysalis Visual Programming Limited, 1987. Used courtesy of HBO/TV.

"Burger Alert," Director: Tony Coronia and *Pete Townsend*, Producer: Marty Napoleon © Napoleon Productions.

In-house promotion spot p. 144 by Rich Yasick, © Production Masters, Inc.

Verso Genoa Medievale Designers: C. Cicconetti, E. Gasparini, M. Mastretta and E. Morten, © Automa.

Animated film © Ex Machina, Paris France.

Technological Threat © Bill Kroyer.

"HBO Comedy Hour" © HBO/TV.

Woody by Mark Stover, Jim Polk, Garman Hericstad, and Dave McLean, © Post Production.

Relax © Nadia Maguenat-Thalmann, University of Geneva, and Daniel Thalmann, Swiss Federal Institute of Technology.

Slide graphic © Kim Schneider.

Other Art Books from North Light

Graphics/Business of Art

Airbrush Artist's Library (6 in series) $12.95 (cloth)
Airbrush Techniques Workbooks (8 in series) $9.95 each
Airbrushing the Human Form, by Andy Charlesworth $19.95 (cloth)
The Art & Craft of Greeting Cards, by Susan Evarts $15.95 (paper)
The Artist's Friendly Legal Guide, by Conner, Karlen, Perwin, & Spatt $15.95 (paper)
Artist's Market: Where & How to Sell Your Graphic Art (Annual Directory) $19.95 (cloth)
Basic Graphic Design & Paste-Up, by Jack Warren $13.95 (paper)
Color Harmony: A Guide to Creative Color Combinations, by Hideaki Chijiiwa $15.95 (paper)
Complete Airbrush & Photoretouching Manual, by Peter Owen & John Sutcliffe $24.95 (cloth)
The Complete Guide to Greeting Card Design & Illustration, by Eva Szela $27.95 (cloth)
Creating Dynamic Roughs, by Alan Swann $27.95 (cloth)
Creative Ad Design & Illustration, by Dick Ward $32.95 (cloth)
Creative Director's Sourcebook, by Nick Souter and Stuart Neuman $89.00 (cloth)
Creative Typography, by Marion March $27.95 (cloth)
Design Rendering Techniques, by Dick Powell $29.95 (cloth)
Dynamic Airbrush, by David Miller & James Effler $29.95 (cloth)
Fashion Illustration Workbooks (4 in series) $8.95 each
Fantasy Art, by Bruce Robertson $24.95 (cloth)
Getting It Printed, by Beach, Shepro & Russon $29.50 (paper)
The Graphic Artist's Guide to Marketing & Self-Promotion, by Sally Prince Davis $15.95 (paper)
The Graphic Arts Studio Manual, by Bert Braham $22.95 (cloth)
Graphic Tools & Techniques, by Laing & Saunders-Davies $24.95 (cloth)
Graphics Handbook, by Howard Munce $14.95 (paper)
Handbook of Pricing & Ethical Guidelines, 7th edition, by The Graphic Artist's Guild $22.95 (paper)
Hot Air 1: An Explosive Collection of Top Airbrush Illustration, by Werner Steuer $39.95 (cloth)
How to Design Trademarks & Logos, by Murphy & Row $24.95 (cloth)
How to Draw & Sell Cartoons, by Ross Thomson & Bill Hewison $18.95 (cloth)
How to Draw & Sell Comic Strips, by Alan McKenzie $18.95 (cloth)
How to Draw Charts & Diagrams, by Bruce Robertson $24.95 (cloth)
How to Understand & Use Design & Layout, by Alan Swann $24.95 (cloth)
How to Understand & Use Grids, by Alan Swann $27.95 (cloth)
How to Write and Illustrate Children's Books, edited by Treld Pelkey Bicknell and Felicity Trotman, $22.50 (cloth)
Illustration & Drawing: Styles & Techniques, by Terry Presnall $16.95 (cloth)

Living by Your Brush Alone, by Edna Wagner Piersol $16.95 (paper)
Marker Rendering Techniques, by Dick Powell & Patricia Monahan $32.95 (cloth)
Marker Techniques Workbooks (8 in series) $9.95 each
The North Light Art Competition Handbook, by John M. Angelini $9.95 (paper)
North Light Dictionary of Art Terms, by Margy Lee Elspass $12.95 (paper)
Papers for Printing, by Mark Beach & Ken Russon $34.50 (paper)
Preparing Your Design for Print, by Lynn John $27.95 (cloth)
Presentation Techniques for the Graphic Artist, by Jenny Mulherin $24.95 (cloth)
Print Production Handbook, by David Bann $14.95 (cloth)
Promo 1: The Ultimate in Graphic Designer's and Illustrator's Self-Promotion, by Rose DeNeve $39.95 (cloth)
Ready to Use Layouts for Desktop Design, by Chris Prior $27.95 (cloth)
Studio Secrets for the Graphic Artist, by Jack Buchan $29.95 (cloth)
Type: Design, Color, Character & Use, by Michael Beaumont $24.95 (cloth)
Using Type Right, by Philip Brady $18.95 (paper)

Watercolor

Basic Watercolor Painting, by Judith Campbell-Reed $16.95 (paper)
Capturing Mood in Watercolor, by Phil Austin, $26.95 (cloth)
Chinese Watercolor Painting: The Four Seasons, by Leslie Tseng-Tseng Yu $24.95 (paper)
Getting Started in Watercolor, by John Blockley $19.95 (paper)
The New Spirit of Watercolor, by Mike Ward $27.95 (cloth)
Painting Nature's Details in Watercolor, by Cathy Johnson $24.95 (cloth)
Painting Watercolor Portraits That Glow, by Jan Kunz $27.95 (cloth)
Sir William Russell Flint, edited by Ralph Lewis & Keith Gardner $55.00 (cloth)
Starting with Watercolor, by Rowland Hilder $24.95 (cloth)
Tony Couch Watercolor Techniques Workbook 1 & 2, by Tony Couch $12.95 each (paper)
Watercolor Interpretations, by John Blockley $19.95 (paper)
Watercolor Options, by Ray Loos $22.50 (cloth)
Watercolor Painter's Solution Book, by Angela Gair $24.95 (cloth)
Watercolor—The Creative Experience, by Barbara Nechis $16.95 (paper)
Watercolor Tricks & Techniques, by Cathy Johnson $24.95 (cloth)
Watercolor Workbook, by Bud Biggs & Lois Marshall $19.95 (paper)
Watercolor: You Can Do It!, by Tony Couch $26.95 (cloth)

Watercolor Videos

Watercolor Fast & Loose, with Ron Ranson $29.95 (VHS or Beta)
Watercolor Pure & Simple, with Ron Ranson $29.95 (VHS or Beta)

Mixed Media

The Art of Scratchboard, by Cecile Curtis $23.95 (cloth)
Calligraphy Workbooks (4 in series) $7.95 each
Catching Light in Your Paintings, by Charles Sovek $18.95 (paper)
Colored Pencil Drawing Techniques, by Iain Hutton-Jamieson $24.95 (cloth)
Complete Guide to Fashion Illustration, by Colin Barnes $32.95 (cloth)
The Complete Oil Painting Book, by Wendon Blake $29.95 (cloth)
Drawing & Painting with Ink, by Fritz Henning $24.95 (cloth)
Drawing for Pleasure, edited by Peter D. Johnson $15.95 (paper)
Drawing Workbooks (4 in series) $8.95 each
The Figure, edited by Walt Reed $15.95 (paper)
Keys to Drawing, by Bert Dodson $19.95 (paper)
Light: How to See It, How to Paint It, by Lucy Willis $24.95 (cloth)
Make Your Own Picture Frames, by Jenny Rodwell $12.95 (paper)
Mixing Color, by Jeremy Galton $24.95 (cloth)
The North Light Handbook of Artist's Materials, by Ian Hebblewhite $24.95 (cloth)
The North Light Illustrated Book of Painting Techniques, by Elizabeth Tate $27.95 (cloth)
Oil Painting: A Direct Approach, by Joyce Pike $26.95 (cloth)
Painting & Drawing Boats, by Moira Huntley $16.95 (paper)
Painting Birds & Animals, by Patricia Monahan $21.95 (cloth)
Painting in Oils, edited by Michael Bowers $18.95 (cloth)
Painting Murals, by Patricia Seligman $26.95 (cloth)
Painting Portraits, by Jenny Rodwell $21.95 (cloth)
Painting Seascapes in Sharp Focus, by Lin Seslar $24.95 (cloth)
Painting with Acrylics, by Jenny Rodwell $22.95 (cloth)
Painting with Oils, by Patricia Monahan $19.95 (cloth)
Painting with Pastels, edited by Peter D. Johnson $16.95 (paper)
Pastel Painting Techniques, by Guy Roddon $24.95 (cloth)
The Pencil, by Paul Calle $16.95 (paper)
People Painting Scrapbook, by J. Everett Draper $26.95 (cloth)
Perspective in Art, by Michael Woods $13.95 (paper)
Perspective Without Pain Workbooks (4 in series) $9.95 each
Photographing Your Artwork, by Russell Hart $15.95 (paper)
Putting People in Your Paintings, by J. Everett Draper $22.50 (cloth)
The Techniques of Wood Sculpture, by David Orchard $14.95 (cloth)
Tonal Values: How to See Them, How to Paint Them, by Angela Gair $24.95 (cloth)